KU-520-347

Reflections

Rob Ward

Published 2009 by MakingSpace Publishers, Isle of Wight, UK

ISBN: 1 900999 28 5

Printed 2009 in China by Shanghai Sculpture Park, Shanghai, China

shanghai
sculpture
park
月湖雕塑公园

Designed by MakingSpace, Isle of Wight, UK

Acknowledgements

My thanks to the people who have supported the
publication of this book. Any publication is a combination
of talents. To the writers who have interpreted my work
with sensitivity and understanding I give my deepest
thanks to Clare Lilley for the beautiful and fitting
main text, Sebastiano Barassi, Marc Wellman, Ursula
Szulakowska and my wife Cathy Ward for their generous
insights, and to Jon Wood for the introduction to 40 years
of work.

My thanks once again to my long term collaborators, David
Burnop and Jonathan Ward, who have photographed,
designed, created and advised on the book with their usual
energy, interest and commitment. Thanks also to Michelle
Lai with her help in realizing the printing of the book. I am
honoured to have had their support.

The publication would not have been possible without the
support of the Arts and Humanities Research Council, the
University of Leeds and the Henry Moore Foundation

Rob Ward

Contents

There is an interesting relationship between sculpture and books. They can share similar phenomenological properties, they can be held and turned in the hand, and they can be appreciated at leisure and in slow time. Such correspondences have a particular urgency and poignancy today as we look at sculpture and read books in the age of their digital reproduction. Sculptures, like books, take up space - space that is becoming increasingly precious and needed for other things — at the same time as they can be an extraordinary means of creating it in the minds and lives of their viewers and readers. They can be weighty, obdurate and stubborn, as they aim to carry their messages long into the future, but standing in intimate relation to the bodies and minds that surround them, they can also be packed with possibilities, generosity and imaginative potential.

Rob Ward is not a bookish sculptor, although his interest in poetry and fiction is noteworthy; nor is his sculpture highly dependent on narrative or allegorical structures, but a book makes particular sense, as an object, form and frame, to present the work of this artist. There is a fit and a meeting of modes and the book format is a personal and physical means of revealing an oeuvre which is itself so physical and personal. It is a way of documenting it, interpreting it and making it accessible. 'Taking things personally' is something we all can't help but do, to some extent or other, but also something that we might feel ought to be avoided. This book, however, is ultimately an invitation to take things personally - to take him and his sculpture personally.

There have been a handful of small, limited edition publications to date already — such as Conventions, Objects and Fields (1995), Crimsworth (1998), Songs (1998), 6 Memos (2001) and Patterns (2005) - which all share the same size and hard back format (like collections of poetry, as it happens), but there is not a large single, well-illustrated book one that provides a sense of the range and development of Rob Ward's practice over the last forty years. This book makes amends for this, presenting photographs of the sculptures, drawings, paintings and installations he has made alongside new writings by Clare Lilley from the Yorkshire Sculpture Park, Sebastiano Barassi from Kettle's Yard in Cambridge and Marc Wellmann, whose interest in three-dimensional art has led him to curate and write on a range of historical and contemporary sculpture in Berlin. These add much to the literature on Ward, a literature which already includes some fascinating and insightful texts by Urszula Szulakowska, who has followed Ward's work for many years. Lilley has written about Ward's life as well as the work, looking at his childhood and education, which included the Bauhaus-inspired Basic Design Course that he undertook at Kings College University in Newcastle in the late 1960s. She also discusses his time at Reading University (1973-75) and his five year spell in Australia (1977-82), as well as his work at Bretton Hall and also in China, where he continues to make and show his sculpture. Barassi, on the other hand, has focussed more on Ward's drawings and the relationship between drawing and sculpture in his practice, whilst Wellmann has addressed the poetry of reflection that we find in Ward's shiny, polished sculptures.

Such a concern inevitably signals the work of Brancusi and it will come as no surprise to many who know him and his work to hear that Ward was, and still is, very preoccupied with this Romanian sculptor's oeuvre. A disciple, you might say, and Ward was not, of course, the only one of his generation to have felt this way. As well as providing his sculptures with shiny surfaces, Ward also thinks of sculptures, like Brancusi, in terms of families of forms (once linking his titles to members of his family). But to foreground the example of this particular sculptor too much would be to overshadow all those other contacts and contexts that have shaped Ward's oeuvre far closer to home. Born in 1949, the same year as Tony Cragg, Ward belongs to generation of British artists, brought

up in the years immediately after World War Two, for whom sculpture was very important. And looking across his sculpture it is possible to see his connections with and contributions to the sculpture that was being made in this country in the 1970s, 1980s and 1990s onwards. A group show, for example, with Ward's work at its heart would be interesting indeed. We would likely find the work of Michael Kenny, Geoffrey Smedley, Martin Naylor, Carl Plackman, Tim Head, David Nash, Keith Milow, Paul Neagu, Brian Catling and Nick Pope. Like many of these artists he used both the walls and floors of the studio and gallery, often within the same work. We would also see the work of 'New British Sculptors', such as Tony Cragg, Richard Deacon, Bill Woodrow, Edward Allington and Anish Kapoor. One of the achievements of this book is to enable us to look at the full range of Ward's work and thus to be further able to make the connections with this national context — and to its painting as well as its sculpture.

Like many of his generation, the primacy of the experience of sculpture was crucial — the encounters with its materials, its surfaces, its volumes and its outlines. This is something that comes across in the exhibition, curated by Terry Friedman with the assistance of Nigel Walsh, which he had in 1989, almost twenty years ago, in the sculpture rooms of Leeds Art Gallery. The exhibition showed drawings as well as a new group of sculptures and drawings, called 'Epiphany' works, he had made during his residency in the gallery that same year. At the end of the essay that introduced the exhibition catalogue of this 1989 show, Ward turned his attention to literature in relation to the sculptures and drawings he was showing. 'For me the drawings are poems; the sculpture is novelistic', he stated. It is an interesting idea and a further indication of how Ward's sculptural imagination has a subtle literary strand to it. This monograph gives us another chance not only to read and look at these works, but also those that Rob Ward made before and after them, both in Yorkshire and beyond.

Rob Ward

Clare Lilley

I have carved out a little thoughtful poetic corner

This publication celebrates over thirty years of work by
the British artist, Rob Ward; a man who embraces the
world and whose work celebrates life. Many artists have
served as inspiration to Ward, including Constantin
Brancusi and Georgio Morandi. But also particular to him
is his interest in writers, from Marcel Proust to James
Joyce, Basho to Italo Calvino. While containing the places
and artefacts of his life, Ward's sculptures and drawings
(which are mutually dependent) are not stories, there is
no narrative. Rather, they contain subconscious beliefs
and visceral sensory responses in ways that range in tone
from a solitary, vibrating note to the symphonic. Ward
himself refers to the drawings as poems, the sculptures as
novels. Within that range are many scores and a great deal
of improvisation. Indeed jazz has also been an important
reference for the artist, both in his sheer enjoyment of it,
as music which is often explicitly passionate and emotional
in its production and reception.

In a recent letter, Ward described his newest work as
being "the sort of thing you'd think about while sitting on
a beach." This is a typically delightful description from a
man to whom words like love, joy and celebration come
easily. And it is one of the reasons that Calvino has been
such a frequent referent for him. Not that Calvino showed
him the way to 'weightlessness' – he needed no exemplar
for that – but rather that Calvino articulated on the page
that which Ward has portrayed through his own work.
And like Calvino, one of the things that is so exciting and
so poignant is that Ward's works, while demonstrating
lightness, are also intellectually rigorous and bound to
years of learning, practice and precise thought; "I think
the things I make are 'surreal' in the sense they come
from a more subconscious play. I often think of the
combination of elements as a kind of Jazz. The way I get to
the celebratory as a way of halting time, honouring time, is
through poetic means..." (Ward letter 2008)

Beginnings

Cornflake 1970 Canvas GRP 2 x 3 x 0.5m
Hexham Journey 1969

Opposite page:
Rob Ward in 1986

Born in 1949, Ward's early years were spent in a small mining community in Somercotes, Derbyshire; D H Lawrence country. His childhood, while modest, was extremely secure and happy and he describes his mother as an original feminist: strong, sharp, matriarchal, mindful of human rights; his father as intelligent, thoughtful and interested in the wider world. His father had been the first of his family to attend grammar school, where he was a scholarship boy. He subsequently trained in the Royal Navy and his later career was as a laboratory assistant for Boots Chemist, the major employer in the region at that time, and where he and Ward's mother met.

Many of the men in Ward's family worked in mining, a hard and tenuous life. Ward's mother was extremely ambitious for her son, who in effect was an only child until the age of 14 when his brother was born, and was much doted-on. Ward was also ambitious for himself and, as is still the case, had great drive and energy. Although he failed at eleven to get into grammar school, he passed the required examinations aged 13 and likens the change from secondary to grammar education as going from prison to a holiday camp. At school he had excelled in football and cricket, and was a good boxer (his father and uncle had a boxing club); at Grammar School he was Captain of the football and cricket teams; indeed he played cricket for Derbyshire.

At Swanwick Hall Grammar School, Ward also had an excellent art teacher, called Cyril Jones, who opened Ward up to other worlds: of the imagination, of the history of art. In his later years at school, Ward recalls spending hours reading art books in the library. He was made Head Boy, was confident and relished his education and the opportunities offered to him. Above all, there is a sense that none of this was ever taken for granted; that he felt, and feels, terrifically lucky.

Art School

Ward's luck continued when in 1969 he was offered a place in Fine Art at Kings College University of Newcastle Upon Tyne — the only fine art honours degree offered in Britain in the sixties. Newcastle had an outstanding reputation: Victor Pasmore and Richard Hamilton had created the Basic Design Course at the University, and two of Ward's contemporaries were Kier Smith and Sean Scully. For the first time, however, Ward felt out of his depth; that he was of a different class to his fellow students and teachers and didn't have the right cultural background. During his first year he was on the point of leaving but was persuaded to stay by his tutor Professor Kenneth Rowntree; from that moment, Ward decided to make art his career, to treat it as a job that needed doing and he remained there until his graduation in 1973.

The modernist teaching at Newcastle has stayed with Ward — both as a teacher himself and as an artist — and he has never forgotten the impact of tutors like Ian Stephenson (who went on to be Head of Painting at Chelsea School of Art), Ralph Holland, John Milner, Prudence Bliss and Len Everts; all respected artists in their own right. In particular he recalls dismantling what he'd learned about art at school; of his changing perceptions and understanding that art was not just about facility, but about how well you can answer a question, and about asking questions of yourself. In addition, the Hatton Gallery connected to the College had a fantastic modern and contemporary collection, which included Francis Bacon, Richard Hamilton and Eduardo Paolozzi. Faculty members were actively engaged in their own and modern art; Kurt Schwitters Merzbarn was installed in the Department, and Tatlins Constructivist Tower was reconstructed by members of the school staff

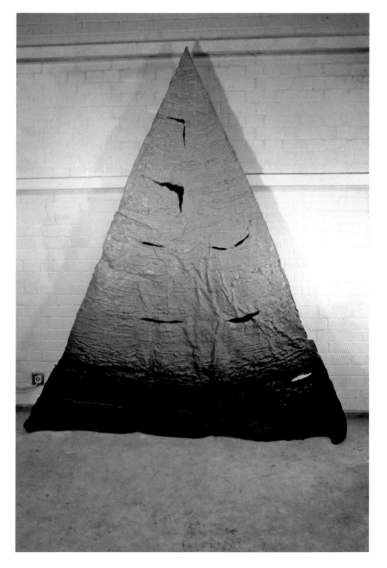

Most importantly was the impact of the Bauhaus-inspired Basic Design Course programme taught at Kings, which had been developed by Victor Pasmore and Richard Hamilton. The programme eschewed traditional teaching methods such as copying, and instead revolved around responding quickly and instinctively, intuition, deconstruction, and

Left Page Clockwise from top:

Untitled 1.5m x 1m x 50cm Stone and Found Objects

War 1970 Canvas Oil Paint Pencil Metal Frame Springs 2m x 1.5m

Ra G.R.P Plaster Oil Paint 2.5m x 2m

Right Page from top:

War (detail) 1970 Pencil Paper 48cm x 66cm

Shoe 1969 Plaster and Boot Polish 70mm x 60mm x 30mm

solving problems. There was an emphasis on nature and organic growth, as well as ideas around mathematics and spatial exercises, which themselves led to ideas about social space. Seminal texts included Paul Klee's Pedagogical Sketchbook and, Darcy Thompson's 'Growth and Form'.Part time and visiting lectures were Harry Thubron , Terry Frost and Hubert Dalwood.

In his third year Ward opted to specialise in sculpture, having already covered the rudiments of art history, painting, glass-making, sculpture and architecture. A very early stone relief, One, of 1969, is simply a block that he split with a hammer and chisel, creating a relief where the block split; a mature statement at that time. Again, his tutors were excellent as both teachers and as artists — Murray McShane, Roy Kitchin, Derwent Wise — and they had studios in the College, with the students (theoretically) working alongside. Structured teaching by this point was minimal and students needed self-discipline to survive; something Ward has in spades, so that this semi-professional environment suited him well. He recollects that while not much formal teaching took place, the collective attitude was important.

The good fortune continued when Martin Froy, an external examiner for his degree show and Professor at Reading University, suggested that Ward apply for a Postgraduate place at Reading, which he was subsequently offered. He attended Reading from 1973 to 1975 and was

taught by some of the leading artists of their generation: Terry Frost as a staff member, with visiting lecturers William Scott, Hubert Dalwood and Patrick Heron. Indeed, Ward's degree show was hung by Frost and Heron, teaching Ward the importance of placing work in a gallery space; how space and arrangement impact so dramatically on a sculpture or drawing.

Left Page from top:
Brown Rhythm 1972 G.R.P Paint 1m x 3m x 5m

Right Page clockwise from top:
Brown Rhythm Detail 1972
Brown Rhythm Detail 1972
BrownRhythmnDetail 1972

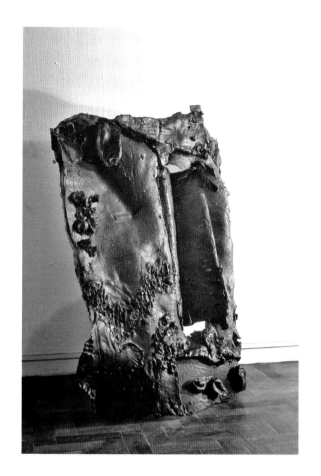
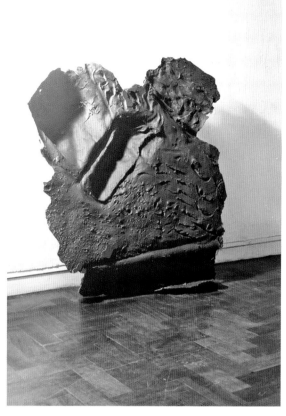
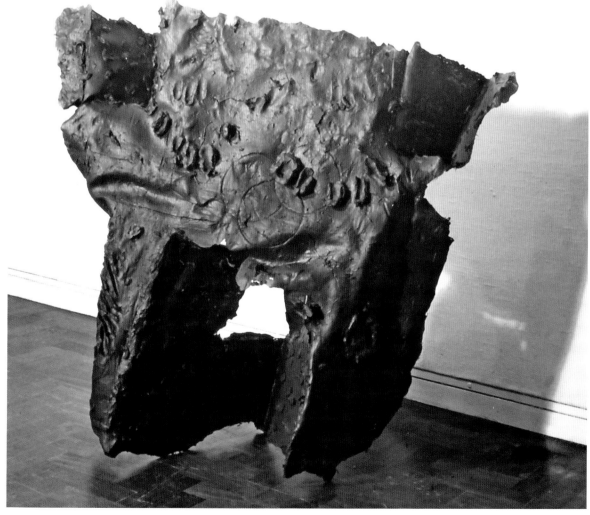

1970s

"The sole purpose of sculpture is neither description nor imitation but the creation of unknown beings from elements which are always present but not apparent." Duchamp-Villon * (quoted by US, Songs 1998)

For a time, in 1973 and 1974, Ward explored pure abstraction by making assemblages of hot rubber casts of water splashes – some very large and shown outdoors – and cast in GRP resin. The first is called Brown Rhythm (1973) and the second, Watersplash (1973), appears to climb a tree; while abstract, its form and title reveal a clear source. Arguably, this is Ward's first work that reveals the properties of water, a theme which is to be revisited many times over the following thirty years.

Landscape (1974) is made from stacked and assembled pieces of roughly chopped and torn green wood logs, also large and installed in the open-air. These are highly ambitious, raw and quite dramatic pieces. In addition to considering notions of surface, material, the (non)-plinth, and of stacking, Ward further developed his understanding of how individual objects relate to one another in space; of how distance creates or destroys pause. Ultimately, for him, the idea of abstraction "becoming so subjective that you can't get hold of it" (conversation 2008) was unsatisfactory and he felt impelled to get back to working with objects and things. The question was how to keep the sculptural language going, and also how to constantly renew it through examination of the object. In this process, Ward is often mindful of Brancusi and said in a recent conversation, "Once you engage with the object you inevitably have to find a way to hold it in space, which inevitably leads you to Brancusi. I'm not sure how you get away from him". *(footnote, January 2008) For me, Brancusi's influence is of less interest here than the idea of holding an object in space, which involves consideration about plinths, scale and proportion, volume, and the interaction with space; considerations which have formed the core of Ward's work for more than three decades.

The Well (1975), therefore, is an important work. While it is reliant on Brancusi's Endless Column for its arrangement of repeated stacked elements (and its embodiment of

the need for spiritual elevation), the sculpture is Ward's language. Unlike the large GRP works, which were a transcription of ideas in abstract form, the Sculptor's Well uses real objects. Comprising wood, wax and concrete at the bottom it is rather beautifully balanced with sculptors' wedges. The bucket and wedge motifs are established here, as are the materials that the artist has made his own. The title indicates how the sculpture contains, and how it has both satisfied and feeds a thirst for succinctly contained and rich statement.

The more complex and expansive sculpture, The Sculptor's Well again references a classical modernist work – Marcel Duchamp's exploration of eroticism, The Bride Stripped Bare by her Bachelors, Even (1915-23). Ward's sculpture comprises a framed window, bucket, a sculptor's modelling stand, cast resin, smashed reinforced concrete, steel rod and fibreglass. On one side of the glass the bucket and stand form a play on a traditional, contained still life. On the other side of the glass it's as though the material contained in the bucket has been exploded; a violent retching up of a sculpture – sculpture in its last throes.

With its symmetrical columns and centrally placed tableau, Story of a Sculpture establishes itself as a form of theatre. Again we see the bucket both as motif as carved stone and wood, as wax, plaster and bronze casts, and pictorially etched into wax, as well as in actuality. At the time the bucket was one of the most ordinary, everyday things in Ward's life; as a student he worked as a plasterer and the bucket was also a domestic item in addition to being an intrinsically practical item for an artist. So it symbolises ordinariness, but more importantly it is ordinariness; it is object. We are led into the sculpture – the installation – from the front and encounter the objects within in terms of their size against our body size, the spaces between as places through which we may or may not be able to pass. This curious combination of the real and of artifice (even the table in the foreground is a miniaturised version of the 'real' table behind) sets up a discourse between viewer and viewed. This is a sort of play within a play and as Velazquez painted himself into Las Meninas (1656) – the artist painting the work on which we cast our view – so Ward

From top:

Watersplash 1973 G.R.P. 2m x 5m x 6m

Watersplash 1973 G.R.P. 2m x 5m x 6m

emphasises the actualities of the artifice.

Clearly, Story of a Sculpture exposes Ward's pleasure in the substance of the materials with which he works. Aside from the occasional use of fibreglass, the works from the seventies are assembled from natural media: wood, plaster, wax, stone, bronze. Of course they are sculptors' materials, pregnant with association and symbolic of sculptural tradition, but presented and combined here in ways which underscore their material richness and inherent practical and aesthetic qualities.

The 1975 work, The Kiss (referencing both Rodin and Brancusi), is a kissing of dimensions. There are two black wax panels at the rear of the installation; a diagrammatic drawing of a bucket is etched into the left hand panel, a three-dimensional drawing etched into the right hand side. In front of them are two wood columns surmounted by plasterers' hawks, a polished stainless steel bucket lined with coloured wax and a circular piece of wood supported by two wedges which resemble a fish; the wedges tilt the circle, which is topped by a masculine protuberance. And before them on a table are two wax casts of buckets 'kissing' – almost closing the gap between the panels and creating a magnetic tension. Also on the table are sculptors' tools: a hammer and chisel. In the foreground on the ground are a plaster bucket being split and then three-dimensional and plaster buckets placed on concrete slabs to either side. Again, a high degree of symmetry and theatricality is created and the whole tableau can be described as if describing a picture: foreground, middle-ground, sides, rear, depth etc., although the two dimensions of the picture plane are here described in three dimensions. So that while the installation is complex and comprised of many parts, it is also incisive and restrained. The object has been changed; the idea of the sculpture has changed.

Within Ward's work, almost from his very first mature sculptures and works on paper, there are recurring motifs, which continue to the present. From his student days, he regarded the life of an artist as being a job to get on and do, in much the same way as those farmers, housewives and other workers within the mining community of his working class childhood considered life. In Ward's case, the stock in trade tools of his profession become the images or forms in his work within which he explores spatial relationships, colour, balance and tension. And even from this early stage, Ward begins his habit of working in defined series: "My practice continues to take the form of chapters in a developing process, each set of

Main image:
Landscape 1975 15m x 6m x 6m Wood G.R.P

Right page from left:
Landscape Sketch 1975 Rubber Wood Bucket 2m x 1m x 0.5m
Landscape Sketch 1975 Wood Bucket G.R.P

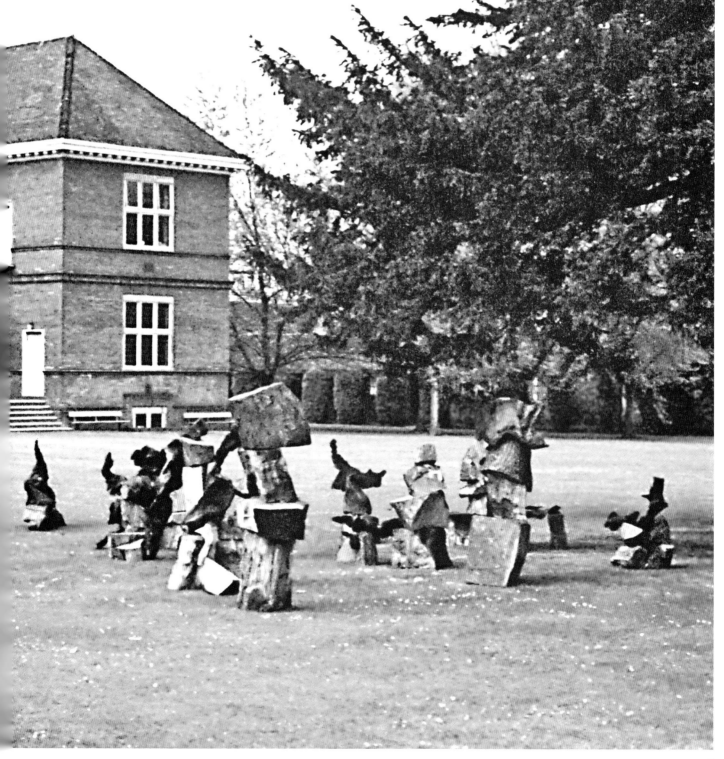

work or exhibition being a meditation and integration into the mechanisms and poetry of the visible".
(Songs 1988, p.4)

In his first year at Reading, Ward had struck a friendship with Joe Coates, a widely read student who introduced Ward to the philosophy of Bachelard, Jacques Lefèvre, Ludwig Wittgenstein and Michel Foucault; it was through Foucault's 1961 book 'Madness and Civilisation' that Ward came to recognise the psychotic mental state that could develop in abstract artists and which drew him to look again at the world of things and to reintroduce the object into his work. By casting those objects he was dealing with ideas around absence and presence. These ideas were reinforced by his reading of Foucault's seminal book 'The Order of Things', translated into English in 1966, in which the author argued that each era allows for only certain acceptable truths and where he questions modern projections of knowledge onto historical subjects.

It was during the mid-seventies that Ward became more fully interested in thinking about surface and of exploring it through drawing. Just as the pictorial plane had been extended out into space through sculptural installation, so he extended space back to the surface through etching or by carving into wax, plaster or stone; in effect, creating very shallow sculpture. Later, he started to use objects as punctuation marks so that in the series Tracings 1997, for example, we see slices of space which might contain objects. Always then as now, Ward sees the potential in every plane, explores it and seeks to divulge it.

After graduating from Reading, Ward won two study scholarships to Athens and Rome. In Athens he read James Joyce's revelatory 'Ulysses' for the first time and to which he has returned time again. In 'Ulysses', each chapter is a day in the life of a particular person, representing individual thoughts, and powerfully indicating that while the heart may remain the same, it can be explored in many different ways. So that Ward constantly returns to the geometry that is inherent within the tools and other forms that he works in sculpture and drawings, just as geometry is inevitably within almost everything. In Greece and Italy Ward read new poetry, by Naruda, Katsenzakis and Cavafy; works which explore the senses, the intellect and the imagination. His epiphany was discovering Haiku, the Japanese succinct seventeen syllable poem that is a sensory response to the natural world in minimal form. He read the master Basho, as well as Ryokan and Etsujin. Athens and Rome also offered a world of warmth, light and possibility. In Athens, Ward's first child Lisa was born

but with no work in hand and age 27, he returned with his family to his wife's home town in North East England. Shortly afterwards in 1977 he was offered the post of Programme Co-ordinator of Sculpture at the University of Newcastle in New South Wales, Australia.

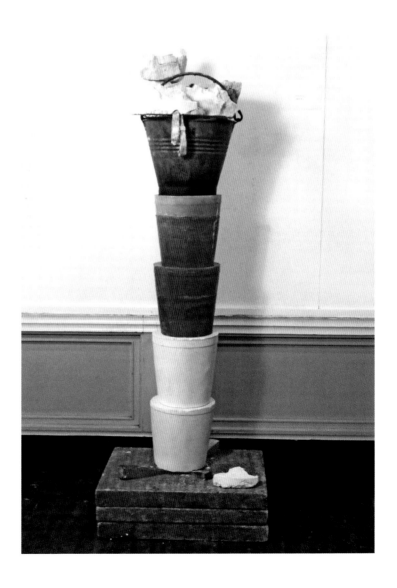

Clockwise from top:
Story of a Sculpture 1974 Etching on Steel Copper Zinc Aluminium 150 x 25cm
Sculptor's Well 1974 GRP, Concrete, Steel, Wood, Brick Dust 2.5 x 1.5 x 3m
The Well, 1975 Concrete Plaster , Wax , Found Bucket Height 200 x 75 x 75

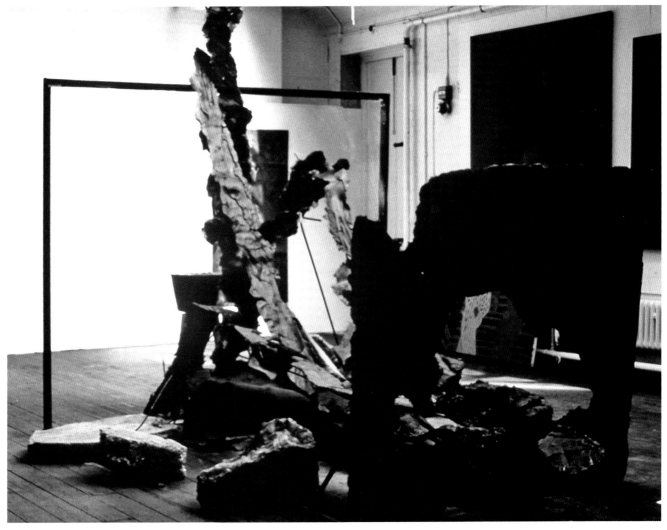

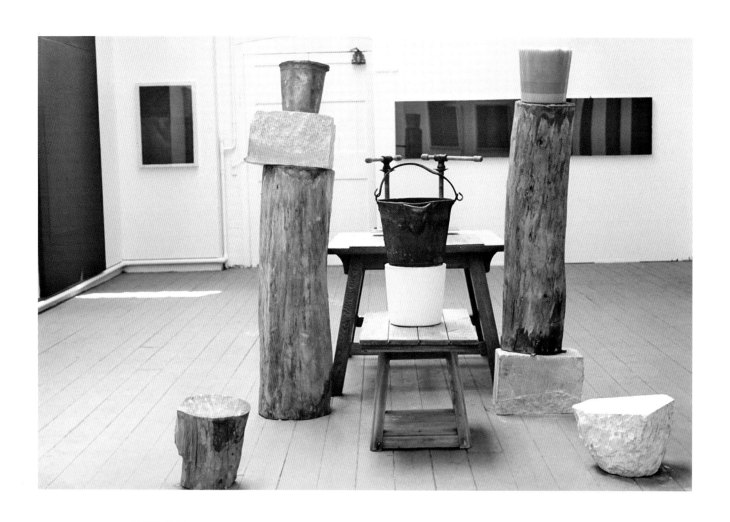

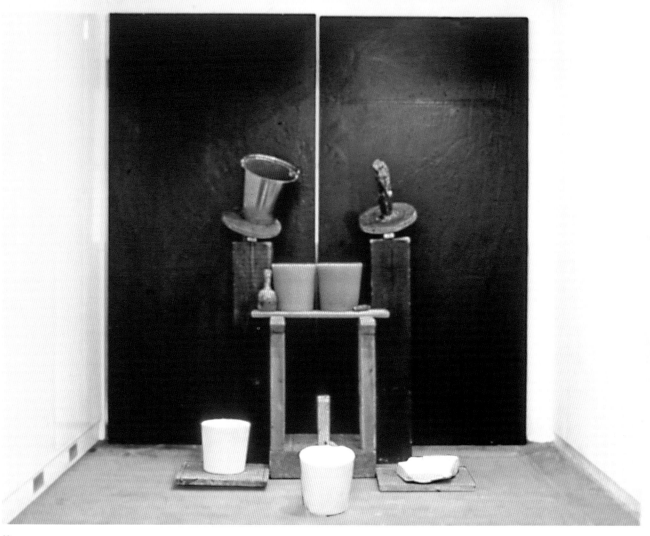

Left Page from top:

Story of a Sculpture 1975 Wood, Stone, Wax, Bronze, Plaster, Found Objects 2 x 2 x 3m

Kiss 1975 Wax Panels Wood Wax Plaster Bucket 2.5 x 2 x 1.5m

Right Page from top:

Sculptor's Banker 1975, Wood and Stone 1.5m x 75 x 75cm

Sculptor's Circle 1974, Wood Concrete Stone 2m x 3m x 3m

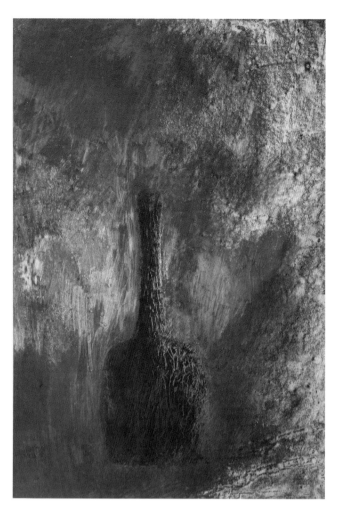

Grate 1974 Graphite on Paper 66 x 48cm

Thor 1974 Graphite on Paper 66 x 48cm

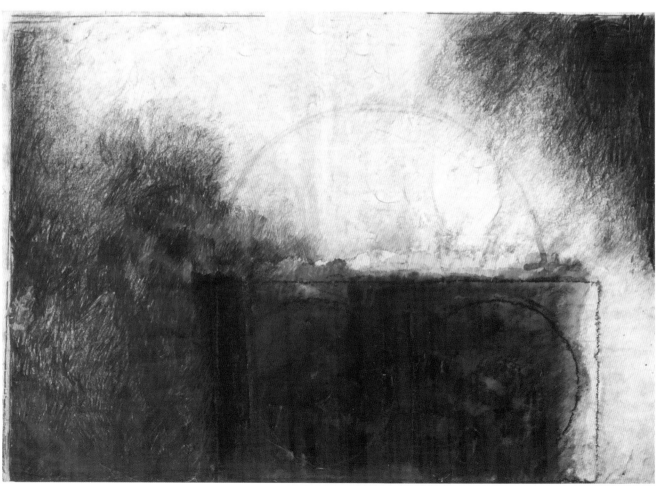

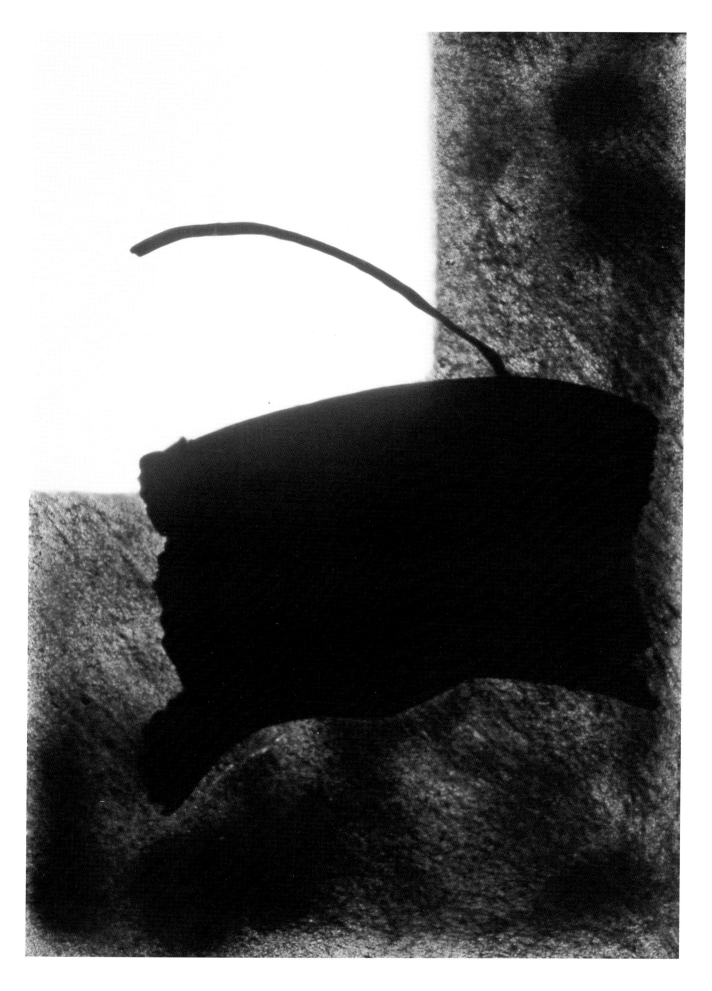

Flying Bucket 1975 Graphite Ink on Paper 66 x 48cm

Left page below:

Out of Focus 1974 Watercolour Graphite on Paper 48 x 66cm

Floor 1974 Graphite on Paper 66 x 48cm

Light Bucket 1974 Graphite on Paper 66 x 48cm

Through The Window 1976 Watercolour Charcoal and Graphite on Paper 39 x 27.3-8in

Tapestry 1974 Graphite Wash on Paper 66 x 48cm

Left Page:

Mask 1974 Graphite Watercolour Wax on Paper 48 x 66cm

Bucket Window Mask 1974 Wax Pencil Paper 66 x 48cm

Right Page from top:

Buckets 1976 Graphite on Paper 48 x 66cm

Looking In The Bucket 1974 Pencil on Paper 48 x 66cm

Australia

I've Brought to Art
I sit in a mood of reverie.
I brought to Art desires and sensations:
things half-glimpsed,
faces or lines, certain indistinct memories
of unfulfilled love affairs. Let me submit to Art:
art knows how to shape forms of Beauty,
almost imperceptibly completing life,
blending impressions, blending day with day
CP Cavafy

Australia presented yet more sensory stimuli and experiences, freedom and space, warmth, wearing few clothes, the beach and ocean, living in a large house with a very decent income, having an abundance of food and friends and fun. Life seemed good, although Ward never lost a hankering for making his mark in Europe, where at that time culture was more seriously considered. His first break came with an exhibition at the Coventry Gallery in Sydney, owned by Chandler Coventry .

The sculptural works made in Australia, while employing similar materials and being immaculately ordered and considered, are also more fluid and more expansive than those made previously. Still Life (1979) was the first work made in Australia. A number of found objects – a fish slice, sculptor's wedge, a piece of silver, an Indian club, a water sprinkler and a black cross – are carefully arranged on a shelf, while around them aluminium panels, inscribed with drawings of the same objects in motion, career around the space so that a dynamic sense of movement is created. By this time Ward was an avid collector of things – fans, bottles, flasks, cones, decorators' plumbs – shapes and objects that somehow resonated with him and which somehow had their own integrity as shapes and practical objects. They were not symbolic, as such, but significant and contained the possibility of contributing to his work. Ward has recently read Primo Levi's 'Periodic Table', in which Levi outlined his theory that humans have instant feeling for certain forms. This keys with Ward's thinking, who believes his response to objects is quite instinctive and attuned to geometry, sensuality and a sense of movement, pointing to how both Mozart and Brancusi build and accumulate units within their work to reach a climactic point.

A yet more complicated installation, which took a year to realise, was These Foolish Things of 1978. Dominated by two large triangular panels on the rear wall, columns and objects are arranged, roughly symmetrically, in rows and descending tiers in front, starting with two timber columns on which two wax cast buckets on roughly cut wooden slabs are forced by wedges to tilt precariously towards one another in an interminable almost-kiss. Below them are stone slab tables that present cast and found objects, leading to two tilting cast-bucket and stone columns. In the foreground is a glass triangle which forms a single perspectival point from and through which to view the entire tableau, as one might view a painting. The ladder makes an appearance, as it has throughout Ward's oeuvre, and Ward considers that the work has a female and a male side, with one bucket emptying and one filling. Here Ward conflates sculpture and painting, space and surface, and invites the viewer to physically enter into this space and to bodily encounter the forms within, which themselves are transformed into poetic, sculptural forms. The work's title is taken from the 1930s jazz standard of the same name, written by Hogey Carmichael and which speaks of sweet-hot longing wrought by separation. While carefully considered, These Foolish Things, with its near-toppling columns, also has a chaotic ring and perhaps reflects Ward's conflicting emotions of being away from 'home', but also of his ability to take risks that he perhaps wouldn't have attempted in Britain. It is a highly metaphorical work in which the artist appears to be wrestling with his own psyche, while also working through the role of subject matter within his work.

Places, Paths and Mountains was shown at the Coventry Gallery in 1980. Like a Japanese Zen garden, the

Rob Ward's Studio Union St Newcastle N.S.W

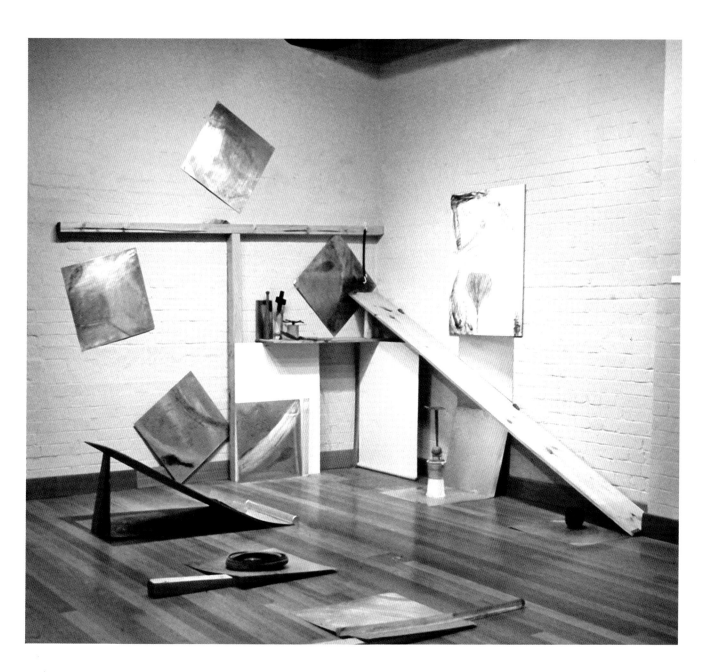

Still Life 1979. Mixed Media 8 x 4 x 3m. Ivan Dougherty Gallery Sydney Australia

installation is made to be entered and the objects closely regarded and considered; the viewer is sometimes required to squat down in order to do so. The work is a complex arrangement of stacked and wedged stone and wood, floor and slightly elevated stone, wood and plaster slabs, arranged found and made objects (water sprinkler, plastic bucket of sand, wax tablet, wax-cast bucket), water and wall panels. Here the 'place' is the gallery: the 'path' is the sculpture: the 'mountains' are distant drawings on the wall. Places, Paths and Mountains indicates Ward's interest in poetry, and most particularly haiku, for it sets out its component parts with an easy simplicity and directness. These things are just things, just themselves. But their combination and arrangement, the dialogue created between finely balanced things, imbues a tremulous, poetic quality. This is the first time that Ward used water directly (although his interest goes back to Watersplash, 1973). He explores the alchemy of water; simultaneously so common as to be overlooked, and yet containing properties that elevate it beyond earthly matter — substance yet insubstantial, essential for life, impossibly reflective, sublime. In Ward's work, water becomes a punctuation mark and is most particularly a vital medium for reflection (actual and meditative). In Places it flows around the room, appearing in different places, appearing in different guises; blue and silver paper, channels, containers, water sprinklers.

Another important development in Australia was Ward's discovery of a ceramic-coated paper called Kromecoat. This material enabled him to inscribe it with needles and other tools, rub charcoal and pigment into it, to sandpaper back and to generally manipulate it. The pure acrylic pigment he used would bleed into the scratched paper or sit on top of the ceramic coating, creating a very rich textured surface; a perfect ground for an artist who strives to pull the surface back out into space, and to push space back beyond the surface. It's a paper that he continues to use and drawing is a vital part of his practice, playing a role within the sculptural work, and also alongside it as an entity in its own right. For Ward, drawing is highly meditative. Unlike sculpture it does not require many time-consuming processes, organisation and stamina. However, because of the drawing process he has developed, there is little room for mistakes, while chance can be a wonderful and satisfying element: "You have to sit and think and then just dive in because once you've made those marks you can't go back. It's quite rapid". *(footnote: in conversation 2008). The drawings made in Australia reflect the dry, earth tones of the landscape as well as the sense of wide-open spaces, populated only by spare images and the edges of

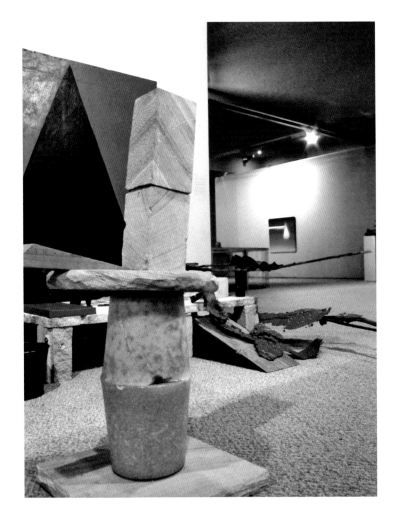

Left Page from top:
These Foolish Things Detail 1978 Mixed Media 3 x 4 x 10m
These Foolish Things 1978 Mixed Media 3 x 4 x 10m
Newcastle Regional Art Gallery N.S.W. Australia

Right Page:
These Foolish Things Detail 1978 Mixed Media 3 x 4 x 10m

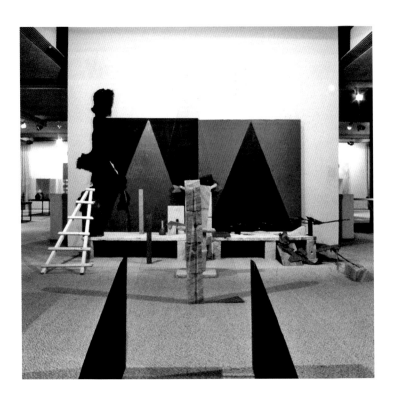

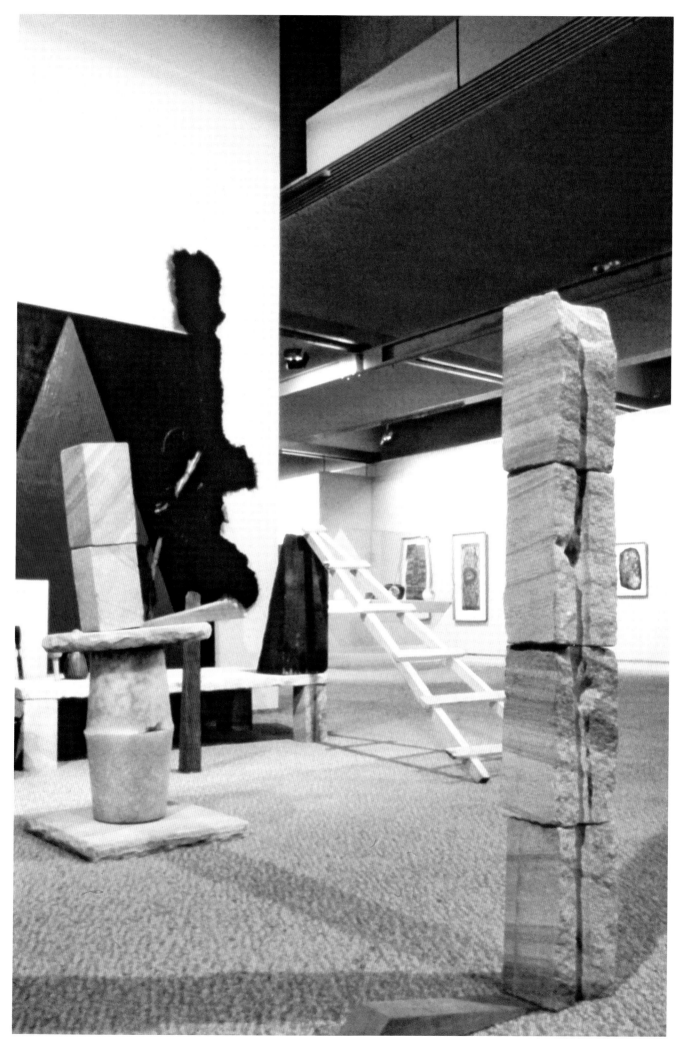

objects. They could almost be described as paintings, but in their transluscence they are more akin to fixed slices of colour and they defy conventional ideas of painting or drawing, contributing to the language of both.

After five years in Australia,during which time his second child, Charlotte was born Ward and his family returned to Britain. They were facing the immigrant's dilemma with regard to schooling and citizenship; Ward describes this as the tyranny of distance – the experience of living so far from 'home'. A further impetus to leave was the death of Ward's father and so the family left for Darlington in the North East of England, and to the home of Ward's wife. In 1982 he accepted the post of Senior Lecturer in Sculpture at Humberside Polytechnic in Hull and worked there until 1987.

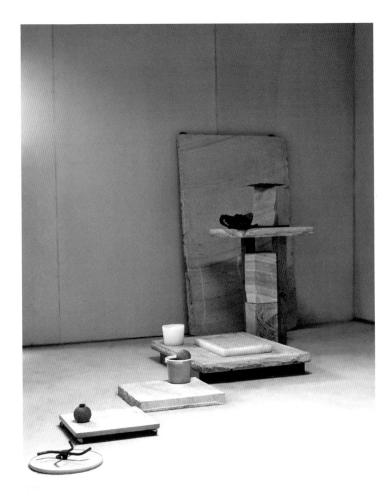

Left Page from top:
Places Paths and Mountains 1980 Mixed Media Graphite KCPaper
Places Paths and Mountains 1980 Mixed Media Graphite KCPaper
Coventry Gallery Sydney

Right Page:
Places Paths and Mountains 1980 Mixed Media Graphite KCPaper

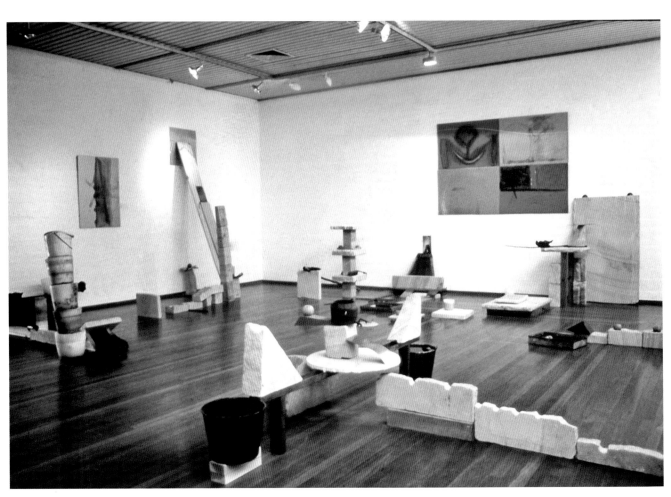

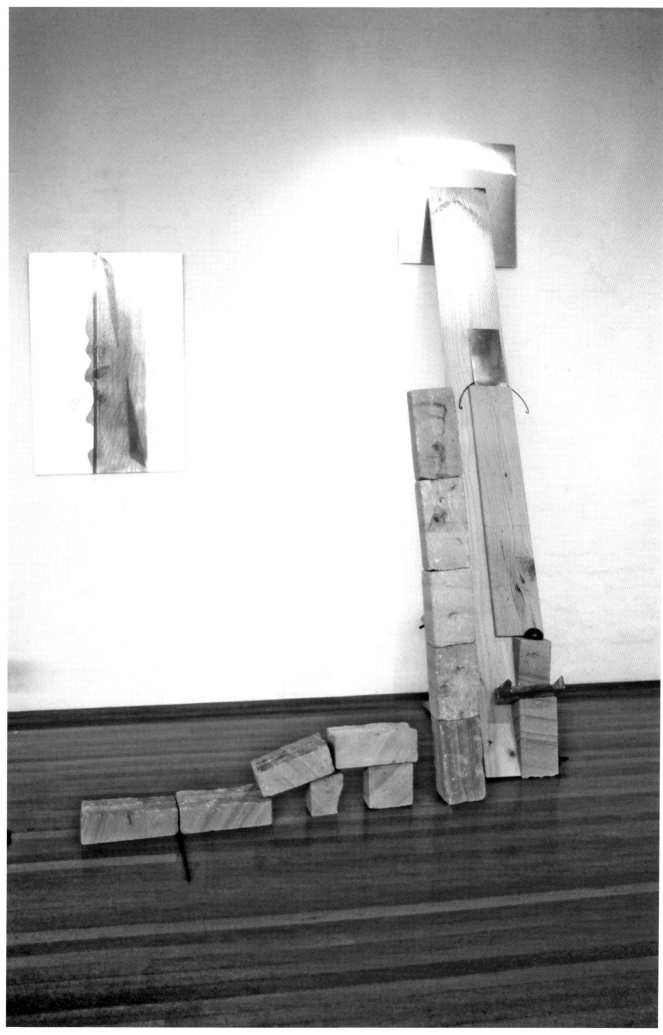

Left Page clockwise from top:

Fountain 1979 Pencil Acrylic Varnish on KK Paper 79 x 40cm

4 Seasons as Objects 1979

Acrylic Varnish Graphite on KK Paper 79 x 40cm

Untitled Graphite Glue on KK Paper 9 x 35.3:4in

Dancers 1979 Watercolour Graphite Varnish On KK Paper 46 x 35.3:4in

Right Page from top:

Two Fish About To Kiss Graphite on KK Paper 79 x 40cm

Fan and Cross 1979 Graphite on KK Paper 29 x 39.1:2in

Sculpture On A Table 1979 Acrylic Varnish Graphite On KK Paper 79 x 40cm

Drawing of Sculpture on a Table 1980 Acrylic Spray Glue Graphite On Blue KK Paper 79 x 40cm

Sculpture Table Mountain 1980 Acrylic Graphite on KKPaper 79 x 40cm Collection Northern Arts UK

Australia 1979 Watercolour Graphite on KK Paper 46 x 35.3.4ins Collection N.Smith London UK

Fans and Curves 1979 Acrylic Graphite on KK Paper 79 x 40cm

Four Seasons 1979 Graphite Varnish on KK Paper 49 x 35.3.4in

Clockwise from top:

Bucket Handle 1979 Graphite Glue MKK Paper 49 x 35.3.4in

Down From The Mountain 1983 Acrylic on KK Paper 98 x 67cm

Self Portrait 1983 Watercolour Varnish Graphite on KK Paper 39 x 27.3.8in Collection Pauline Dallas Hong Kong

Untitled 1979 Acrylic on KK Paper 95 x 76cm

Carmel 1979 Watercolour Graphite on KK Paper 49 x 35.3.4in

Places Paths Mountains 1980 Graphite Varnish Watercolour 66 x 48cm

Fish on a Table (After Bonnard) Acrylic on KK Paper 95 x 76cm

England and
Hebden Bridge

Ward's work is characterised by the way in which he establishes exhibitions or projects and then makes a body of work in response to that opportunity, or in response to his living conditions. So that while working at Hull and commuting between the college and Darlington, his work became smaller in scale, less expansive and more prone to drawing. All at Sea (1981) for example, contains many of the motifs with which we are familiar -, there are fish, fish slices, fans , tools. The arrangement is deliberately scattered, dislocated and transient, as its title suggests, reminiscent of looking underwater, and a state of mind.

In tandem with the break-up of his first marriage, Ward lost his job at Hull and was out of work for a year, during which he made the 'little haiku' drawings; beautiful, pared-back pale works in which the ghosted forms hidden within the paint and the ceramic-coated paper float and shift. He moved to Hebden Bridge in West Yorkshire in 1987 and while his work life was difficult, his new personal relationship helped him establish roots in this small mill-town community.Cathy and Rob were married in 1988, and Jack was born in 1989.For a short while he was Senior Lecturer in Art and Design at West Glamorgan Institute of Higher Education and commuted between Swansea and Hebden until 1989, when he was appointed to the post of Principal Lecturer in Sculpture at Bretton Hall, University of Leeds near Wakefield in West Yorkshire, the institution for which he continues to work. It is the case for most artists who teach, that balancing teaching commitments with working to produce new work is a difficult and demanding business. It is also the case that often the contact with students who challenge ideas and who themselves are engaged in making new forms, formulating new thoughts, can inspire and energise. For Ward, both sides of the balance are true and certainly his teaching

work has enabled him to be extremely articulate about his own practice, and has encouraged him to continue thinking, to keep developing.

A highly significant exhibition of drawings of 1977-87 and the Epiphany drawings and sculpture of 1988-89, organised by the Henry Moore Centre for the Study of Sculpture, was held at Leeds City Art Gallery in 1989, following a residency on the flat roof of the gallery. During the residency, during which the public could see the artist at work and talk to him, Ward made a sculpture from lead, wax and wire – all softened by the heat of the summer sun. In Ward's words, he "painted the whole idea of a sculpture" – a piece which froze the moment in a form of visual poetry.The work was called On the Roof, after a Drifters song. The work was transient , the wax melted , and the lead oxidised in the Sun.

The gallery exhibition presented a retrospective of drawings and gave Ward the opportunity to make a new body of sculpture in circumstances that were considerably more favourable than of late. He showed works conceived during a 1983 residency in Grizedale Forest: King and Queen (1989) and David's Chair (1984). They are compact, intense sculptures structured around the thick trunks of trees. In the context of the forest they constitute found objects. They contain and present some of the cast bronze objects with which we are familiar; buckets, water sprinkler, Indian clubs; also carved wooden balls. And again these elements are stacked, balanced and wedged so that while the forms themselves are solid, there is still an essence of poise. The bucket of David's Chair and the body of King and Queen are filled with black sand, conveying a sense of something terribly dense and somehow unreachable.

Portrait of the artist during
his retrospective exhibition at
Leeds City Art Gallery in 1989

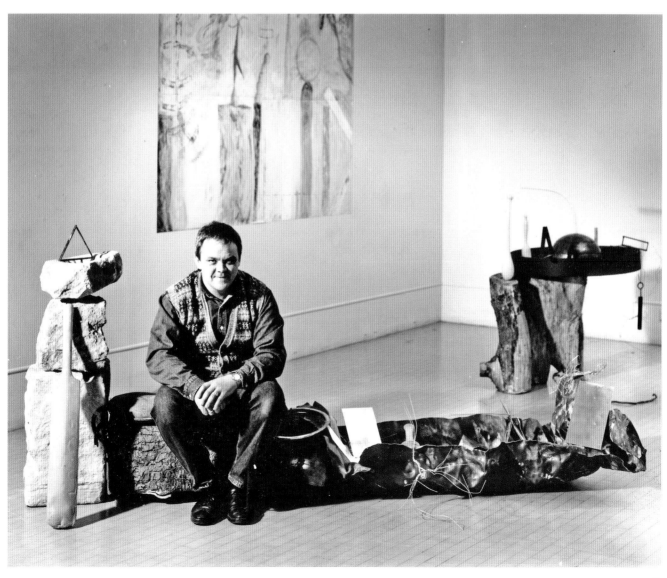

Much of the work in the exhibition related to Ward's experience of the area around his new home and his walks with his wife and dog:

"The combination of medieval landscape, unfarmed, with shifting perspectives of nature and architecture, and dramatically changing weather, gave me new insight into my work. I saw new appearances, new light on different levels, a new way forward. My collection of objects – my baggage through life – had found their proper location. It was the perfect spot for me, all my inspirations in one place. We walked, too, the nearby country round Mirfield. There the view is semi-industrial and you can see fifteen chimney stacks, ten churches, triangles of church spires, standing stones and stiles."
(Leeds cat. p.18)

Landscape had always been an important reference, inspiration and component of Ward's work, but his sense and experience of this West Yorkshire locality is fundamental to the Epiphany works. Of this series he has referred to how James Joyce "set out to create an epic adventure relating it to everyday life" *(Leeds cat p18); the title of the group gives a very clear indication of the artist's comprehension of the essence of something extraordinary in his life and art; of his intellectual and sensory journey towards this point in time. The drawings were large and more like things that you could walk into rather than just look at, and all are entitled Mirfield. They are populated with Ward's collection of objects, which are presented or suspended in deep (landscape) space, together with the presence/essence of the forms he encountered on his walks. The other drawings in the exhibition, made between 1977 and 1987, combine the artist's experience of Australia and his subsequent, somewhat troubled circumstances, in the period up until the late eighties. Frequently the Brancusian triangular forms enter the works, alongside the water sprinkler, fan, Indian club et al.

The tenor and mood of the drawings is evident. Poem (1985) is a kind of haiku; pale, light, quiet forms forcefully present – memory, exactitude, silence. As in much of Ward's work, it exemplifies his belief that there is something beyond the material; a spiritual space. The practice of meditation through a form of Yoga called 'The Five Tibetans' is a part of the artist's life and this sense of contemplation is both contained and projected by the objects within many of the sculptures and within the inscribed and worked surface of the drawings. And drawing itself is a meditative process, is about "returning yourself to yourself" *(ref. Crimsworth 1998, Ursula S). Ward has

understood and absorbed the Japanese art of placing, whether in a Zen garden or in a domestic arrangement; the pauses and rhythm created by the spaces between and around the objects forming part of the whole.

"I have always liked the " idea" of painting and sculpture, its historical fact and the science behind it... contemporary concepts, the old Duchampian nutmeg, have always seemed like banging a drum and no sound coming out. Every time I pick up a brush, Morandi or Matisse and loads of others are there."
(email 'On Pleasure' 2008)

The Epiphany sculptures are compact, complete, beautifully conceived and made. Developing from them, Ward made Saw Horse in 1991, a commission from Terry Friedman of the Henry Moore Centre for the Study of Sculpture; cast bronze objects set upon a wooden saw horse which have a clear allegiance to the work of Morandi – the same spareness and eloquence. Because the found objects in this and the Epiphany sculptures are cast or carved, there is a tighter unity than in previous works. By casting his 'baggage' of objects, Ward has pushed away from the biographical and from narrative and the result is invented sculptures that are themselves as things in the world. Simultaneously they are sensual and elemental, featuring black reflective water and dense, black sand, which absorbs all light and pulls the viewer's gaze. They speak of resolution.

On The Roof 1989 Wax Lead Steel Installation
Leeds City Art Gallery

All At Sea 1981 MixedMedia
All At Sea 1981 Varnish Graphite on KK Paper 158 x 80cm

From top:
Dragonfly 1984 Pigment Graphite on KK Paper 95 x 76cm
Walking Climbing 1984 Acrylic on KK Paper 100 x 80cm

Off The Tracks 1985 Pigment on KK Paper 100 x 65cm · Collection Grace Cheng Hong Kong

Left Page clockwise from top:

In The Cupboard 1983 Acrylic on KK Paper 95 x 76cm

Bird 1986 Acrylic Charcoal on KK Paper 95 x 76cm

Home Bird 1985 Acrylic Charcoal on KK Paper 95 x 76cm

Right Page:

Outcrop 1986 Acrylic Graphite on KK Paper 95 x 76cm

Clockwise from top:

Bird on A Wire 1983 Acrylic on KK Paper 49 x 23cm

Object and a Hill 1985 Acrylic on KK Paper 80 x 150cm

Floating Void 1984 Acrylic on KK Paper 95 x 76cm

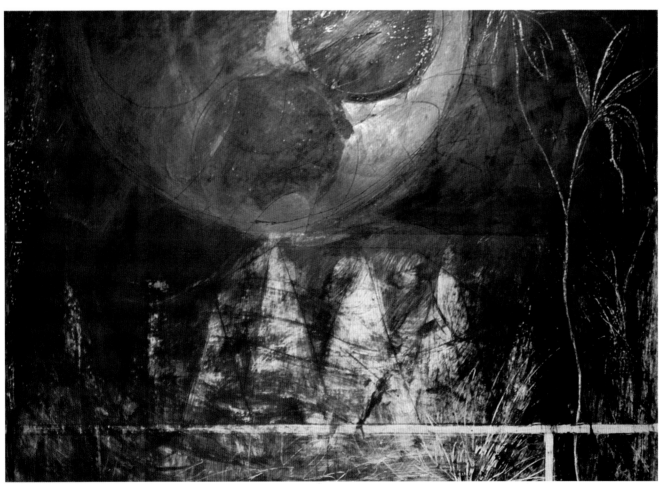

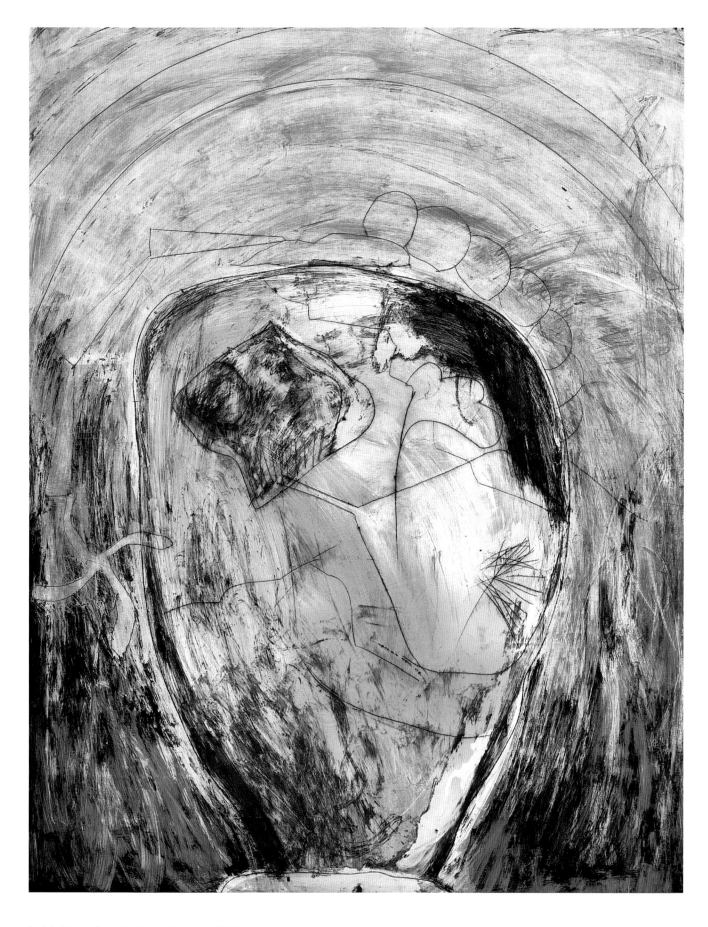

Rock In Water 1987 Acrylic Varnish Graphite on KK Paper 49 x 35 1:4 inches
Collection Katarina Zavodska Palm Beach USA.

From top:

Landscape Big Sky 1986 Acrylic on KK Paper 95 x 76cm

Hanging Valley 1987 Acrylic Graphite on KK Paper 95 x 76cm

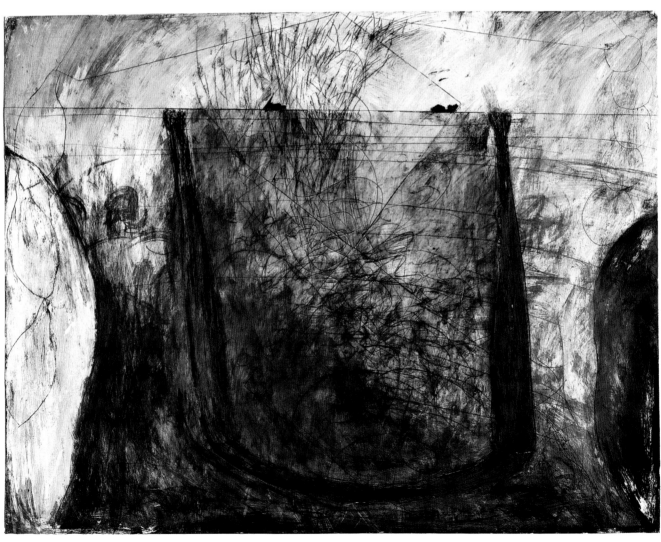

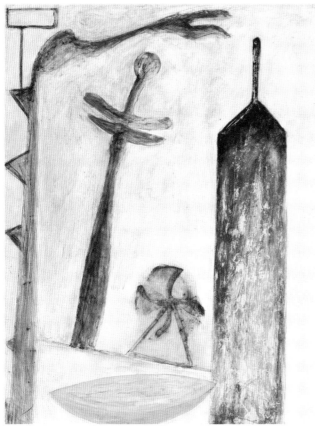

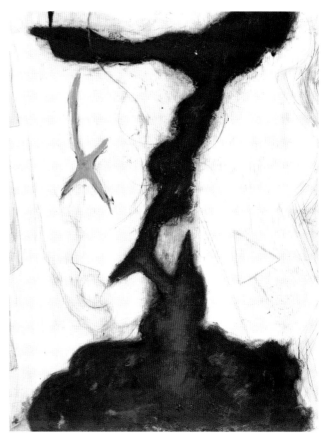

Clockwise from top:

Haiku 2 1987 Acrylic on KK Paper 95 x 76cm

Haiku 1 Acrylic on KK Paper 95 x 76cm Collection of Robin Lister UK

Still Life With Sprinkler 1988 Acrylic on KK Paper 95 x 76cm

Smoking 1987 Charcoal Acrylic on KK Paper 95 x 76cm

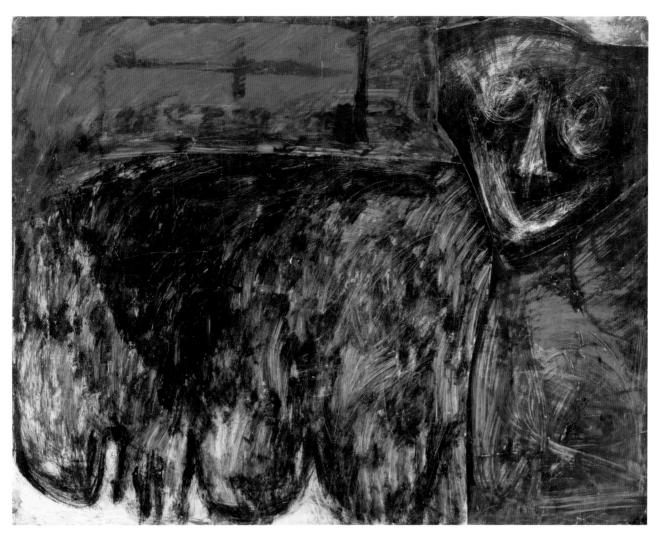

Left page from top:
The Beast 1986 Acrylic on KK Paper 76 x 95cm
Objects and a Kiss 1981 Acrylic on KK Paper 80 x 100 cm

Right page from top:
Vessel 1985 Acrylic on KK Paper 95 x 76cm
Crevass 1985 Acrylic on KK Paper 76 x 95cm

From top:

The Map of Love 1980 Acrylic on KK Paper 160 x 100cm

Dancers 1979 Acrylic on KK Paper with Varnish 160 x 100cm

First Haiku 1986 Acrylic on KK Paper 150 x 80cm

Grizedale Silurian Trail 1978 Acrylic on KK Paper 95 x 76cm
Collecton of Pauline Dallas HongKong

Another Country Acrylic on KK Paper 125 x 90 cm
Collection Lesley Cheung Hong Kong

Thinking About Corrina 1984 Acrylic on KK Paper 150 x 80 cm

Still Life & Landscape 1987 Collection Henry Moore Study Centre

From top:

Philosophical Drawing for Sculpture 150 x 240cm

Collection Gulin Yuzi Paridise China

Soul Kitchen 1987 Acrylic on KK Paper 150 x 240cm

Left page clockwise from top:
Epiphany 4. 1985 Stone Wood Bronze Steel Black Sand 58 x 150cm
Sill Life and Water Sprinkler 1987 125 x 90cm
Saw Horse 1992 Bronze Wood 127 x 91cm
Collection Dr Terry Friedman UK

Right page from top:
Mirfield 5. 1988 Collection Jo Fung Hong Kong 153 x 76cm
Mirfield 3. 1988 Acrylic on KK Paper 153 x 76cm

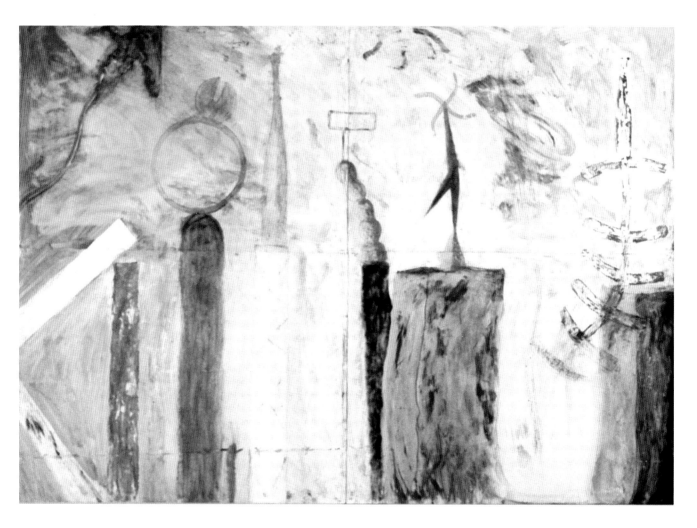

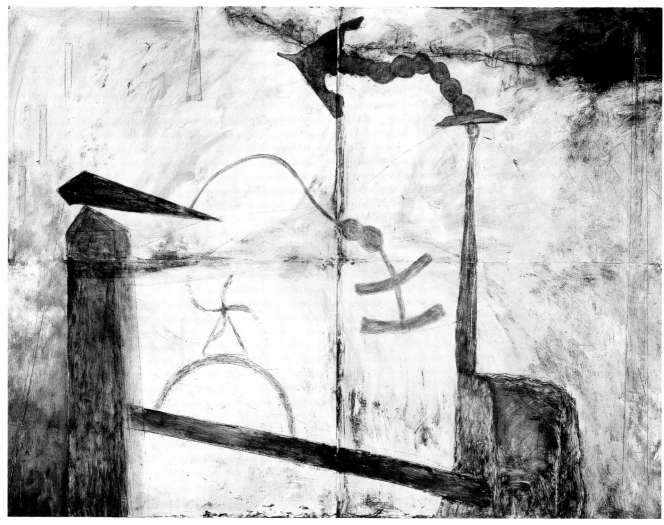

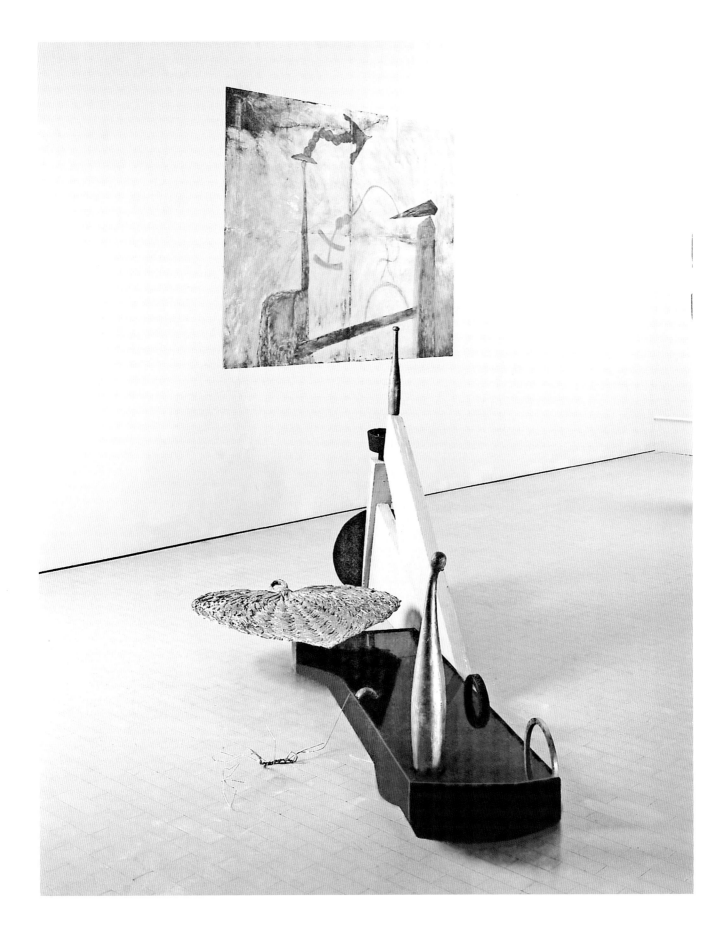

Left page:
Epiphany 3. 1988 Bronze Steel Stone Water 114 x 208cm

Right page from top:
Mirfield 2. 1988 Acrylic on KK Paper 153 x 76cm
Collection Ivan Koenitz Palm Beach, Florida
Epiphany 2. 1988 Stone Wood Bronze Steel Water 270 x 190 x 23cm

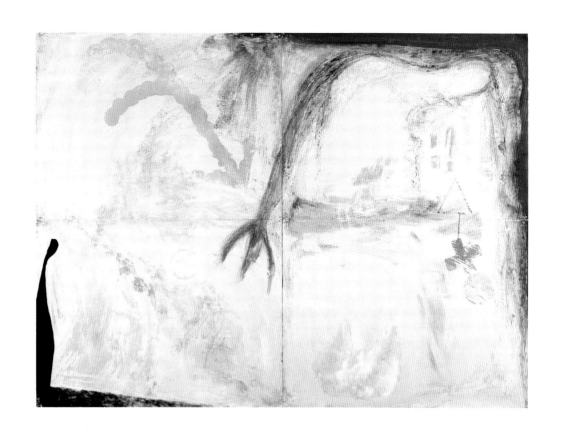

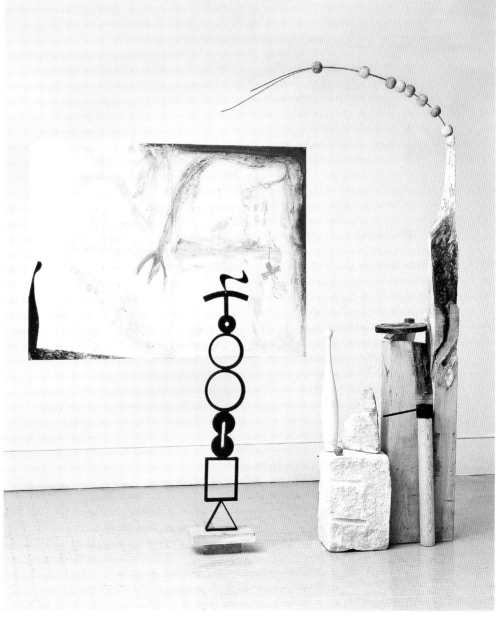

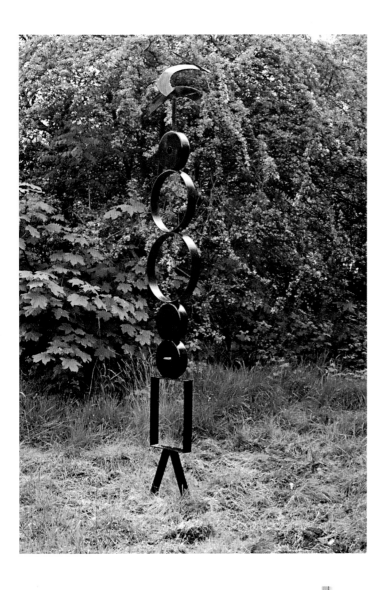

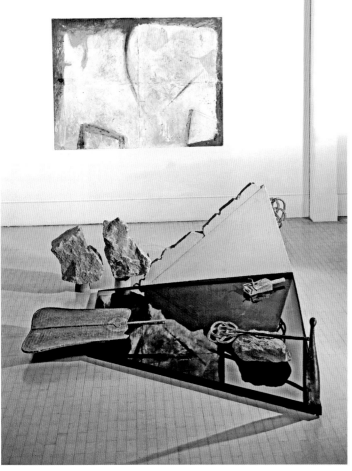

Left page: from top

Epiphany 1988 Painted Steel 3 x 0.5 x 0.2 m

Collection Ironbridge Museum of Steel Sculpture

Epiphany 4. 1988 Steel Water Stone Bronze 70 x 150 x 120cm

Right page from top:

Epiphany 5. 1988 Wood Lead Steel Wire Wax 109 x 96cm inches

David's Chair 1987 Wood Copper Bronze

David's Chair - King and Queen 1987 Bronze Wood Copper 2 x 2 x 1 m

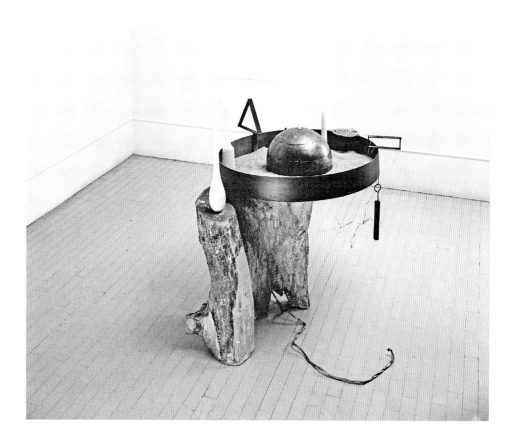

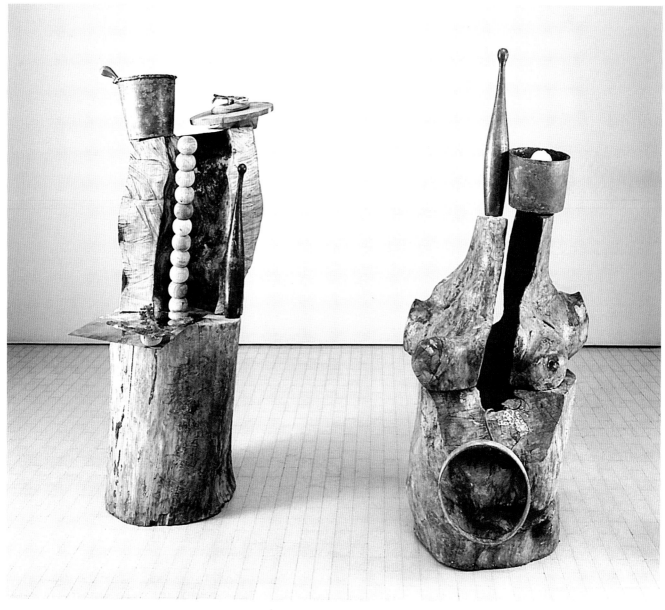

By striking contrast, Ward made the installation
Crimsworth at Leeds Metropolitan University Gallery
and at Angel Row Gallery in Nottingham in 1994. This
extraordinary installation covered the entire space of
the gallery; the walls lined in deep red pigment paintings,
the floor covered with creased waterproof material and
flooded with reflective water. Only a slim 'pontoon'
reached out into the room to give access and a place
from which to experience the transformed environment.
The sensory experience was completed by music, a
soundtrack commissioned from the musician and composer
Bill Nelson, which filled the room. Like some of Ward's
earlier installations, Crimsworth uses theatrical devices
– a controlled viewing point, a 'stage', shifting sound and
(reflected) light – to create an intense and highly charged
experiential place whose effect on the viewer is to induce
a changed mental state and an overwhelming awareness of
self in the present.

Crimsworth 1994 Installation Painting Polythene Water
Leeds Metropolitain University Gallery
Soundtrack by Bill Nelson

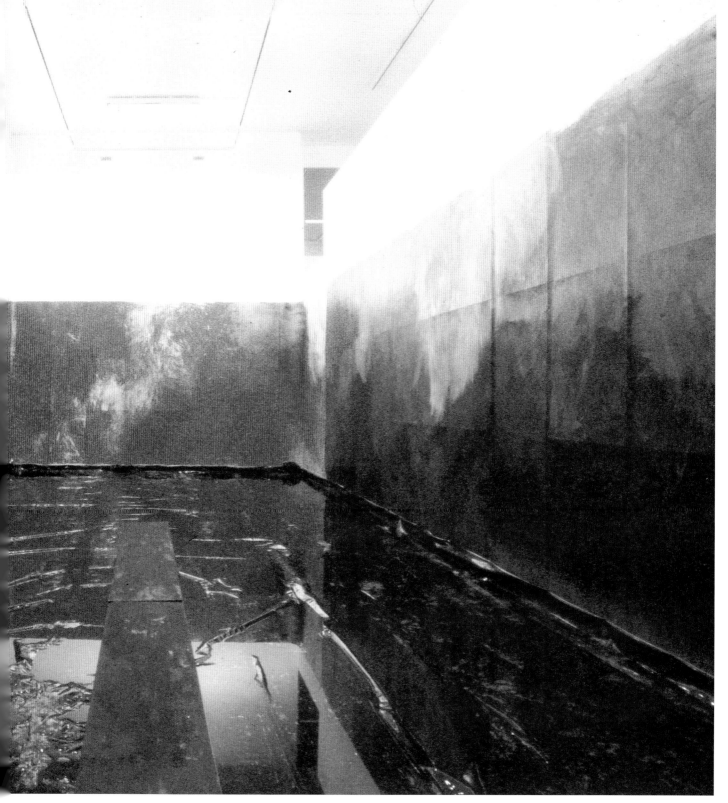

In the same year he made Tall Poppies, his first public sculpture, commissioned by Bretton Hall College and installed in the campus pond within the beautiful grounds of the Bretton Estate and Yorkshire Sculpture Park. The work has a clear organic resonance, one of growth, of grouping. The title also refers to the Australian term to cut the heads off tall poppies — to take a self-important person down a few notches. So that while the work is celebratory, it is also iconoclastic.

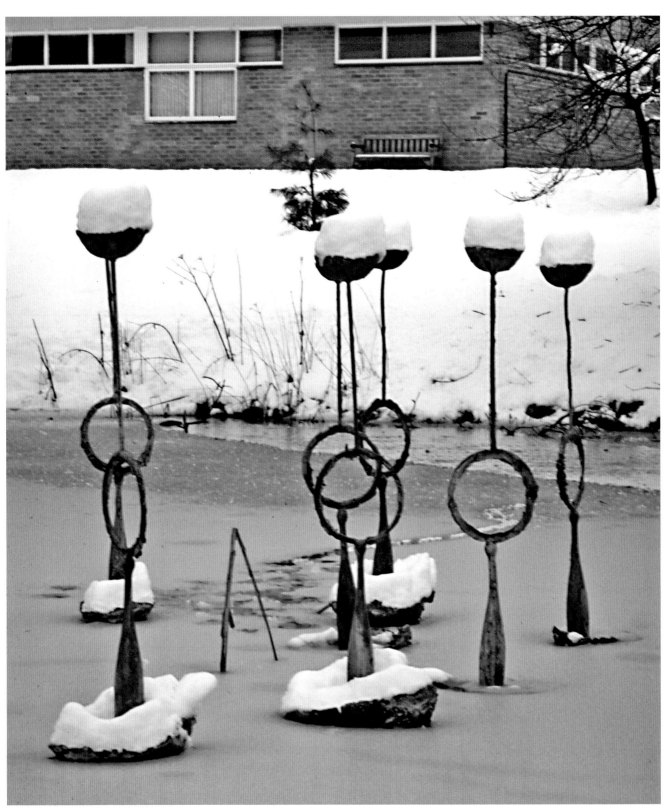

Left Page:

Tall Poppies 1994 Bretton Hall UK Bronze 2 x 6 x 6m

Right Page:

Tall Poppies 1994 Bretton Hall UK Bronze 2 x 6 x 6m

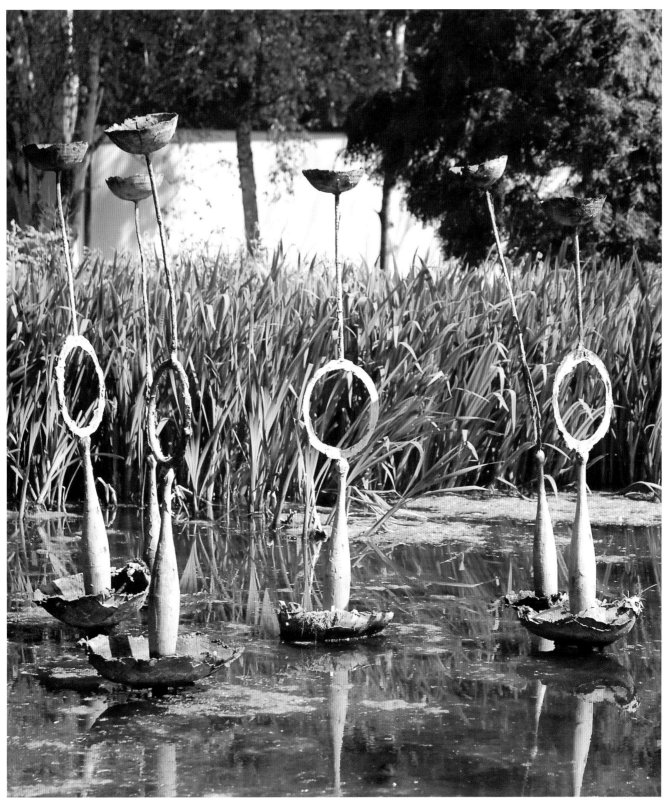

In his extensive 1995 exhibition, 'Conventions, Objects and Fields', at Florida Atlantic University Ward made a series of 28 red paintings, each coupled with a utensil or object, but not the familiar objects of Ward's baggage to date. They are fabulous, rich, sensuous colour-field paintings on Kromecoat paper; layer upon transluscent layer of pigment and clear varnish built up and worked back to create panels of perfect luminosity and tonal range. The objects are carefully placed, again with Morandi-like spareness, on slight glass shelves just to the left of the painting where they are both juxtaposed and form a bond, with object, object-shadow, and relief panel activating the three-dimensional space around them. The series' title and the individual, simple titles reveal much: Interaction with 3 white bottles; Echo with flues; Light source and glass grinder; Tondo with copper dish; Balance with a bull's ring; Negative space and brass vessel. There is no narrative, no personal reference; but a form of pure abstraction and spatial enquiry that contributes to the lexicon; "a meditation on the conventions of painting, edge, frame etc. The objects were the things on the glass shelves and the fields were the total area of the painting, object and cast shadows. Red is a colour I am drawn to – I'm no good with brown and green – it's the primaries which energise me, and often provide the background. Plus the various reds I use work pigment-wise with the ceramic paper; some of the pigments react more readily with the surface and the varnish. It's the surface and the vibrancy which act like a slice through something, as though it's been cut – different to painting where everything sits on the surface, more like cutting through a slab of stone. Also, the red of the Conventions series runs the range of reds: orange/red to Magenta and Bordeaux". *(ref. email conversation April 2008)

"an abstract world of pure relations, which has a different existence from the world of things..."
RJ Soto, quoted by Ursula Szulakowska, Conventions, Objects and Fields. Pub. MakingSpace, Bristol 1995

Conventions Objects & Fields 1995
Scmidt Centre Arts Florida Atlantic University

Left page from top:

Conventions Objects & Fields 1995 Field & Jug with Water 124 x 190cm

Conventions Objects & Fields 1995 Echo with Flues 124 x 190cm

Right page:

Painting - Conventions Objects & Fields 1995 Acrylic on KK Paper 90 x 76cm

Clockwise from top:

Corners - Conventions Objects & Fields 1995 Acrylic on KK Paper 90 x 76cm

Wind - Conventions Objects & Fields 1995 Acrylic on KK Paper 90 x 76cm

Texture - Conventions Objects & Fields 1995 Acrylic on KK Paper 90 x 76cm

Picture in a Picture - Conventions Objects & Fields 1995 Acrylic on KK Paper 90 x 76cm

One - Conventions Objects & Fields 1995 Acrylic on KK Paper 90 x 76cm

Clockwise from top:

Grid - Conventions Objects & Fields 1995 Acrylic on KK Paper 90 x 76cm

Edge - Conventions Objects & Fields 1995 Acrylic on KK Paper 90 x 76cm

Conventions Objects & Fields 1995 Fragmentation with Cream Jug

Negative Space - Conventions Objects & Fields 1995 Acrylic on KK Paper 90 x 76cm

The Crimsworth drawings series, shown together in 1998 at Il Salto Del Salmone, Turin, were a group of sixteen drawings resulting from Ward's response to the landscape and ideas generated by his daily walks around Crimsworth, near to his home in Hebden Bridge. In Zen-like disciplined fashion, Ward set himself the task of making one drawing each week, a meditative process in itself resulting in reflective, harmonious works which have less to do with his emotional process, than a sorting of memory, of light and of colour. In a recent conversation he said he likes "the thinking time of how the poetry comes together" * (Jan 08), and certainly these are visual poems that have come about through the pace and rhythm of walking in a familiar landscape. "I've always seen what I do as a kind of visual poetry. I like the word beauty. I like the word poetry." * (ibid).They are testament to an understanding of transcendence; in Kant's terms, the idea of the connection between self-consciousness and the ability to experience the world of objects – so the mind generates both the structure of objects and its own unity. A very pure idea. *(Kant, Critique of Pure Reason). As such, these drawings "examine the landscapes of the mind" * (ref. Ursula S, Crimsworth, pub. Making Space, Bristol 1998) and they do so with joy.

Crimsworth Beauty 1996 Chrome Kote Pigment 180 x 117cm

Crimsworth Elbow 1996 Chrome Kote Pigment 180 x 117cm
Crimsworth Slice 1996 Chrome Kote Pigment 180 x 117cm

Crimsworth Stile 1996 Acrylic on KK Paper 180 x 117cm

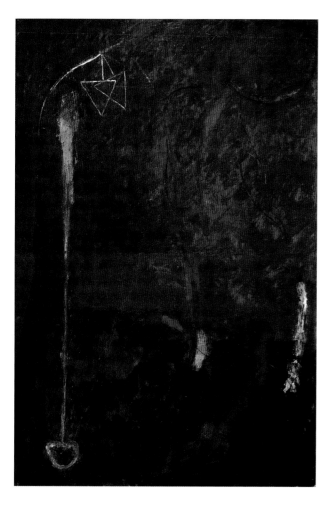

Left page clockwise from top:

Crimsworth Charger 1996 Acrylic on KK Paper 180 x 117cm

Crimsworth Night 1997 Acrylic on KK Paper 180 x 117cm

Crimsworth Gap 1996 Acrylic on KK Paper 180 x 117cm

Right page:

Crimsworth Poem 1996 Acrylic on KK Paper 180 x 117cm

Collection Micheal Walsh & Petra McNulty

Left page clockwise from top:

Crimsworth Red 1997 Acrylic on KK Paper 180 x 117cm

Crimsworth Tracing 1997 Acrylic on KK Paper 180 x 117cm

Crimsworth Light 1997 Acrylic on KK Paper 180 x 117cm

Right page:

Crimsworth Star 1997 Acrylic on KK Paper 180 x 117cm

Left page clockwise from top:
Crimsworth Flyer 1996 Acrylic on KK Paper 180 x 117cm
Crimsworth Split 1997 Acrylic on KK Paper 180 x 117cm
Crimsworth Moment 1997 Acrylic on KK Paper 180 x 117cm

Right page:
Crimsworth Place 1997 Acrylic on KK Paper 180 x 117cm
Collection Justin and Louise Sellers UK

Ward held another major exhibition in 1998, at Bennington
College in Vermont entitled 'Songs'. Once more, the
exhibition comprised a series of pairings, this time
variously-sized drawings, principally with bronze-cast
found and made objects, but also including glass shelves,
water, wood, paper, leather and stone. Each work is a
song, usually dedicated to a significant person in the
artist's life — his family and friends — or responding to
another song or text or place.

In part due to the sense of a personality being introduced
to each work because of their titles, there is a distinct
dialogue between drawing and object and their sculptural
space is extensive (once again approaching the idea of
theatre), thereby drawing the viewer into the space,
the dialogue and completing the artwork. Drawings are
hung at eye level or at floor level and are geometric in
construction; sculptures rest on the floor, on plinth-
arrangements, on shelves, or are wall-mounted;
conventions that Ward considers, engages and subverts
in his ongoing practice to renew sculptural language. And
in this there is a connection with Walt Whitman, a poet
of significance to the artist, who broke conventions and
taboos in terms of style, language and subject matter. And
in whose 'Leaves of Grass' (1855), song is a component
part — linking it to Ward's love of life, of his life, and his
complete regard for those who make up his life. For these
richly hued drawings and patinated bronzes are sensual
works and while there is no discernible narrative and they
are clearly engaged with formal painterly and sculptural
concerns, they speak of the gamut of life with all its love
and passion.

I

I sing the body electric,
The armies of those I love engirth me and I engirth them,
They will not let me off till I go with them, respond to them,
And discorrupt them, and charge them full with the charge of the soul.

4

I have perceiv'd that to be with those I like is enough,
To stop in company with the rest at evening is enough,
To be surrounded by beautiful, curious, breathing, laughing flesh is enough,
To pass among them or touch any one, or rest my arm ever so lightly
round his or her neck for a moment, what is this then?
I do not ask any more delight, I swim in it as in a sea.
There is something in staying close to men and women and looking
on them, and in the contact and odor of them, that pleases the soul well,
All things please the soul, but these please the soul well.

*Walt Whitman, Leaves of Grass 1855, Book IV; 3 I Sing the Body Electric, parts 1 and 4.

Songs 180 x 117cm

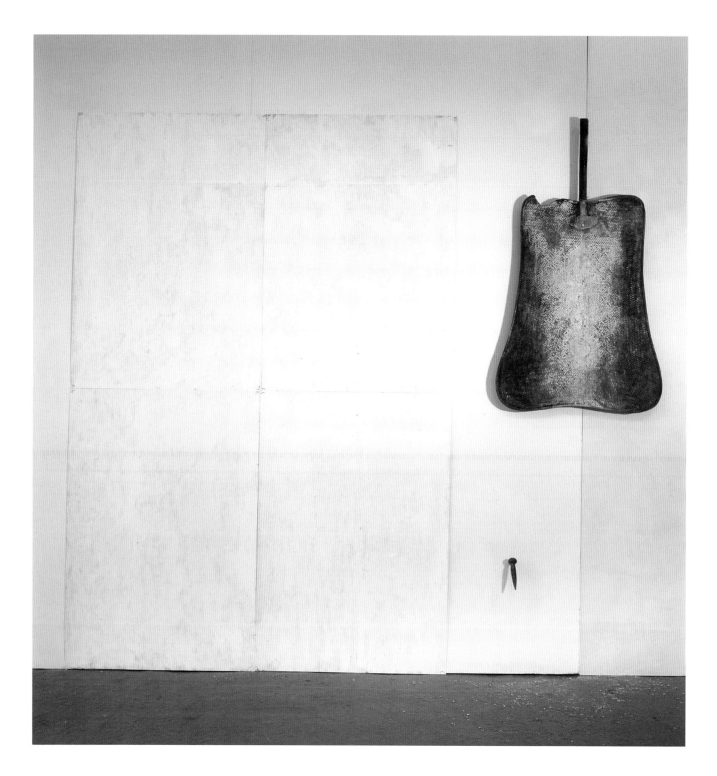

Lisa's Song 1998 Bronze Acrylic on Ceramic Paper 198 x 142cm

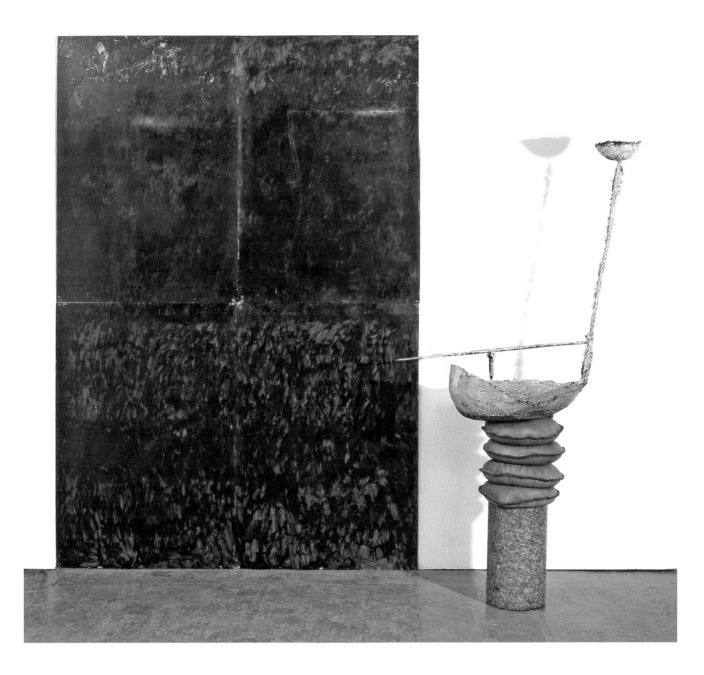

Dean's Cream 1998 Bronze Leather Marble,Acrylic on Ceramic Coated Paper 198 x 142cm

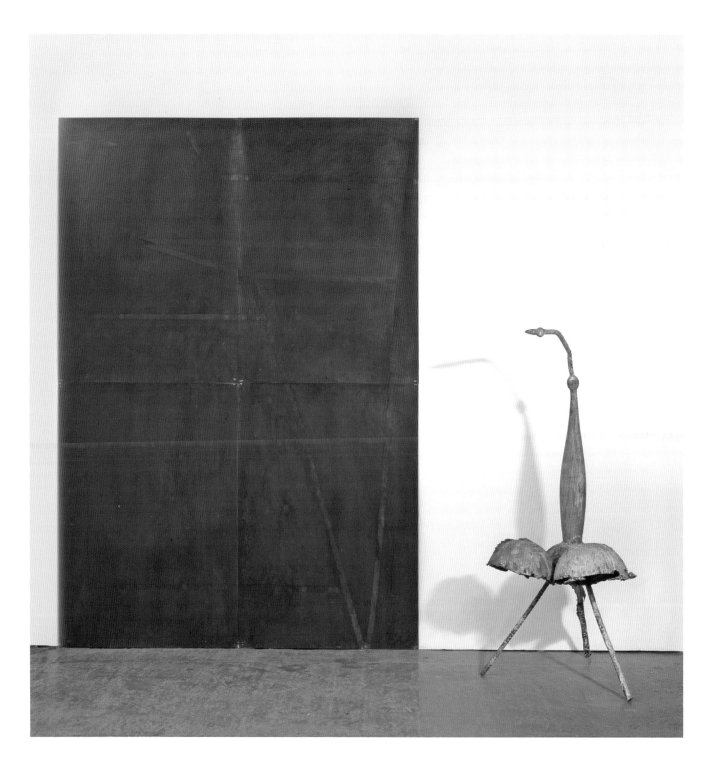

Billy's Song 1998 Acrylic on Ceramic Coated Paper. Bronze 198 x 142 x 91cm

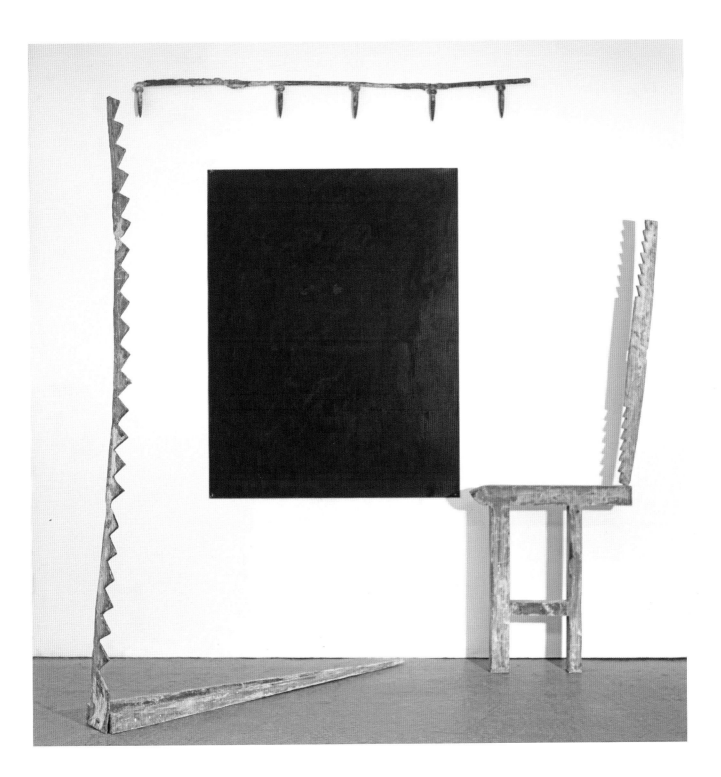

Song for Katya 1998 Bronze Acrylic on Ceramic Paper 198 x 142 x 91cm

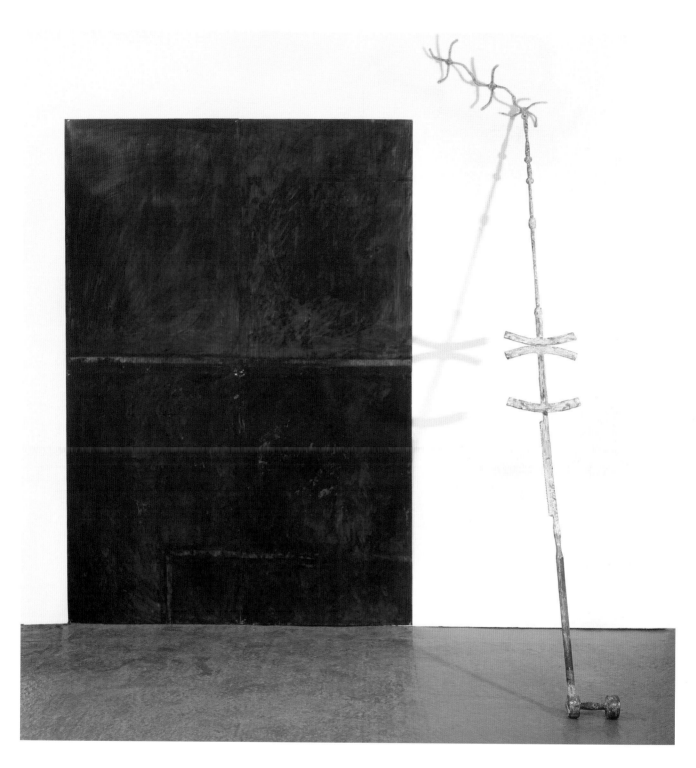

La La La 1998 Bronze & Acrylic 198 x 142 x 91cm

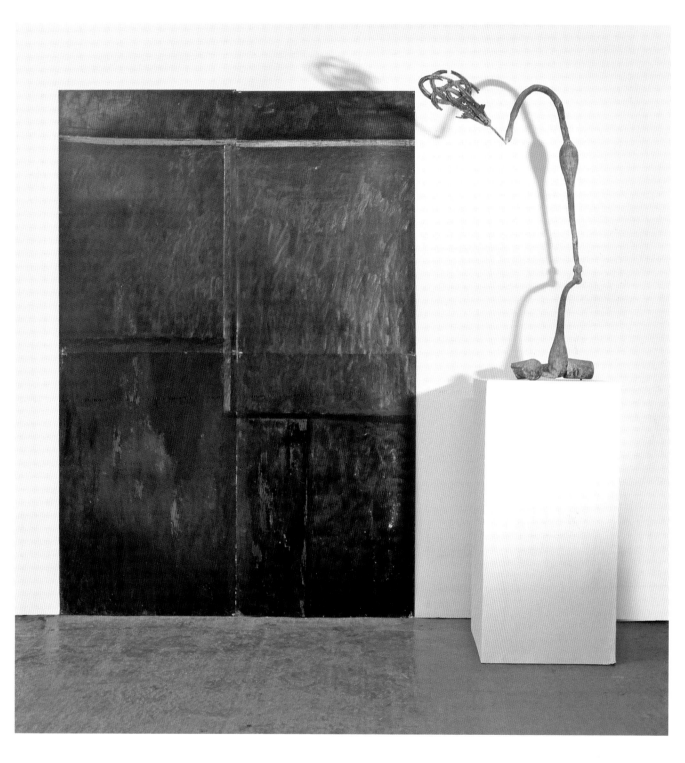

Jumping Jack 1998 Bronze Acrylic 198 x 142 x 91cm

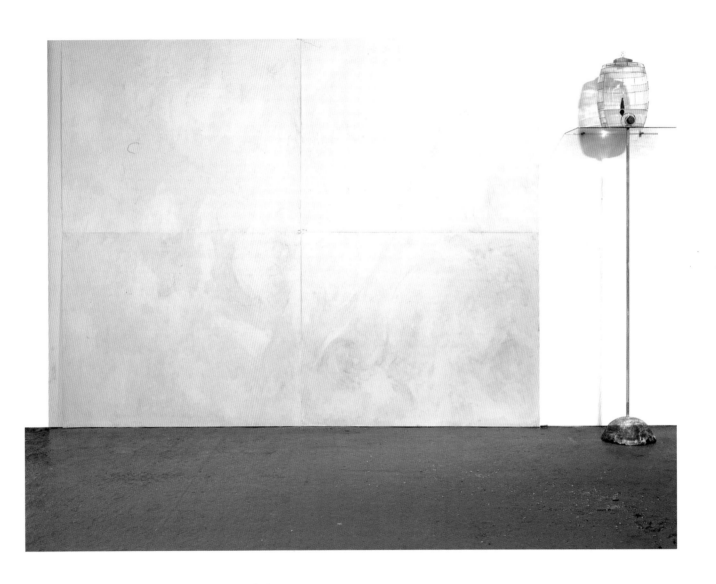

Song for Myself 1998 Acrylic on Paper, Glass Water & Wood 198 x 142 x 91cm

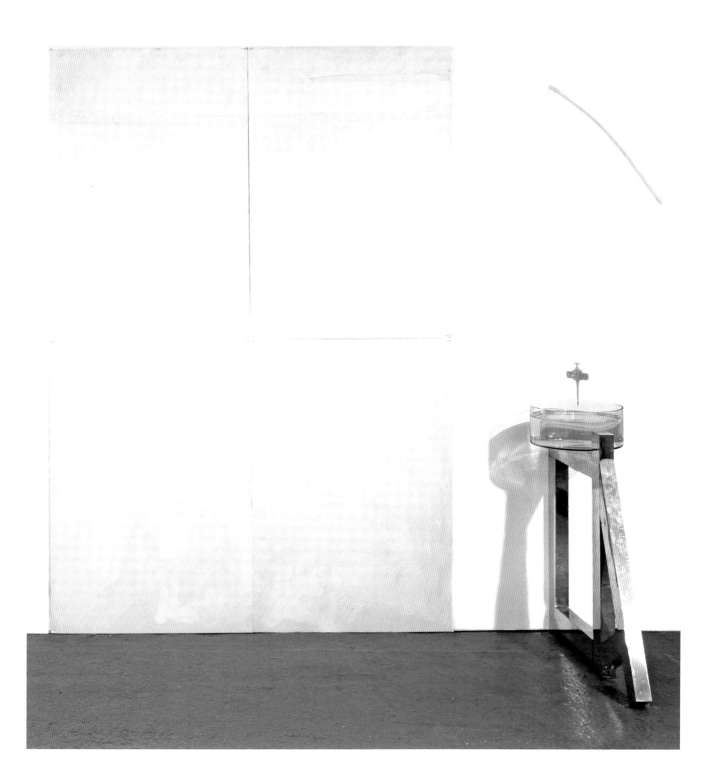

Willard's Song 1998 Acrylic on Paper, Bronze Glass & Water 198 x 142 x 91cm

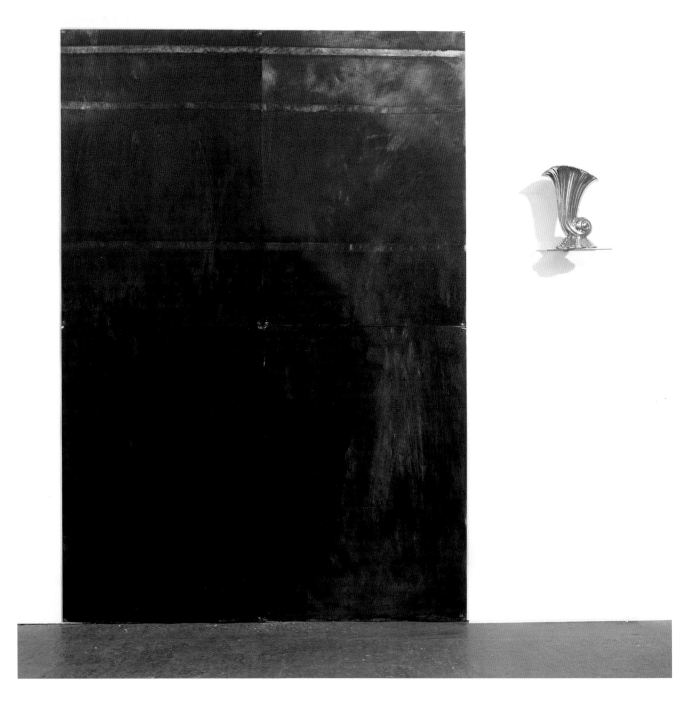

Tony's Song 1998 Acrylic on Paper, & Ceramic 198 x 142 x 91cm

Song For My Wife 1998 Acrylic on Paper, Bronze & Glass 198 x 142 x 91cm

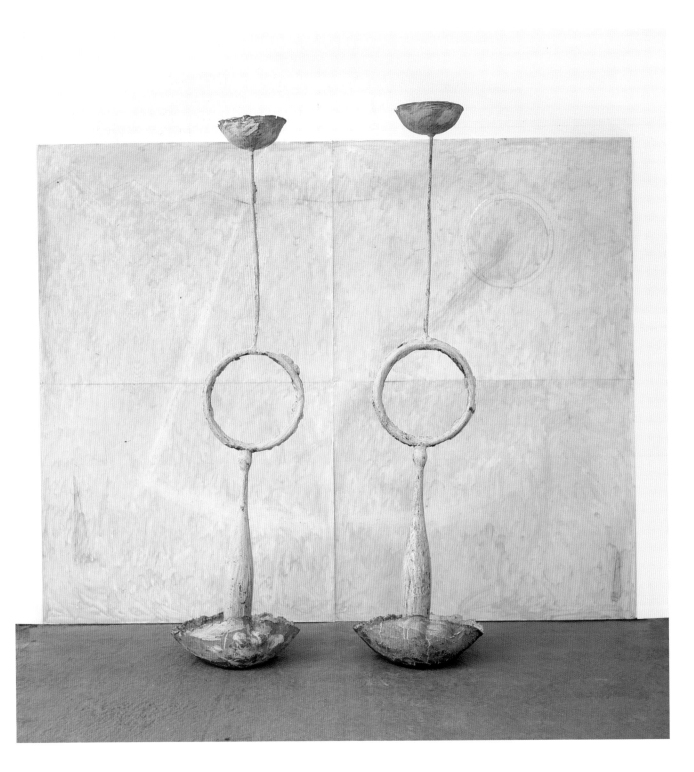

The Miller's Song 1998 Acrylic on Paper, Bronze 234 x 183 x 24cm

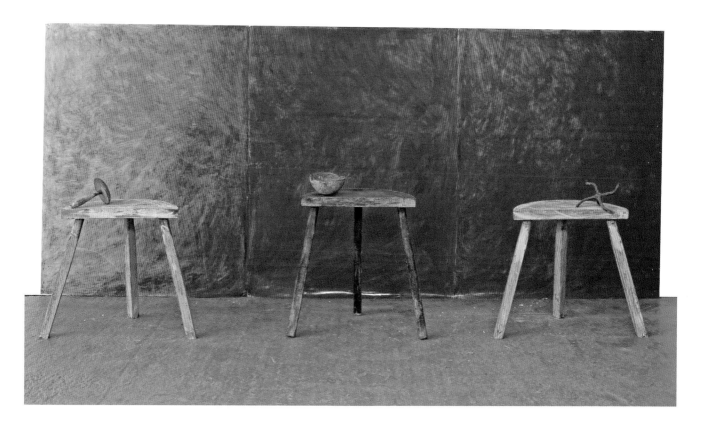

Bennington Song 1998 Acrylic on Paper Bronze 228 x 90 x 76cm

Six Memos, a stunning installation in the Chiesa di St Agostino in Bergamo, Italy in 1998 is a tribute by Rob Ward to Italo Calvino. Specifically the works refer to Calvino's meditations on the art of writing, 'Six Memos for the Next Millennium'. The titles of the texts, and of the works made by Ward, are a recital of the characteristics of writing deemed most important by Calvino: Lightness, Quickness, Exactitude, Visibility, Multiplicity. Calvino died before the last essay, on Consistency, was written:

"My discovery of Calvino's 'Six Memos for the Next Millennium' was as much an Epiphany as was reading 'Ulysees'. I became absorbed by his poetic formula, the range of intellect, and his ability to dance across the history of literature. More particularly, the Memos — Lightness, Quickness, Multiplicity, Exactitude and Visibility — are all qualities I treasure in my practice."
(* 6 Memos publication p.1)

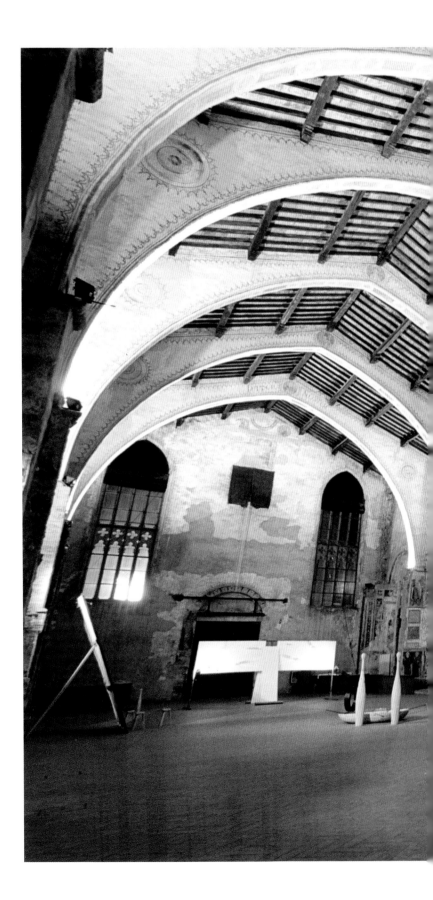

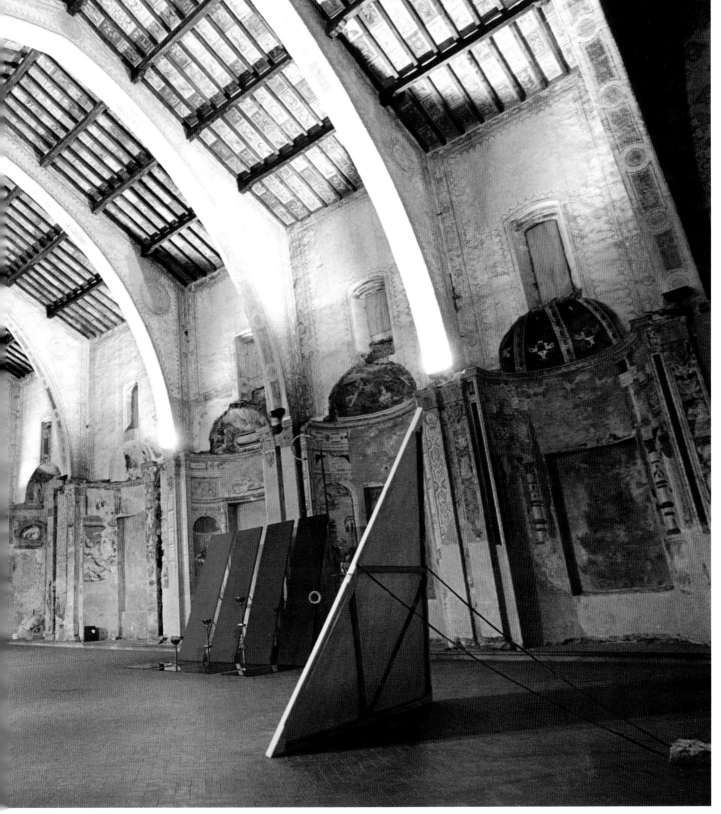

In the beautiful publication that followed the exhibition, Ward's own notes thread through extracts from writers whose work has been meaningful to him over the years; from Dante and Lucretius, to Emily Dickinson, Jorge Luis Borges and Roland Barthes. And of course Calvino, for whom compassion, tolerance and acceptance are rooted in our imaginative connection with other people and other lives. So, too, Ward. Time and again, these texts reiterate the making of art without intellect, without filtering through the senses or the limits of self; of an art that is absolutely the moment, without ego. In his text for the Six Memos book, this is what Elio Grazioli calls "the impossibility of a pure representation of the real".

The five works themselves are bold, startling statements for the small, exquisite 17th Century church. Slabs of deep colour enrich three – Visibility, Multiplicity and Quickness. They are populated by Ward's recurring forms; Indian club, three-legged stool, shallow bowl, ring, glass shelves. Theatrical devices and reflection play their part and bind the five sculptures together. The memos are a study of the architecture of painting. Each painting stands in space to relate to the church. Each memo is a contemplation of the

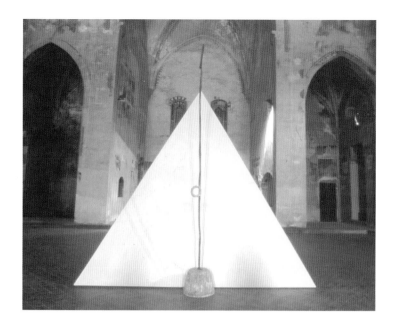

Left page from top:
Rapidita (Quickness) 2000 Wood Bronze Glass Canvas Metronome 2.5 x 3 x 3m
Visibilita (Visibility) 2000 Wood Canvas Pigment Glass Brass 2.5 x 2 x 2m

Right page:
Esatteza (Exactitude) 2000 Wood Glass Steel 2 x 2.5 x 2.5m

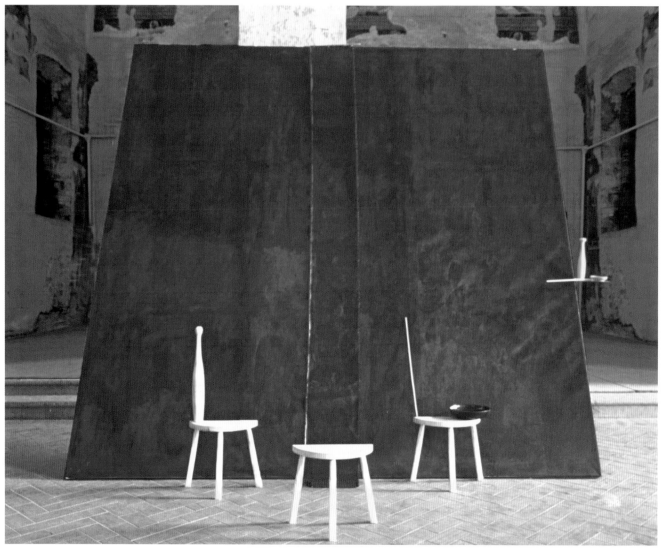

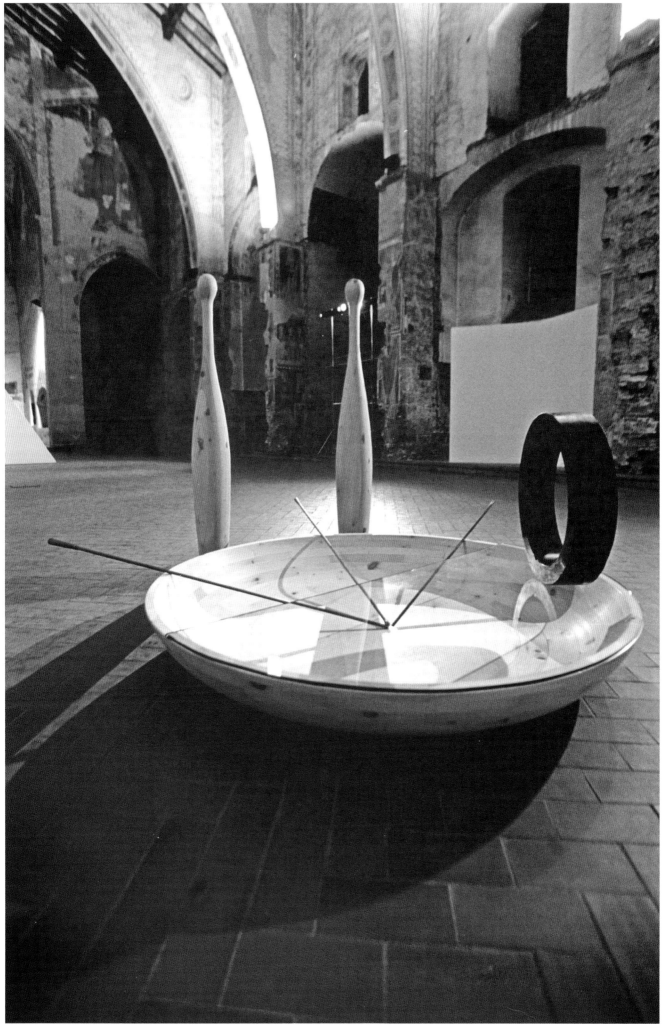

word. Lightness appears light, but is in fact the heavies work. Multiplicity doubles the images with water and glass. Quickness has the potential for movement but is still. Exactitude is turned on a Lathe to be perfect. As Grazioli states, Calvino's unrealized essay Consistency embodied "coherence, congruence, solidity, connecting the parts of a whole... to Rob Ward it represents the whole of the exhibition".

''Were I to choose an auspicious image for the new millennium I would choose that one: the sudden agile leap of the poet-philosopher who raises himself above the weight of the world, showing that with all his gravity he has the secret of lightness, and that what many consider to be the vitality of the times... belongs to the realm of death.'' The quote is from 'Lightness'. Calvino's literary life was spent trying to remove weight from people, places, cities, and above all, from language itself. So does Rob Ward work to rid his drawings and sculptures of process, for them to be direct and clear, of "about honouring time spent". (email 'On Drawing', 2008)

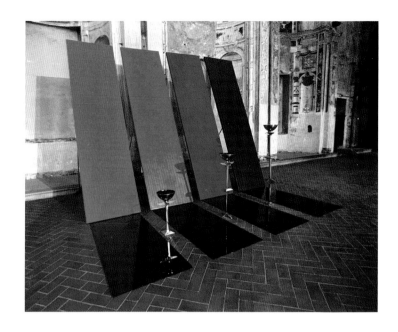

From top:
Multiplcita (Multiplicity) 2000 Aluminium Water Glass Pigment on Steel 2.5 x 4 x 2.5m
Multiplcita (Multiplicity) 2000 Aluminium Water Glass Pigment on Steel 2.5 x 4 x 2.5m
Chiesa Di St Agostino Bergamo Italy

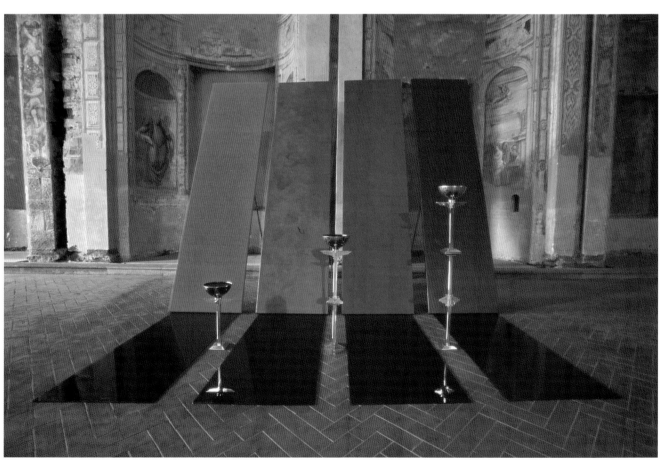

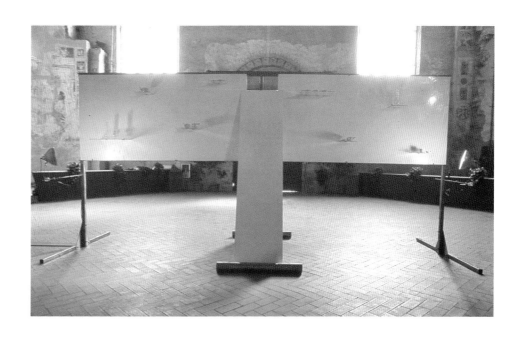

From top:
Legerezza (Lightness) 2000 Glass Aluminium Paint 2.5 x 4 x 1.5 m
Legerezza (Lightness) 2000 Glass Aluminium Paint 2.5 x 4 x 1.5 m
Chiesa Di St Agostino Bergamo Italy

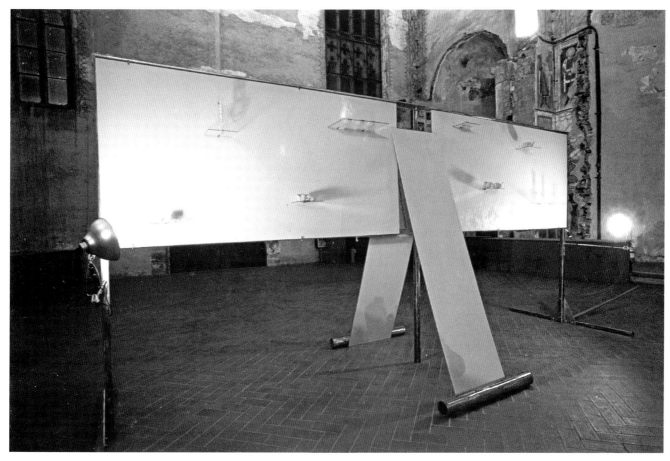

2000

The period since the turn of the millennium has been
extraordinarily prolific for Ward. His promotion to Head
of the Centre for Sculpture at Bretton Hall, University of
Leeds meant he had less direct teaching and allowed him
to arrange his time differently, enabling him to produce
ambitious new work. In addition, in 2002 he gave up his
many visiting lecturer posts in order to concentrate more
fully on his own work. Commissions and exhibitions in
the UK, Italy, China and Taiwan were also the catalyst for
making outdoor works, some on a monumental scale, and
a development of his practice that has informed his studio
work. This recent period has seen Ward work with bronze
and wood, but most particularly with stainless steel and
marble.

Ward had first visited China when he showed in Hong Kong
in 1990. From that point he had enjoyed the country and
its people. Invited back in 2000 by his friend and artist,
Mike Lyons, to make work for the Guilin Yuzu Paradise
sculpture park and to take part in a symposium, Ward
found an ease in being able to work for the first time with
assistants and with ready access to materials that suited
his easy manner and which enabled him to start working
on a different scale.

Rob Ward easing his aching back
on some choice Chinese granite

Philosophical Sculpture of 2001, sited in Guilin Yuzi, is a three by five metre stainless steel and black marble sculpture in which a perfect tubular steel circle and the frame of a perfect tubular steel cube balance opposite one another at the very tips of a sharply constructed set of scales, set upon a four-sided pyramid. Contrasting with these hard-edged forms are a pair of organic legs that form an archway op top of the scales; almost chaotic in comparison, they keep the geometry in balance. The legs are a reference by Ward to The Winged Victory of Samothrace (c. 220-190 BC), that for over a century has been prominently displayed at the Louvre and is one of the world's most revered sculptures. This epitome of incredible, figurative sculpture is juxtaposed with Euclidian geometrical forms, thereby setting up a philosophical dialogue. The legs also reference the powerfully striding figure of Umberto Boccioni's The Unique Forms of Continuity in Space (1913), and indeed the breadth and vitality of the history of sculpture across millennia. With its beautiful, highly reflective, black marble base that performs like a pool of still water, the sculpture is a startling work within the densely wooded park and its grassy floor.

"I made Philosophical Sculpture in three weeks with the help of two assistants, fantastic people. It opened my eyes to making big work with help. I had done it all myself before. So I retuned to make more work there – great facilities – I became one of the family; they like my sense of humour, I like their humility, manners and fun. So I made big stuff there: two commissions for America and work for Taiwan, which led to Shanghai. However the first work made in stone, Theatre, made me think of the possibilities of some small works in marble; they are expert stone carvers... and the still life objects seemed perfect for the material. It also led me to think about mass a bit more – previous works had been very much drawings in air. The Chinese have a different idea of time to us. I like it." (email 'On China" 2008)

The somewhat gentler work, Oil Catcher (2003), is sited on an islet within the River Hebden that runs through Ward's home town of Hebden Bridge. Made from aluminum castings of circular machine parts (and related to an earlier steel work Epiphany I, made in 1990 for Ironbridge Museum of Sculpture), the sculpture softly captures the beautiful surroundings and the rings are arranged so that the work changes from each angle. Of course it indicates a continuing allegiance to the ideas considered by Brancusi and particularly his Endless Column at Targu Jiu in Romania, but more especially it indicates a building

interest in siting work outdoors and of enabling varying tones of expression within different environments.

Ward made the bronze Flower in 2004 for the Shanghai Sculpture Park. Recalling his Tall Poppies (1994) for Bretton Hall, the sculpture appears to be flower-like and organic in nature. In fact it is a an assembly of object-forms: a shallow dish surmounted by three Indian clubs, a sphere topped by three rods that end in shallow dishes; all collecting light and rain. And all reflected by the pool of water in which the sculpture appears to float.

Although Ward's successive work continues to fall into the series that have been his life's practice, this use of reflection (water, polished marble and stainless steel) has been extended in recent years. One of his largest and most impressive works is Cathedral (2003), commissioned for a business park near to Bretton Hall. Occupying the spatially difficult place at the centre of a traffic roundabout, this nine metre high spire more than happily holds its own against the surrounding eclectic buildings, roads, M1 motorway and soft landscaping. More than that, its highly polished surface beautifully reflects the changing sky, fauna and buildings which are sliced, faceted and abstracted by its triangular forms, setting up a dynamic and constantly shifting surface.

Throughout 2003-04, Ward made a body of smaller works that were exhibited under the title 'Patterns' in Germany and Italy in 2004. The catalyst for the group was an invitation from Wilfred Cass at the Cass Sculpture Foundation in Goodwood, West Sussex for Ward to make a maquette for a much larger work (Gate). Ward became intrigued by the idea of taking the hand-held to the monumental and around the same time became aware of a number of redundant moulds, or patterns, that were being scrapped by a Yorkshire engineering works – in effect, found objects – and which he used as moulds for sculpture. Ward exhibited thirty sculptures, cast in bronze, stainless steel, aluminium or iron, that were shown on plinths. Of these, twelve were paired with an integral wall drawing of a single, drenched colour, in which was etched the outline of the accompanying object together with a single horizontal line towards the base of the drawing, indicating the plinth.

The title of the show, in addition to referencing the engineering moulds, also refers to the repetitive rhythm of sculpture with drawing, and the relationship between two and three dimensions that so occupies the artist. In these works there is a real sense of alchemy, of changing

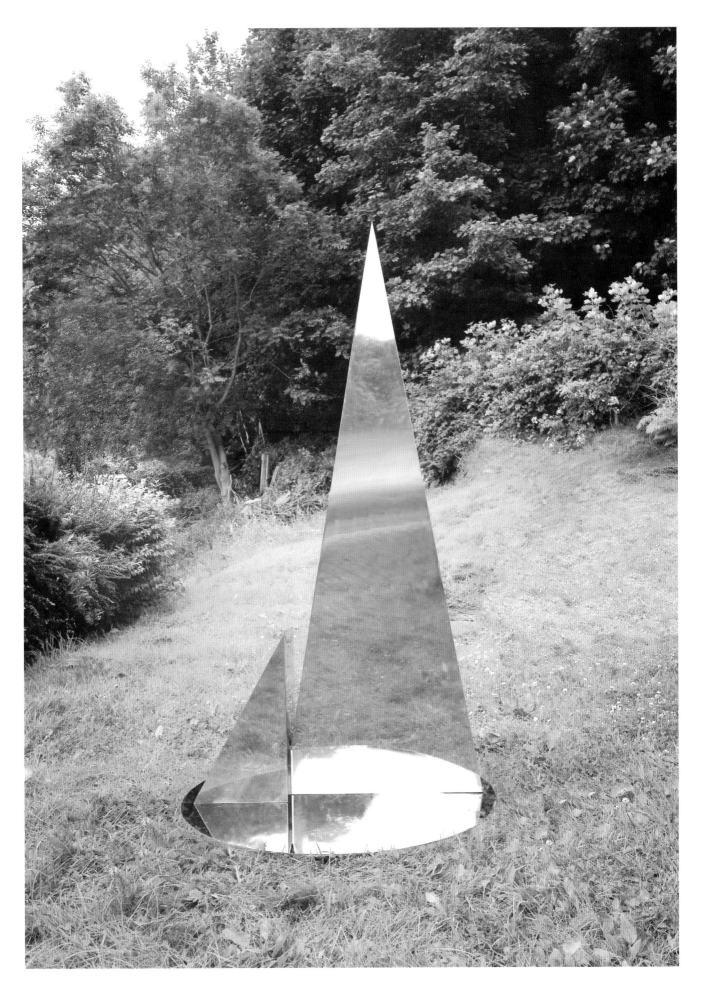

Small Cathedral 1
2004 Mirror Polished Stainless Steel 15 x 1 x 10

base metals, base forms, into something other; something of another plane. There is a preciousness, too, about the highly polished works in bronze or steel which both invites and forbids touch, their bright, shiny surfaces dancing with light and reflections that serve to dematerialise the form. By contrast, works such as the iron Water Clock, or matt-patinated Adam absorb light and are therefore more solid and dense. While works in aluminium, like Inversion and One, both absorb and reflect light so they seem to softly float in space. Both of these are barely duplicated within the drawing that sits behind; shadowy traces within rich pigment. The simplicity and directness of One is very beautiful. Clearly the shape of the sculpture implies the figure 1, but there is a deeper, meditative resonance here that might be akin to 'Om', in Sanskrit denoting the primal vibration that begins a transformative process which delivers a higher state of awareness. Its title also refers to that stone work of the same name that he made in 1969; a sculpture created simply from the action of hammer and chisel on a simple block of stone that itself implied a single, powerful exhalation of breath.

Working on a similar monumental scale to Cathedral, Ward made Pool and Palace in 2004 for West Palm Beach, Florida. Pool is 25 metres long and Palace five metres across and five metres high. Both were fabricated in polished stainless steel in China and both use water as a component part (and electric light in the case of Pool). Like Cathedral, they are highly architectural works. Palace in particular is a hefty, fantastical sculpture, constructed from elements that on a different scale might be a child's building blocks. It is an exciting, exuberant, shimmering fantasy architecture that is entirely at one amidst the surrounding palm trees and theatrical Florida buildings, which it in turn reflects.

Theatre, also of 2004, was made for the Chin Pao San cemetery in Taiwan and has a completely different sensibility. Its granite 'doorway' that in fact serves more as an niche or shelter, intended to be a Theatre for one person, is fronted and topped by three differently sized, perfect stainless steel spheres. They give multiple convex reflections of the grassy slopes, trees and expansive sky, serving as calm sentinels to this peaceful place and a space for contemplation. The landscape, sculpture and the viewer all interact in the reflection, affording multiple views from one position. Similarly House (2004), also sited in Chin Pao San, reflects the environment, while two concave elements embrace a space that can be entered via doorways cut into the elements. As in Ward's early work, the viewer interacts with and is reflected by the installation and becomes

part of it; as is the case with of all of the stainless steel reflective works. In Striking Red (2005), shown at Guilin Yuzu Paradise sculpture park, the carefully curved sections are painted in familiar pigments — deep yellow, mid blue, dark red — and are flanked by reflective stainless steel spheres. At three metres high, the later work, Gate (2007) for the Cass Sculpture Foundation is of a similar scale. It is a complex, illusory, geometric sculpture that extends notions of physically and metaphorically going from one place to another, of passing beyond. Concurrently it is an intricate assemblage of intersecting planes and geometrical elements and, in its reflective surface, an unabashed celebration of the beautiful grounds at the Cass Foundation.

The elements of works such as House are re-worked on a smaller scale in 2005, with Gesipa, which combines the curving section of the cone from House and the sphere of Theatre with an ellipse of marble in a beautifully compact work that assumes the sense and elements of a still life. A half-metre high Palace, fabricated in brilliant, polished stainless steel,(also made in white marble) allows us to see that the sultan's hat fantastic architecture of the monumental Palace is, indeed, formed from a sized-up decorator's plumb and two shallow dishes.

Balance, reflection and contained space are the dominant features of a group of stainless steel sculptures made in 2006. These extremely fine and elegant works — Buttress, Inversion, Two and Shoe — recall forms such as a tuning fork. Their titles indicate both their direct sources, and the directness and simplicity of their expression. Fabricated in West Yorkshire and on a smaller scale to some of the

Left page:
Pool 2004 Stainless Steel Water 3.5 x 3.5 x 22m
Downtown At The Garden West Palm Beach Florida

Right page:
Pool 2004 Stainless Steel Water 3.5 x 3.5 x 22m
Downtown At The Garden West Palm Beach Florida

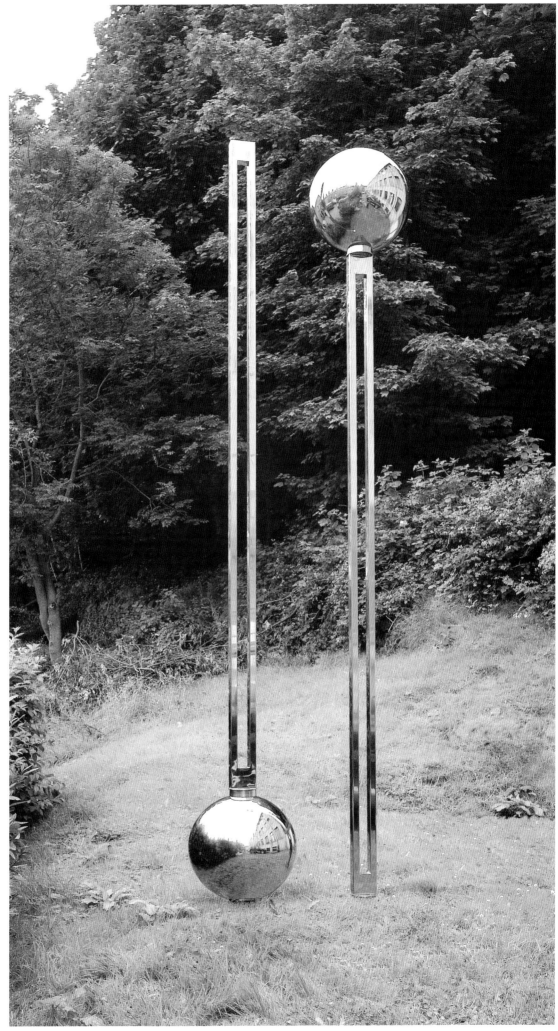

preceding outdoor steel sculptures, they illustrate Ward's confidence in exploiting the strength and delicacy that stainless steel allows, enabling finely wrought corners, edges and joints. Again their surfaces reflect and enfold their environment, including the viewer who is forced to contemplate himself in relation to the sculpture. Indeed the adoption of the sphere in many of these works could be seen as an extension of the mirror (frequently convex) used as a device in paintings by artists such as Vermeer, van Eyck and Velazquez, enabling them to add both another physical dimension (that outside of the picture plane) and, sometimes, a rendition of the artist himself within the frame; a layering of time and space. For Ward the strength and durability of steel has, paradoxically, given him the ability to make these slight, graceful gestures so that they lie somewhere between the analogous novel and poem.These works explore the sanctity of place, places to be inhabited, by one person. They also articulate ideas of drawing. The reflection flattens the form, and "allows drawing and time to occur on the surface"

In 2007 they are extended with smaller sculptures such as Stressed A, Swing (recalling works from the nineties) and A Dozen Eggs, made in polished bronze and a celebration of that most perfect of forms. In the full size outdoor work and smaller Marriage (2007) we see a return to the forms of Cathedral, and of thirty years ago in These Foolish Things (1978); sharp, triangular elements reaching to the sky and flanked by smaller triangular elements. In the smaller, 1.5 metre version, the elements, or protagonists, are set upon a circular stage and actually spotlit in theatrical fashion. In both versions the stainless steel elements are juxtaposed with those in rusted steel, giving the works greater compositional variety and possibly also alluding to the male/female gender split that we first saw in works such as These Foolish Things.

Amidst the steel sculptures of 2006, Ward made a series of works developed from small sculptures shown in the 'Patterns' exhibition. They are of different sizes in turned wood, including Fantasy Tower which of course connects with some of his architectural sculptures and makes use of elements such as the decorator's plumb and what might be a section of hat stand. As with all of Ward's work, it is beautifully conceived and constructed. Spife, a portmanteau word, combines 'knife' and 'spoon', and is named after the tool used for cutting kiwi fruit. Also assembled from laminated machined and turned wood, it is clearly utensil-like, but without discernible purpose. Similarly, the much larger two elements of Tiddle/Po allude to a bedpan and urine bottle, but their scale and delicacy

of form in such an unlikely material (laminated ply) push them into a surreal world so that they exist as sculptures in their own right – one stretching out and giving, the other open and accepting. As with much of his cast and fabricated sculptures, Ward used the expertise of pattern makers in West Yorkshire to make the works.

The two metre high wooden sculpture, Gates of Paradise, is different in structure to the others in the group since, like Palace, it has the appearance of being assembled in completely symmetrical fashion from pre-formed pieces of wood, like toy building blocks. Indeed the delicacy of the uppermost curving forms are formed from engineering patterns. The form and title of the sculpture alludes to a pagoda structure. Its art historical lineage also connects it to Lorenzo Ghiberti's legendary bronze Baptistry doors of the Duomo in Florence; a commission he won in 1401, aged 21, and which took twenty-one years to complete. The doors inspired Rodin in the making of his extraordinary Gates of Hell and they have been a source of inspiration for many artists throughout their six hundred year life; it is this place they occupy in the history of sculpture to which Ward has responded, creating his own pagoda-like, utilitarian version.

In Ward's most recent body of work, medium-sized and large white marble sculptures for an exhibition in Shanghai Sculpture Park, there is a sense that almost anything is possible. These sculptures amalgamate many of the forms and ideas of the preceding thirty years. The source of each stacked or carved form can be found in the dusty corners of Ward's studio – plumb, bell, sculptor's mallet, Victorian doorknob, tool handle, egg, pot, flask. All are here, waiting to be magnified beyond easy recognition and combined with geometric solids (cone, sphere, cylinder) and sculptural devices (plinth, dais), carved by expert Chinese craftsmen, and issued as a family of curious and wonderful stacked chess-like sculptures. Perhaps they could never have been made anywhere else in the world since these forms chime so well with some of the decorative artefacts of China and particularly the craziness of real fantasy-architecture on Shanghai's waterfront, and where materials and talented artisans are available. They are testament to Ward's astounding understanding of scale and of connectives; literally, the way things join together. And while you can't get away from Brancusi's stacks, the peculiarity, the slight discomfort of proportion, the occasional precariousness of balance is all Ward's own.

"The impetus behind the marble work? I had made the architectural pieces, in 'Patterns' and the large scale works,

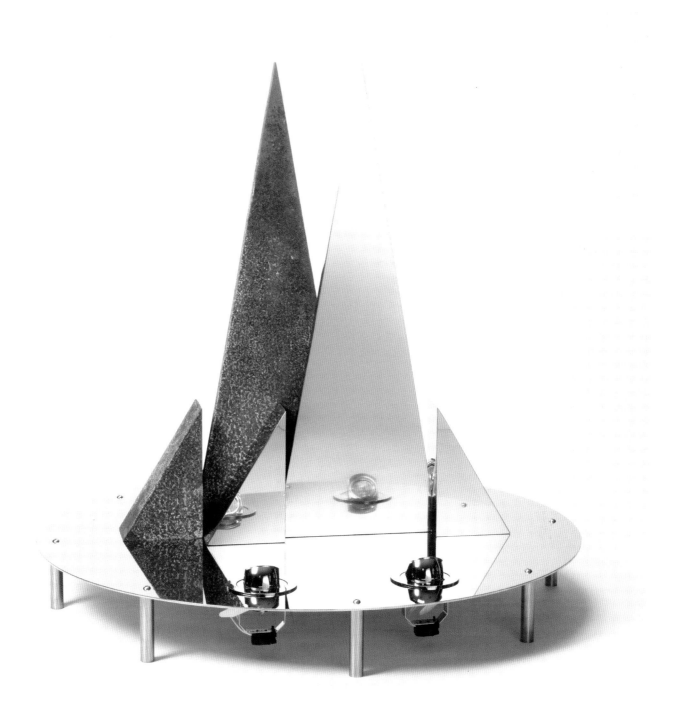

Maquette For Marriage Steel and Stainless Steel Lights 1.5 x 1.5 x 1.5m

Cathedral, Palace etc. and was thinking about architectural detail. The big work is quite minimal, mini-architecture. It occurred to me that there was scope to explore a scale which could be real, as in architectural detail, stones on buildings, and also explore the scale of the objects they came from, their strange combinations, and also act as possibilities for bigger sculpture. I think they are also quite pleasurable. I thought about calling them teaching a stone to smile. There's something about a stone cold piece of white marble making you smile." (email 'On China' 2008)

As with previous series, the sculptures are accompanied by a set of drawings with the group title Smotherfly, the name of a place close to where Ward grew up, so that through both media Ward is thinking about and comparing places that are separated in time by some fifty years. While still made from Kromecoat paper, the drawings are more painterly than previously, with less scratching into the surface, less graphic, and more focus on the paint being overlayed and the relationship between colours explored. In addition to their being related to specific places, senses and thoughts from Ward's childhood, this new set of drawings is actually painted over old works so that in making them Ward was aware of reminiscences from different times of his life; "a double time capsule". (Ward Smotherfly email May 2008). Together with his China experiences and the fact that they are paired with the new marble sculptures (although not specific to particular sculptures as previously) they become a triple time capsule, or an ongoing continuum that builds on past work and ideas but which pushes the medium in new directions. Like the veritable layers of an onion, the depth of these works is gradually revealed; a play within a play within a play. Art historically, of course, the works allude to early modernism – the idea of the found object, revealing the subconscious by a direct connection between hand and mind, and creating an easy interplay between surface, space and object, between the painterly and mass. Jazz analogies are inevitable: improvisation, syncopation, fusion.

The most recent series of works are called Flowers in the Studio , an ensemble of 6 Paintings and Sculptures . Six flowers , Dahlia , Daffodil, Cornflower , Pinks , Camelia, and Buttercups and Daisies are depicted as backgrounds to Six sculptures , each one using elements and furniture used in Wards studio for many years. Dahlia is a work which features a wooden aquatint box , used to stand a glass bottle filled with water which acts as a weight and balance for the flower form in Bronze , topped by a bell. Pinks is a Donkey , used in Life drawing classes , fronted

by a Stainless Steel mirror, with a Bronze cushion where the artist would be, the implication of the artists presence. Each of the works establishes a different dialogue with the artist as watcher, occupying different views, and writing new poetry on the simple idea of bringing flowers into the Studio.

It is a privilege to see such continued mature flowering in an artist in his mid-career. The lessons in terms of scale, volume, interval and space are well learned. The life is well lived, with consideration, intelligence, knowledge and, perhaps, moments of transcendence that feed into an impressive artistic output. Ward set out "to make something that was my own" (letter 2008), and has certainly achieved that aim, while it is clear that there is plenty more to come. And so Ward's clear sense of luck continues, although it has to be said that it's a luck he's made for himself and is surely due, at least in part, to his openness to the world and those who inhabit it.

"I suppose pleasure is a leading word in what I do. It's somehow a little different to Brancusi's Joy, gentler perhaps. I think over the years you become enured, if that's the right word, to failure, and work with the doubt. You also become better, or sharper at manipulating and mitigating failure, because you aren't frightened of it... I think I have a talent for telescoping ideas and things together, it's what makes my stuff different, but I have no idea where I stand in the scheme of things; doing this with you has helped me a lot. I am never without thinking about the work – obsessive? I'd like to think it would be possible to give it up. What do sculptors do when they retire?... The great thing about showing abroad is getting different views, especially China where there is this combination of hard living and moral appreciation, which fits me... Pleasure, the intellect is a pleasure and so is the physical, it's when they work together, I get success."

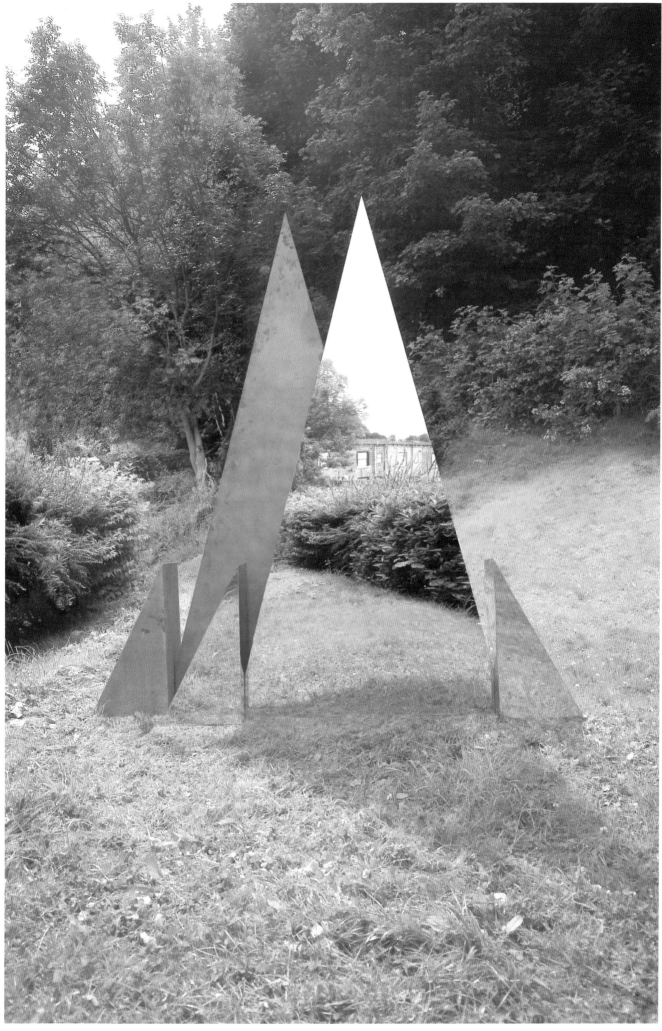

Ladder 2008 Bronze 3 x 1 x 1 m

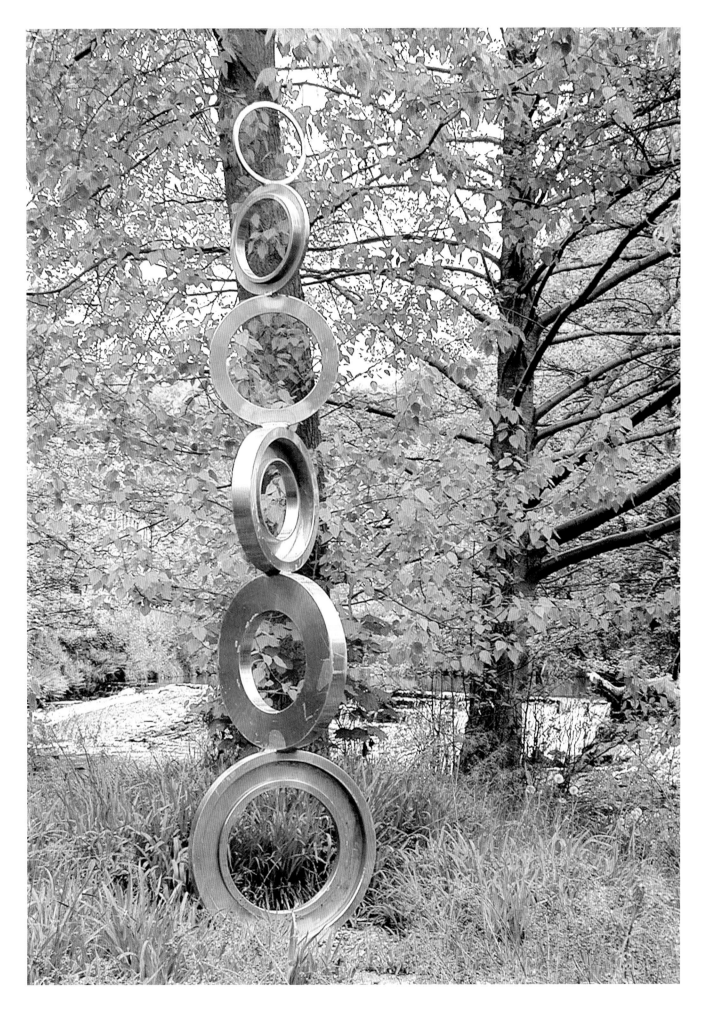

Oil Catcher 2001 Cast Aluminium 4 x 1 x 1m Hebden Bridge UK

'1634'

2005 Stadt Museum, Waiblingen

This installation was commissioned by the Stadt Museum in
Waiblingen, South West Germany in 2005. The title refers
to the year 1634 when most of Waiblingen was destroyed
by fire during the conflicts of the Thirty Years War, killing
or driving out many of its citizens.

The installation consists of a large painted wall panel
stretching from ceiling to floor. On the opposite wall is
another panel of polished stainless steel which acts as a
mirror for the other elements. Three rectangular stones
sit directly onto the wooden floor and further towards
to centre of the room are three bronze stools cast from
original wooden milking stools.

Each element's relationship to the floor is important and
acts as a means of uniting the space in which they all exist.
The solidity of the stone and the density of the bronze
contrast with the multi-layered, vaporous space within
the painting. The intensity of the red evokes the heat of
destruction, whilst its cooler reflection in the steel mirror
implies our distance from it in time.

The space created in 1634 is quiet and contemplative, yet
firmly brings the viewer to a point of reflection with the
events of the past. The weighty presence of the stones,
which are relics from the events of the year 1634, bring a
sobering sense of historical witness to the piece.

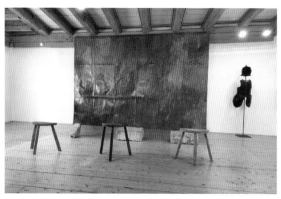

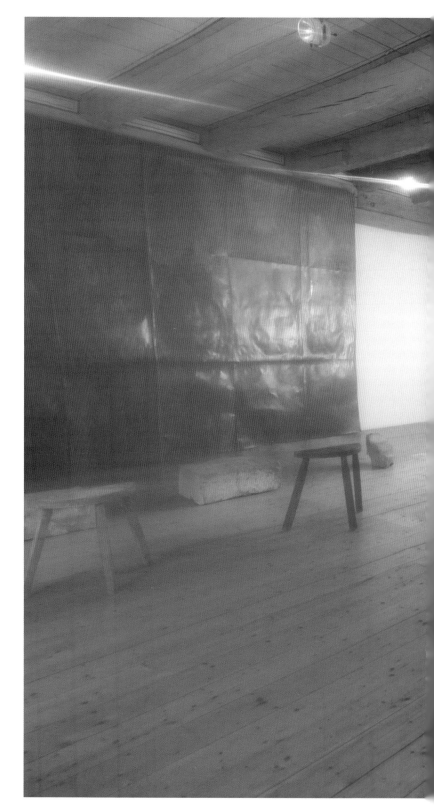

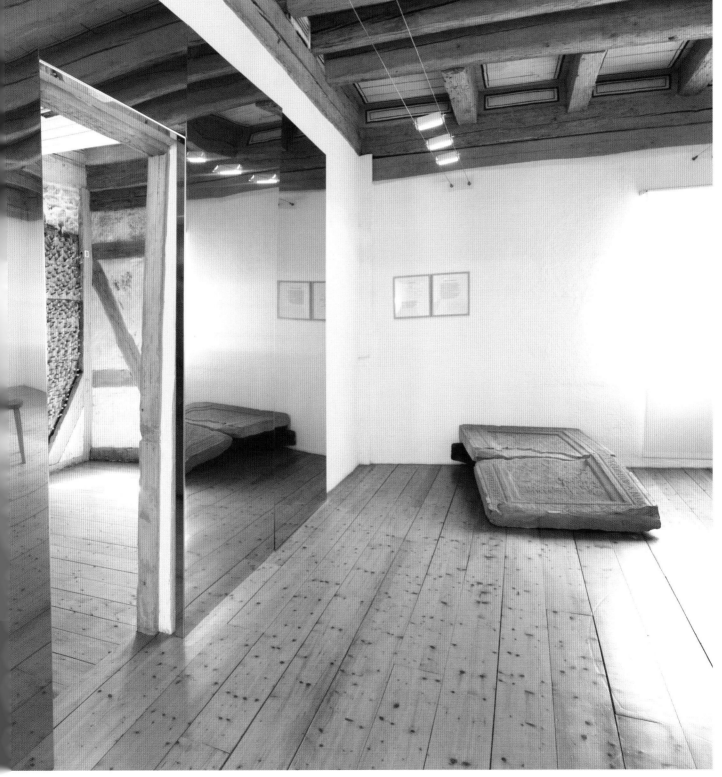

Flower

Visitors to Shang Hai Sculpture Park encounter Flower
at the start of their tour, in a large pond close to the
entrance. The piece has an organic plant-like feel and the
viewer is encouraged in this analogy by the title. It has five
distinct sections which are stacked vertically in an upward
movement accentuated by the water which emerges and
overflows from the cups at the top. Flower was made
quickly and utilises elements such as the skittles, bowl,
cups and stalks which appear in other works by Ward.

Essentially a fountain, the flow of water is controlled by a
pump situated beneath water level which rises via pipes
contained in the vertical skittles and stalks. The large bowl
resting on the surface of the water was modelled in clay
before being cast in bronze, which is the material used
throughout the piece. Whilst the whole has an organic feel,
it also plays with simple geometric ideas, for example half
spheres at the top and bottom with a full sphere in the
centre. The verticality of the piece is emphasised by its
reflection in the water.

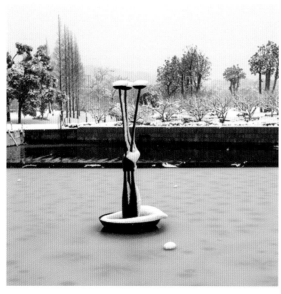

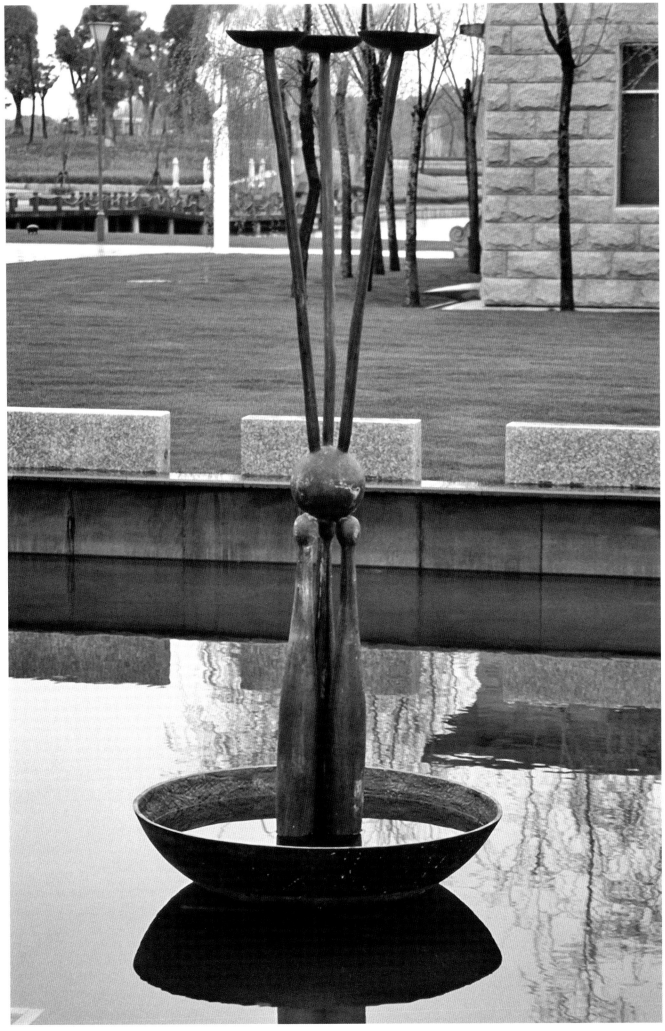

Cathedral 2

Cathedral 2 was commissioned by Peel Holdings for a prominent site in Calder Holmes Business Park, just to the east of the M1 near Wakefield in West Yorkshire. Standing 9 metres high by 6 metres wide and 1 metre deep, Cathedral 2 is constructed from four large triangular sections of mirror polished stainless steel. The outer sections squat up against the two central elements which rise up to echo the spire of nearby Wakefield Cathedral. The piece shares the function of marking out a place - of rising skywards against the horizontal landscape - but Cathedral 2 is not a building. Although it employs architectural ideas - spires, buttresses and scale – it is free from the usual constraints of function and practicality and can instead play with these ideas to aesthetic effect. Cathedral 2 also marks a place of contemplation, literally of reflection but not necessarily in a religious sense.

The forceful verticality of Cathedral 2 is tempered by its shifting surface of light, which is ever changing in response to its surroundings. At times its form is clear and hard edged, at others a transient procession of fleeting reflections. Cathedral 2 succeeds in functioning as an authoritative corporate symbol, whilst retaining the potential for individual contemplation and reflection.

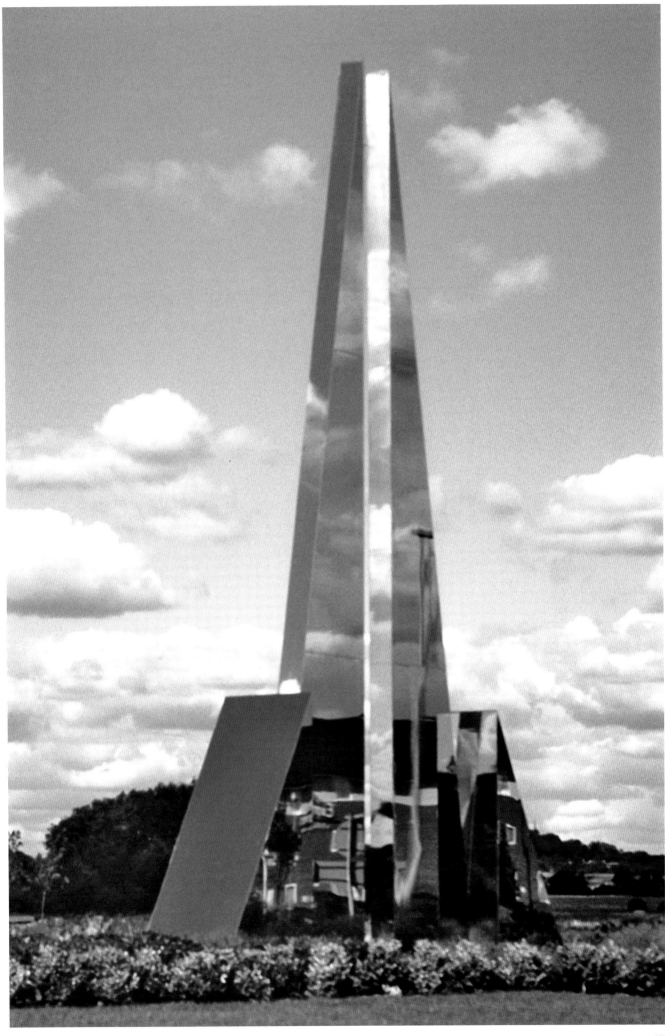

Theatre

2004, Chin Pao San, Taiwan

Theatre arose from the modification and enlargement of an earlier small scale work. The tension in the piece is structured around a series of contrasts in shapes, textures and spatial relationships. The heavy earth-bound pink granite plays against the highly reflective surface of the mirror polished stainless steel, whilst the three spheres contrast with the rectilinear nature of the granite 'entrance'.

The highly reflective convex surfaces of the steel spheres reproduce distorted images of the viewer, landscape, sky and changing weather conditions. If the viewer stands inside the 'entrance' looking outwards he or she can see the smaller spheres reflected in the large one, as well as his or her own image. When the viewer moves the spheres become like screens on which the action is played out and on which the viewer can watch their own intervention in the sculptural space. The two smaller spheres on top of the 'entrance' provide a reflection of the uppermost surface of the granite to the viewer on the ground.

All three spheres produce varied horizon lines which bring into play the elemental balance between earth and sky. The mature tree to the right of the frame was planted especially to enhance the formal quality of the sculpture's setting.

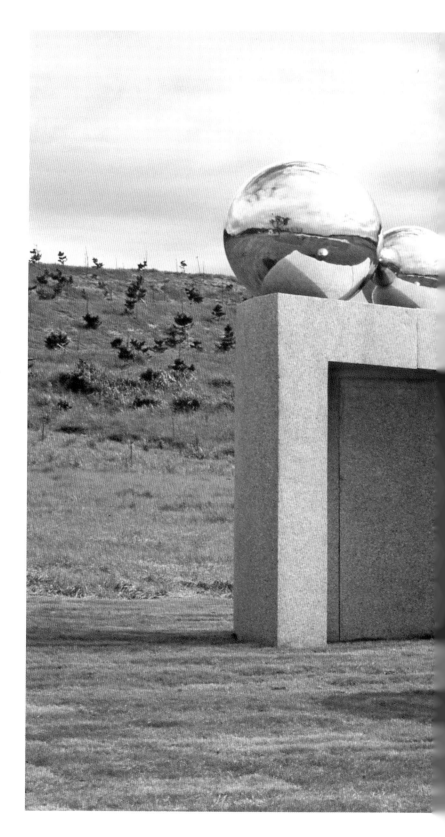

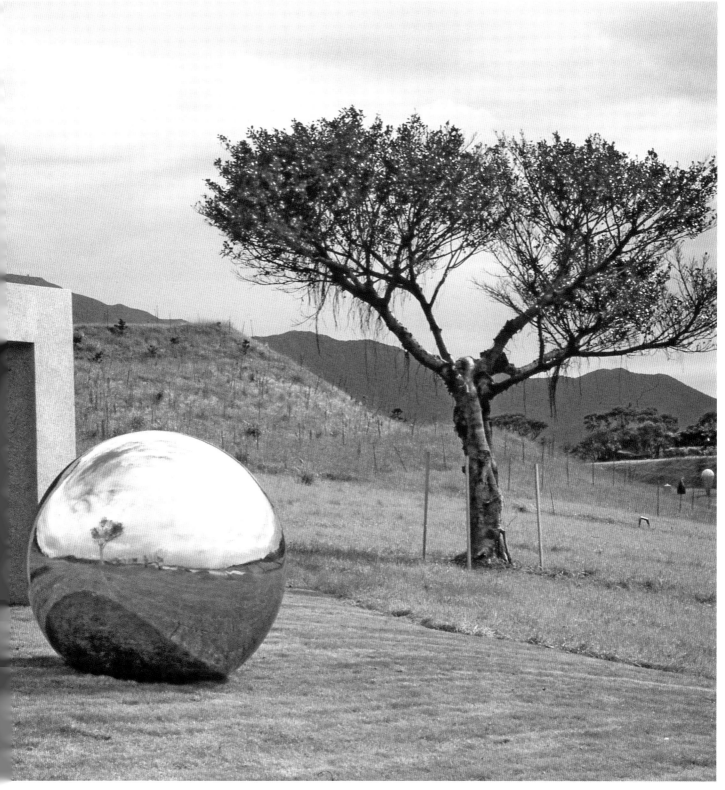

House

2004, Chin Pao San, Taiwan

House is situated at Chin Pao San in Taiwan. Fabricated in mirror polished stainless steel, it stands at a height of 2.5 metres with a width and depth of 2 metres. House belongs to a series of works which explore architectural themes and motifs and has appeared in several versions using different scales, metals and finishes.

House consists of two curved, almost triangular elements which, through their positioning, form the 'walls' of a semi-enclosed space or interior with two doorways in perfect alignment. The outward simplicity of House conceals a subtle complexity of forms such as the tapering thickness of the 'walls' from one side to another and the gently turning angle of the thick planar edge. This unexpected twist to otherwise straight forward forms provides visual and physical interest to the viewer.

In relation to human scale House is large enough to feel like an architectural space and yet not quite like a house; it is too small, has no roof or windows, it is made of steel and the doorways are too small to walk through upright. The space is intimate but not domestic; it envelopes and yet does not entirely confine or protect. The piece poses questions to the veiwer; what is a house and what kind of a house is House?

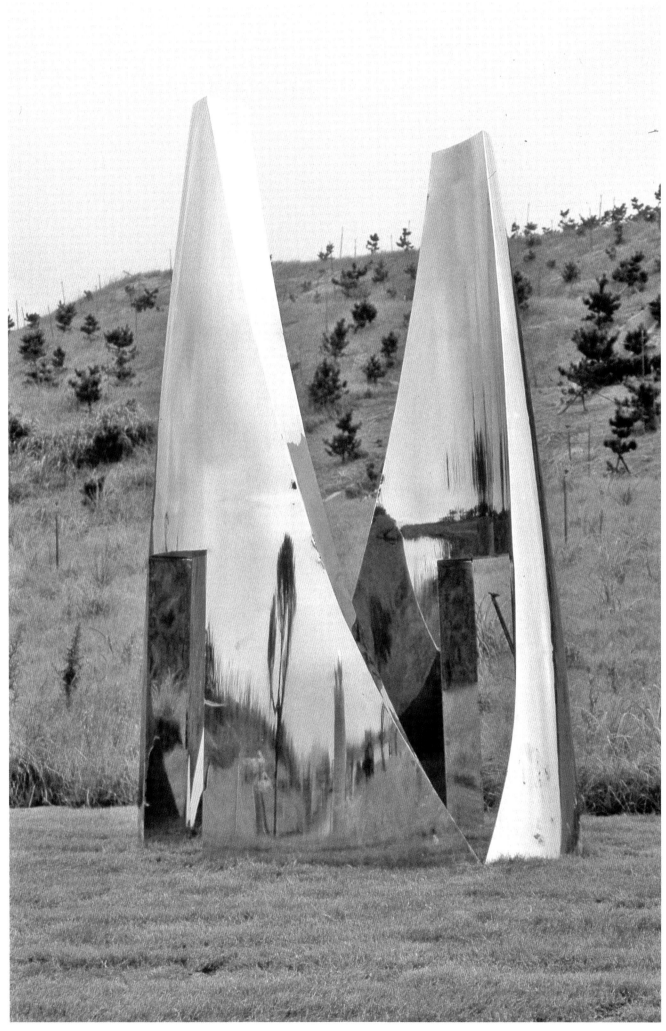

The Bells

2004, Turin, Italy

The Bells stands in the grounds of Castello Aglie, near
Turin in northern Italy. It is 3 metres high and cast in
bronze (the traditional metal for bell making) which
has then been patinated. The vertical sections and
adjoining central circle were cast directly from shapes
drawn into sand. Their rough texture and crude edges
have been retained giving an organic feel to the work
which contrasts with the smooth surface of the three
bell at the top of the piece. The varying upturned
angles of the bells imply they have been frozen at full
peal and yet the lack of clappers suggests only the
memory of their sound.

The three bells at the top are echoed by three vessel
forms at the foot of the work which catch water when
it rains. The whole structure also alludes to a bizzare
body with three open 'mouths' at the top, a long trunk
and three 'feet' at the bottom. The piece plays with the
idea of linear containment of space or framing, whilst
the dish and bell forms expand the sense of volume
and three-dimensionality.

The viewer is almost forced to consider the significance
of bells as the title and the inclusion of bells within the
piece, bring this reference to the foreground. Bells are
used in many cultures across the world as a means of
communication, for religious or other ritual, in music,
and for their supposed magical powers. The tulip shape
of the bells in this work identifies them clearly as
western bells.

The Bells is a curious and slightly absurd piece of
work. Its structure alludes to a body of some kind;
Simultaneously it resembles a mysterious prop for
some unexplained ritual or task.

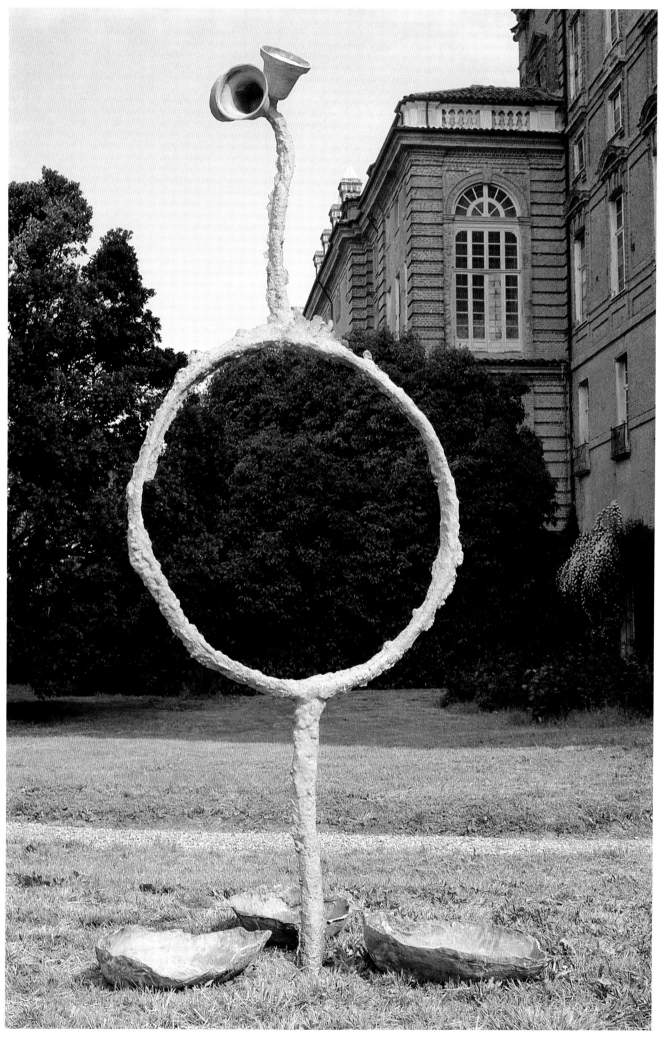

Philosophical Sculpture

2000, Guilin, China

Philosophical Sculpture was made for an ambitious
sculpture park in the Guilin region of southern China. It
stands 3 metres high and is fabricated in stainless steel.
Its basic form is a partial striding figure balanced on the
fulcrum of a cross beam and reminiscent of the colossi of
the ancient world. This type of balance scale is one of the
oldest and most accurate with which humans have weighed
elements of their world and is often used to symbolise
justice and moral judgement. The title also alludes to the
ancients, as Greek philosophy forms the basis of Western
thought.

The work combines geometric and organic shapes by
stacking and balancing elements on top of one another.
The lower conic element is a square-based polyhedron,
the apex of which forms the balance point for the cross
beam. At opposite ends of the beam sit a cube and a circle.
The wavy edges of the striding figure intersect with the
surrounding space suggesting possible continuity beyond
its visible boundary. Compared to the other elements
the figure is indeterminate and incomplete and presents
a powerful yet unpredictable presence amongst the rule
bound geometric shapes. Although the majority of the
forms are geometric it is the 'figure' which takes up a
dominant central position critical to the balance of the
whole piece.

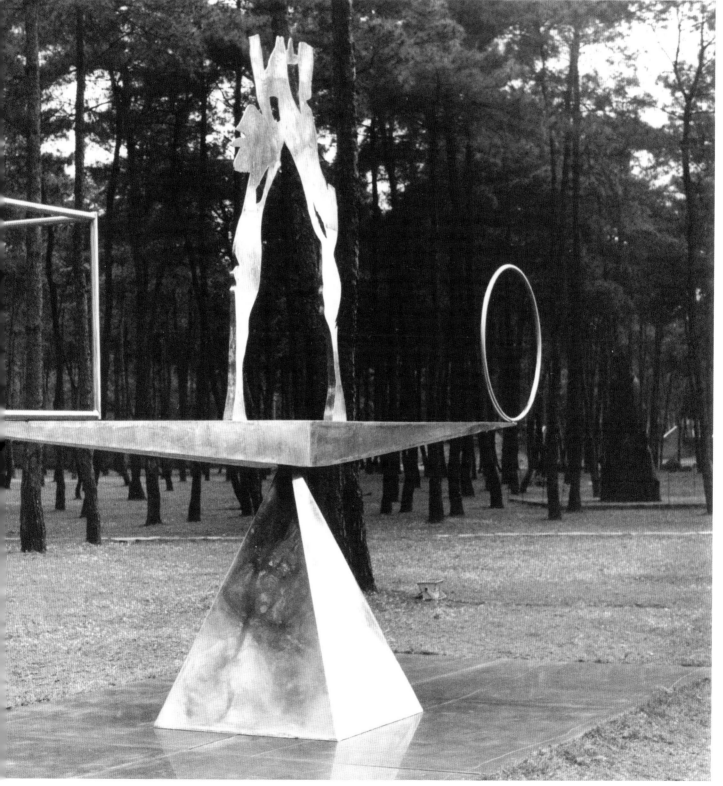

Striking Red

2005, Yuzi Paradise, Guilin, China

As with much of Ward's work, Striking Red explores the relationship between the two dimensionality of surface and the three dimensionality of form, especially where one changes the nature of the other through its proximity. It uses some of the same sculptural elements as the earlier work House but produces a piece with a very different character. Where House explores the idea of containment and intimacy, Striking Red opens outwards toward its immediate and wider surroundings. Its central section is constructed from the same large, triangular elements, which bend and taper towards the edges. Its curving surfaces are painted in primary red, blue and yellow, enhancing the clarity of form and contrasting with the distorted reflections in the steel balls. As the viewer moves around the outside of the work, these primary colours are viewed in changing conjunctions facilitated by the space through the central 'doorway'. This gives a view of the opposite steel ball which acts like a mirror to bring the far side of the work into simultaneous view.

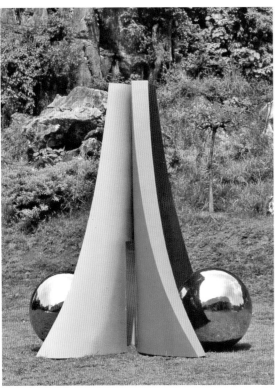

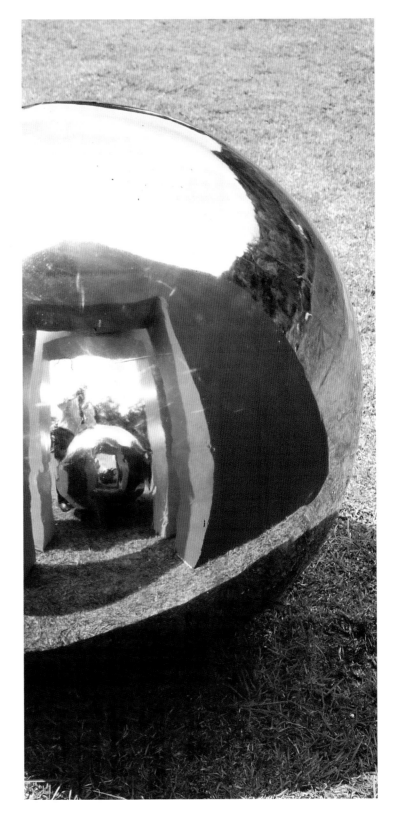

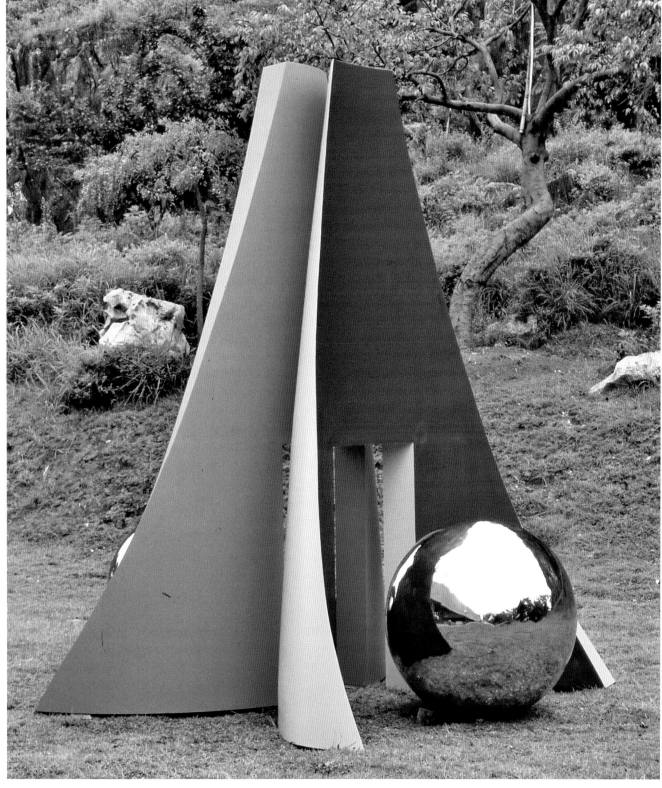

Pool

2005, Florida, USA

Pool is a large scale sculpture commissioned by Menin
Developments for a pre-defined site on a new build
in West Palm Beach, Florida. Fabricated in stainless
steel, Pool stands 3 metres high, 2 metres wide and an
impressive 22 metres long. Ward describes the piece as
a water sculpture rather than a fountain as the use of
water is based on a gentle trickle and flow rather than the
ostentatious spurt of a fountain.

At each end of the work is a large cubic form with flat
back and stepped front, on top of which sits a further
rectangular cube. The water exits from the highest section
and trickles down all sides of the work where it is collected
by a channel running forward into the rills at ground level
which slope slightly towards the centre with a collecting
tank beneath. At night the sculpture is lit by two rows of
lights at each end.

The end sections of Pool are based on the ancient Eastern
form of a ziggurat. Ziggurats were stepped constructions
topped by shrine or temple, usually forming part of a
larger religious complex. In Pool the reference to Eastern
design motifs is also seen in the rills which are often used
as important symbolic features of purity and life-giving in
Islamic architecture. Use of water in this piece creates a
unity between man made structure and the natural world
and introduces an aural dimension for the viewer.

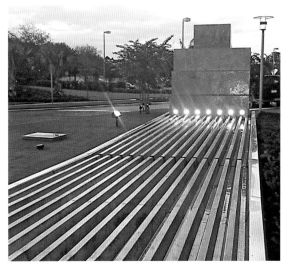

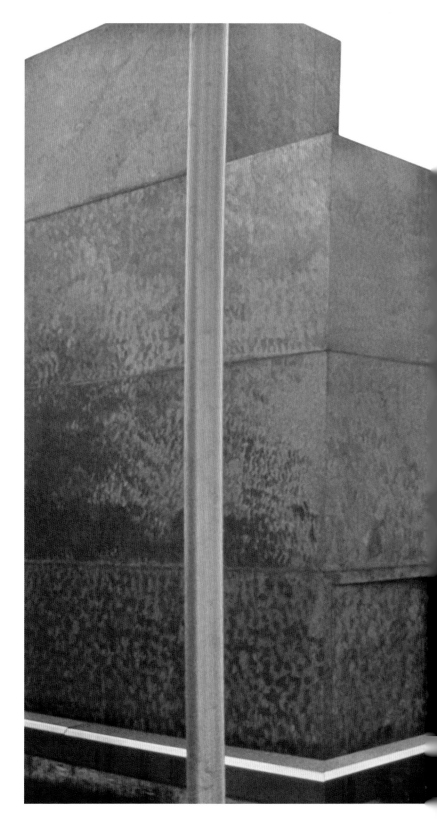

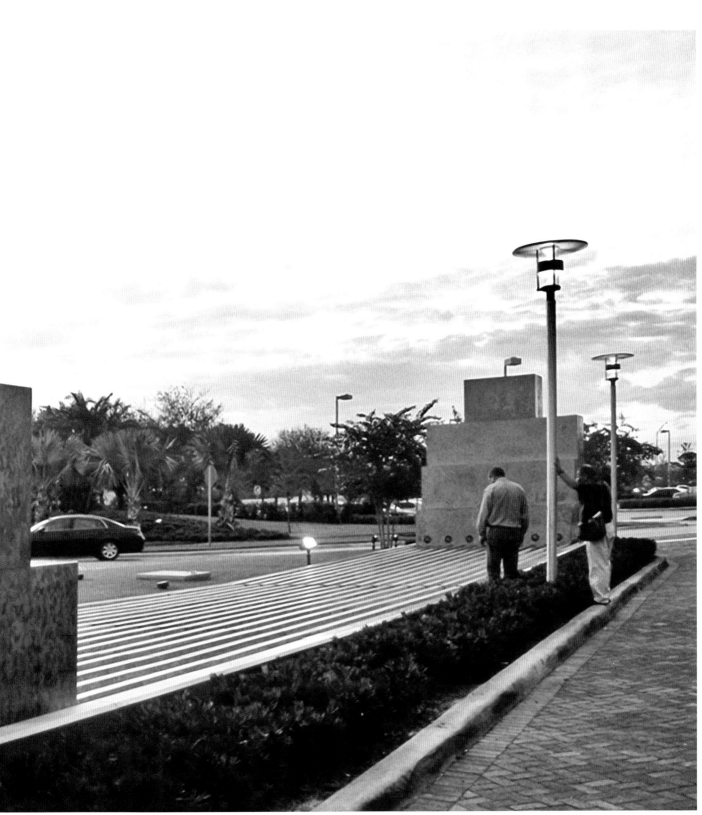

Palace

2005, West Palm Beach, Florida USA

This large scale work was commissioned by Menin Developments for a new build at Down Town at the Gardens in West Palm Beach. Enlarged to an architectural scale, the idea originated from a show of small sculptures based on discarded industrial patterns (wooden block moulds) used to produce engineering components. Palace is fabricated in stainless steel and finished in cross-hatched satin. In this piece Ward avoided the high mirror polish of other works in favour of a more subtle surface, which intensifies rather than fragments its forms.

Circles, cylinders, squares and cones are the basic geometric elements which are stacked together to create a grand and unusual fountain. The elegance of its form is realised through a careful use of balance and symmetry which articulates a sense of both solidity and lightness. The pool in which the whole piece sits also acts as the reservoir from where water is pumped via a central pipe up to the very apex of the cupola. Here it exits to trickle down over the curving metal until it returns to the collecting pool at the bottom.

As in other works by Ward, the cupola, use of water and title may be read as gentle references to eastern architectural forms.

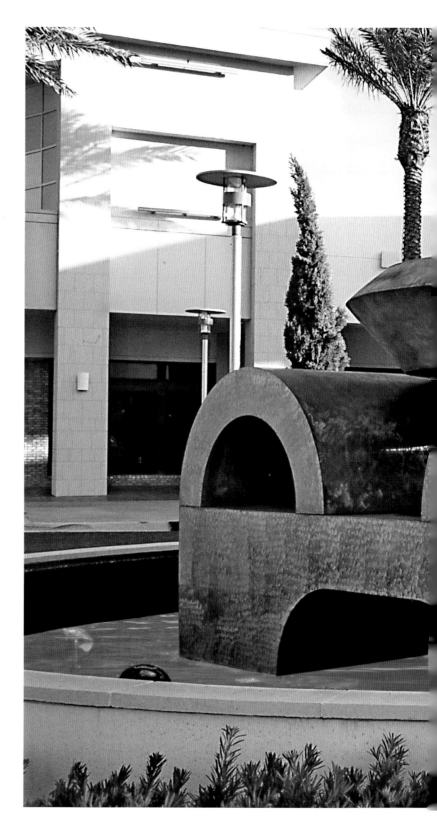

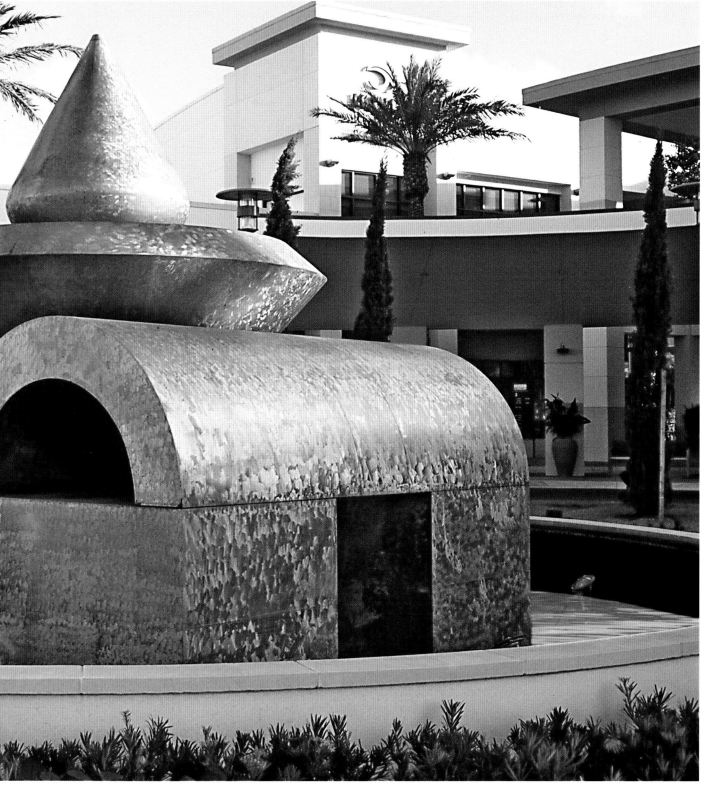

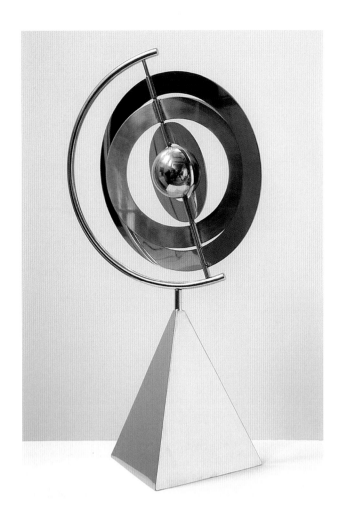

Left page clockwise from top:

Orary, Patterns 2004 Polished Stainless Steel 64 x 25 x 25cm

Collection Centre for Enquiry. Mass. U.S.A

Door, Patterns 2004 Polished Bronze 32 x 10 x 24cm

House, Patterns 2004 Polished Bronze 32 x 20 x 24cm

Collection of Andrea Mack California U.S.A

Right page clockwise from top:

Ship of Fools 2006 Shanghai Sculpture Park 2,5 x 5 x 5m

Wall 2004

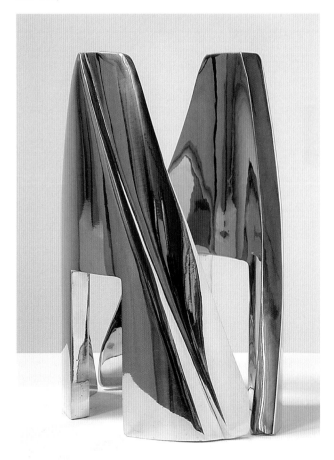

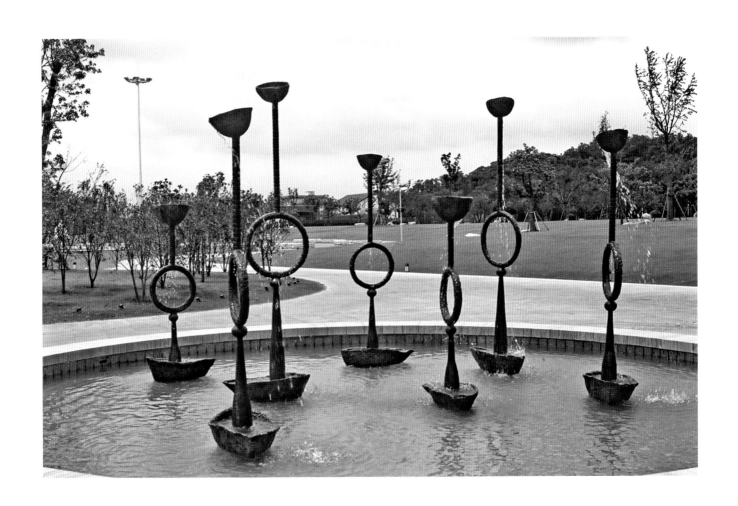

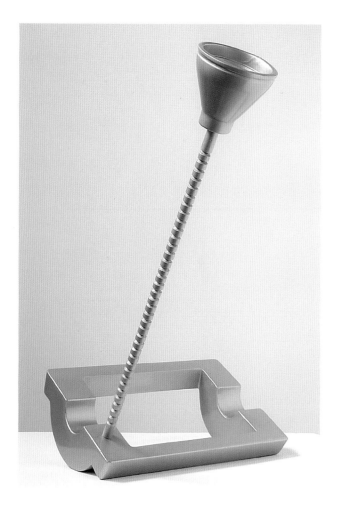

Left page clockwise from top:
Rocker (2) Patterns 2004 Cast painted Aluminium 70 x 24 x 36cm
Fantasy Tower, Patterns 2004 Polished Bronze 33 x 15 x 26cm
House 2, Patterns 2004 Polished Bronze 32 x 20 x 24cm

Right page:
Inversion Patterns 2004 Cast Painted Aluminium 70 x 45 x 14cm

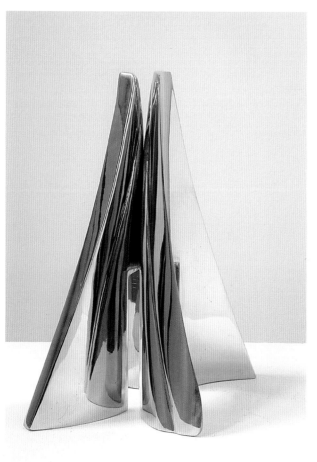

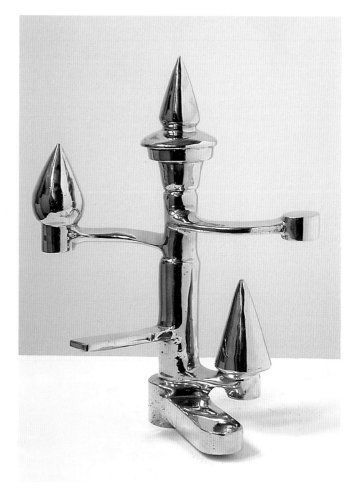

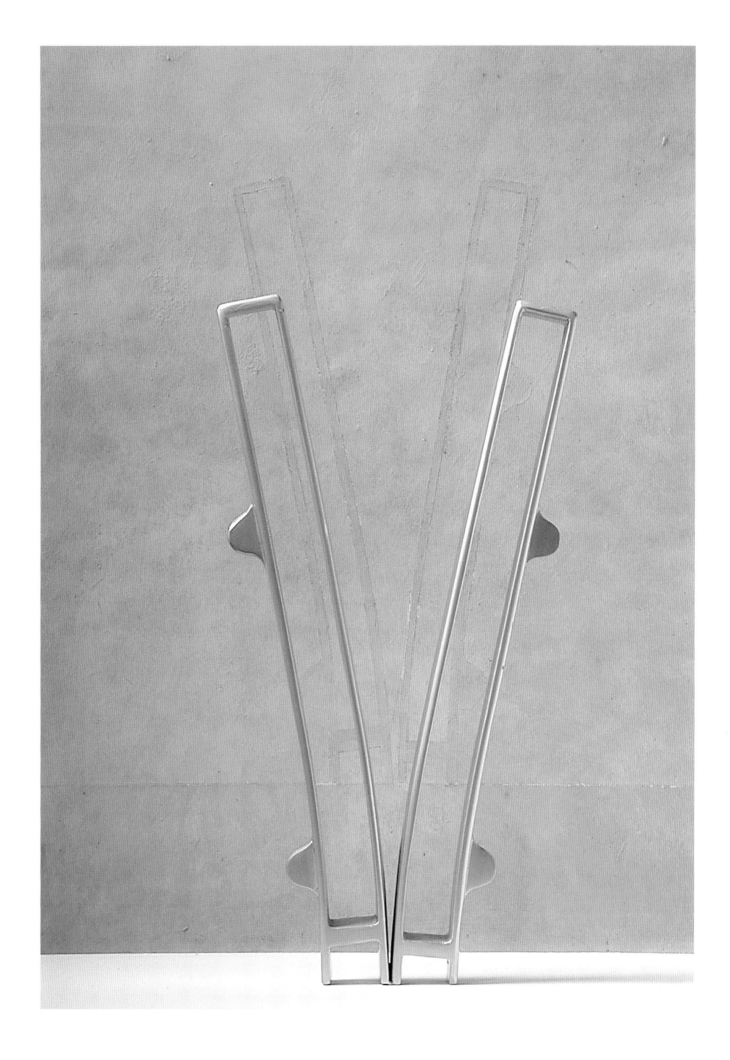

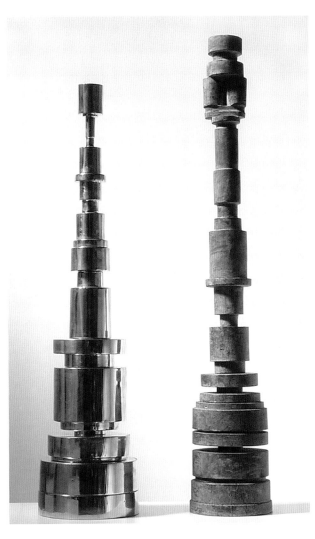

Left page clockwise from top:

Adam and Eve 2004 Polished and Patinated Bronze

Adam 100 x 15 x 18cm Eve 90 x 18 x 18cm

Small Sculpture Patterns 2004 Polished Bronze 41.5 x 16 x 23cm

Fountain Patterns 2004 Cast Iron 52 x 26 x 26cm

Right page:

One Patterns 2004 Cast Painted Aluminium 85 x 45 x 10.5cm

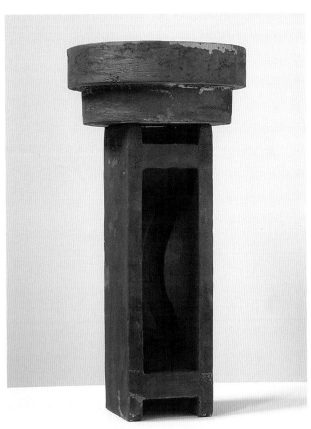

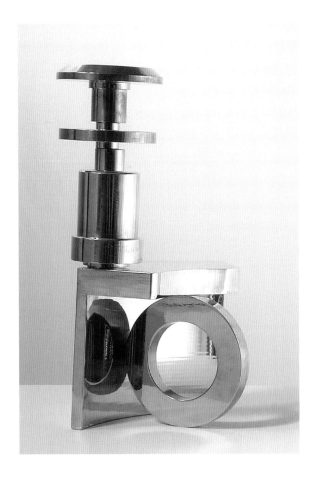

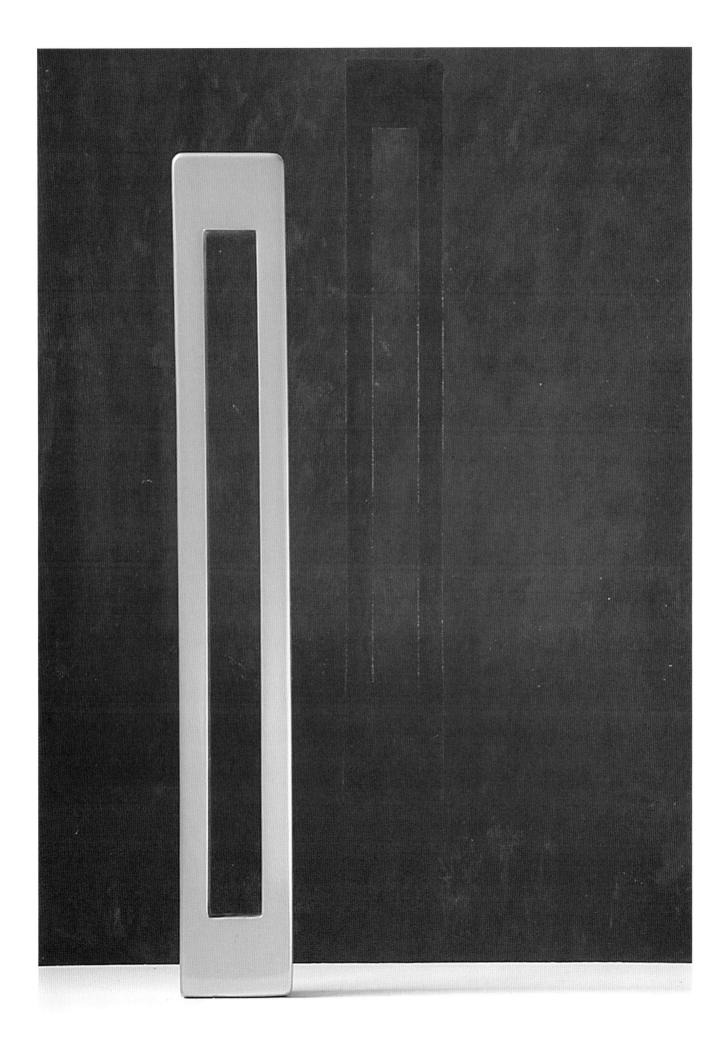

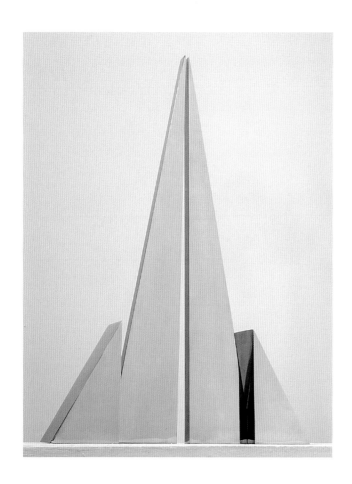
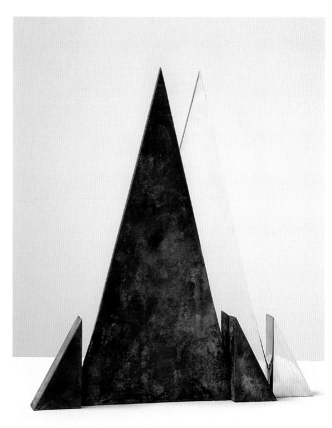

Left page clockwise from top:

Cathedral, Patterns 2004 Mirror Polished Stainless Steel 59 x 7 x 40cm

Twin Spires Patterns 2004 Polished and Patinated Bronze 38 6 x 34cm Collection Lydia and Paolo Scartozzi, Turin, Italy

Palace Patterns 2004 Cast Painted Aluminium 33 x 21 x 24cm Collection Mark Whitaker, UK

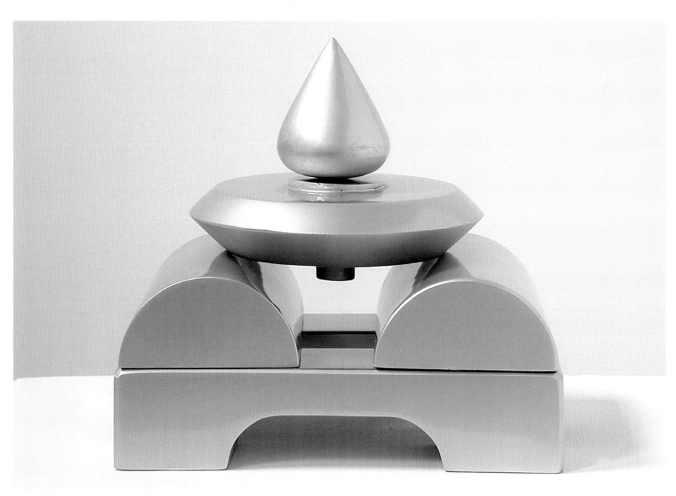

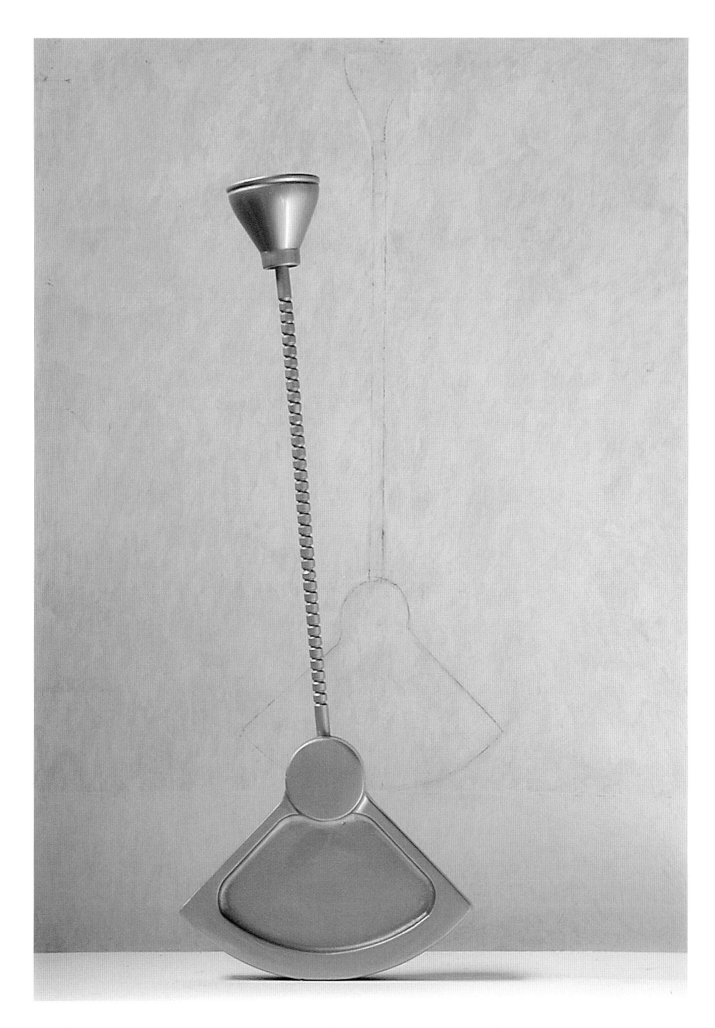

Rocker (i) Patterns 2004 Cast Painted Aluminium 90 x 4 x 30cm (Drawing only - Collection Patricia Bottalo, Turin, Italy)

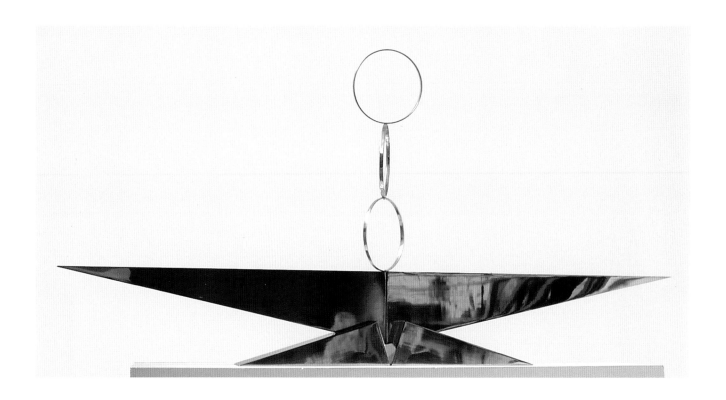

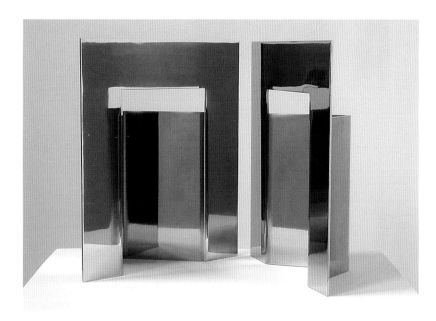

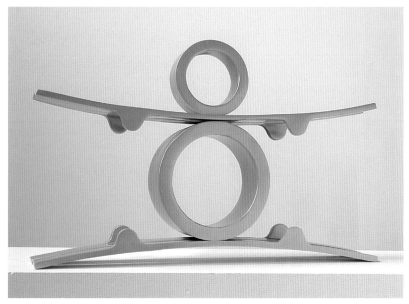

Left page clockwise from top:
Bird in Space
Gate 2004 Collection of
Adrian Gasser and Markus Frei Switzeland
Balancing Form

Right page:
Monument 2004

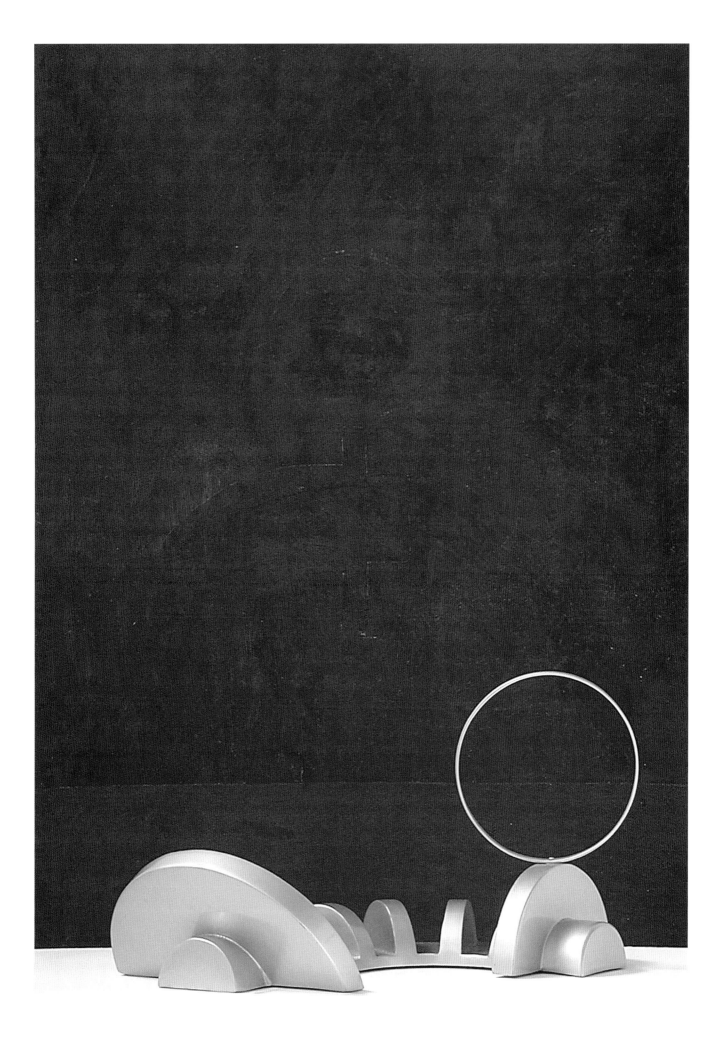

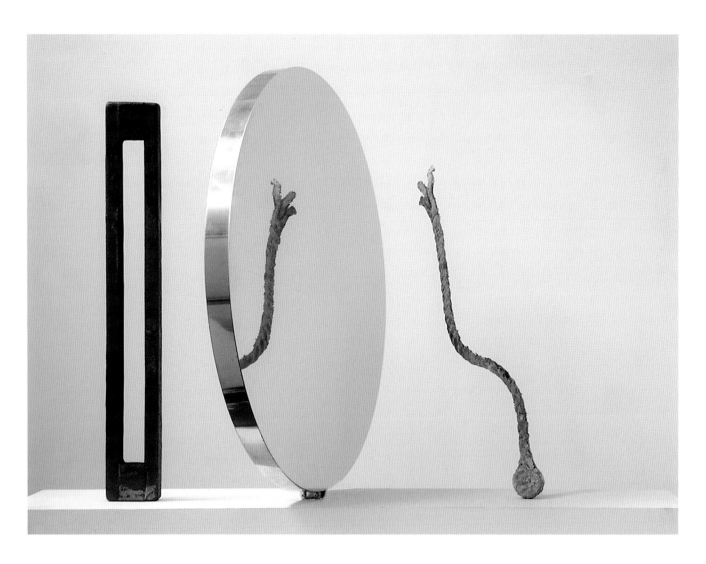

Left page clockwise from top:
Definitive ideas for Sculpture in Landscape 2004
Bath 2004

Right page:
Bridge Tower 2004

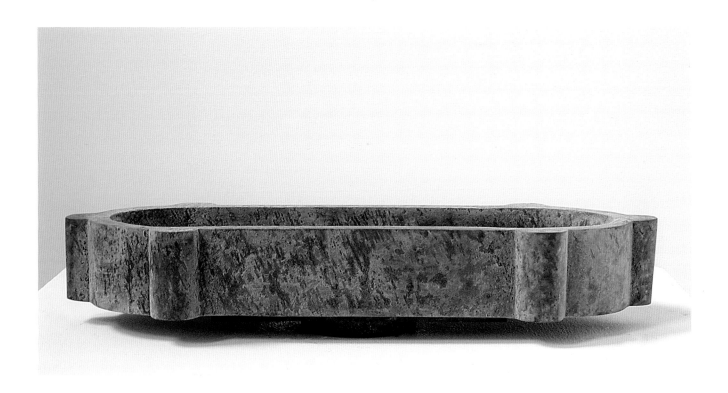

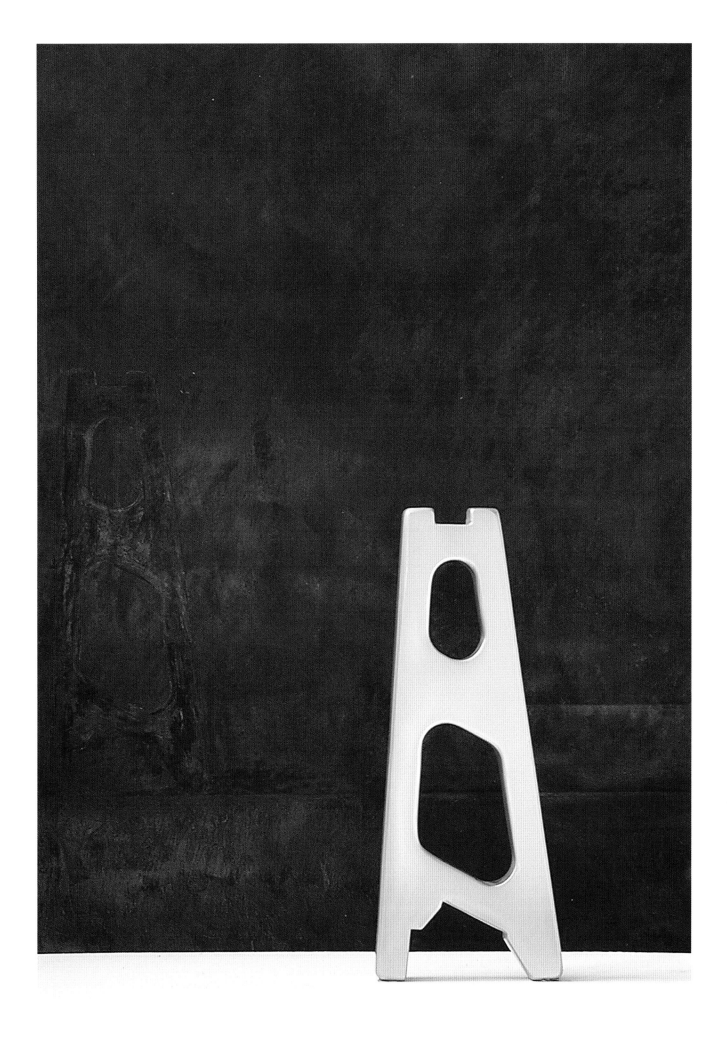

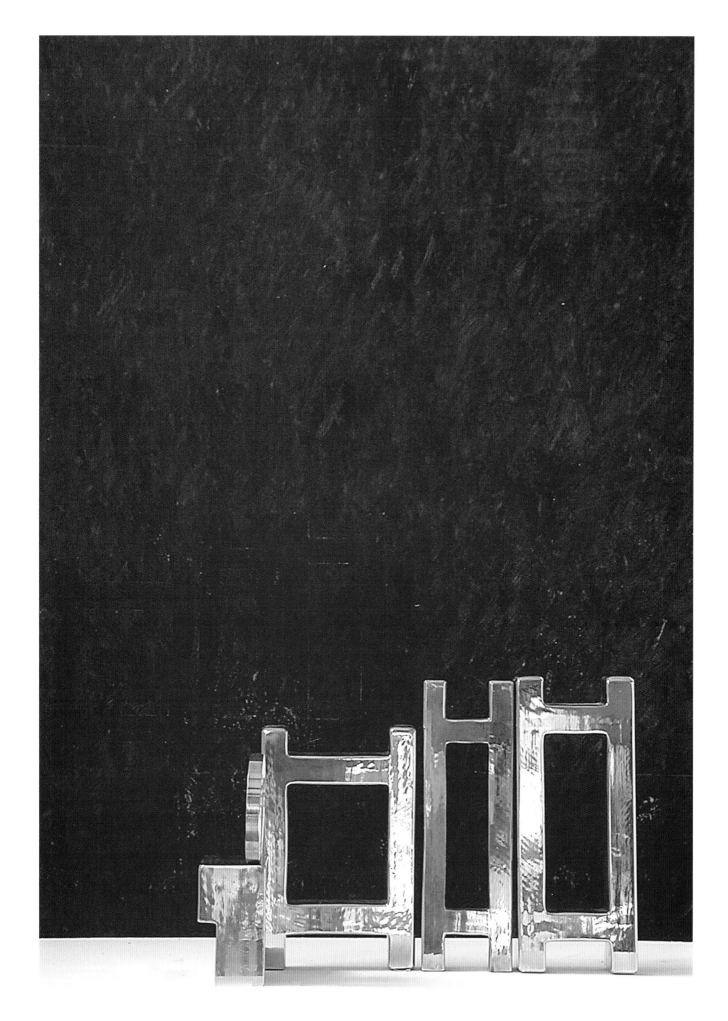

Screen 2004

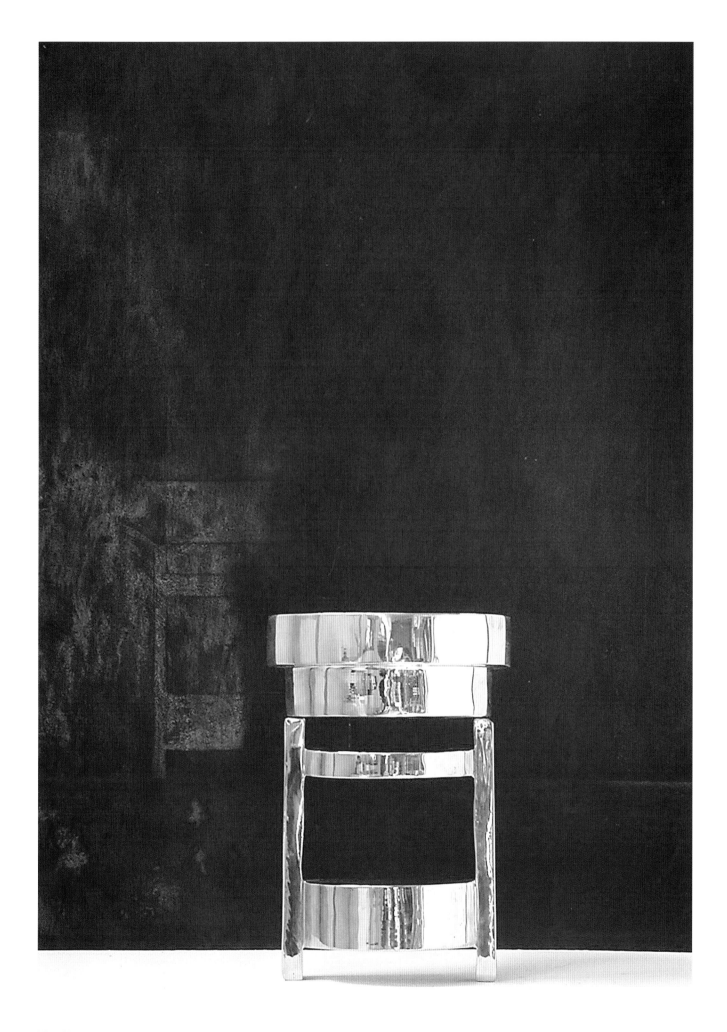

Water Tower 2004

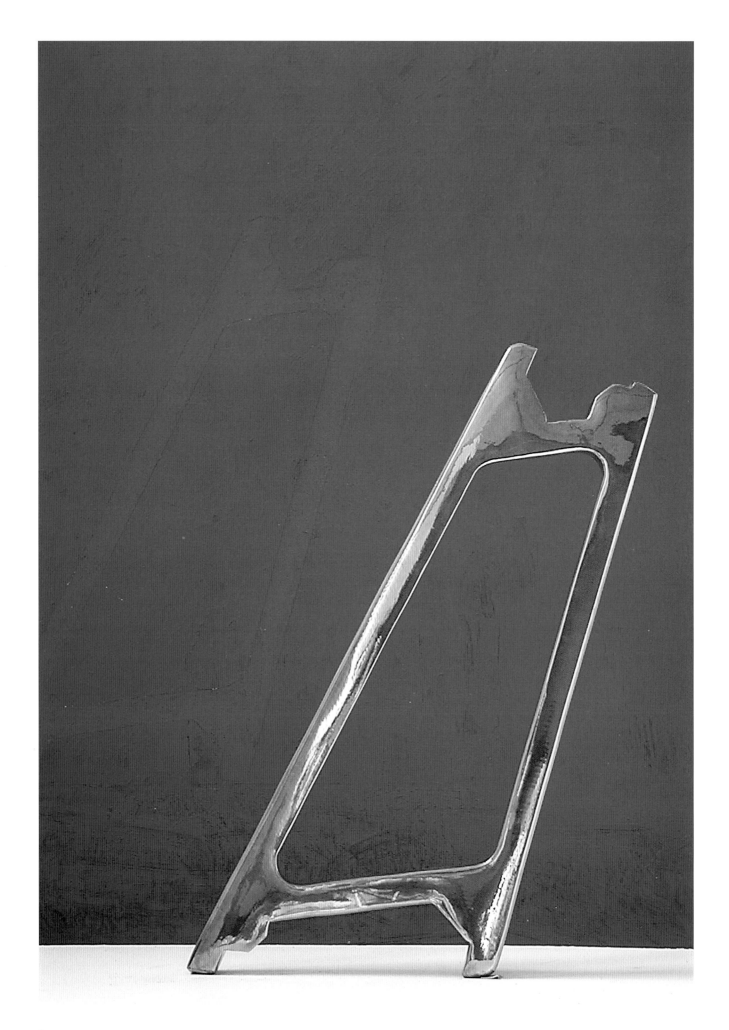

Buttress 2004

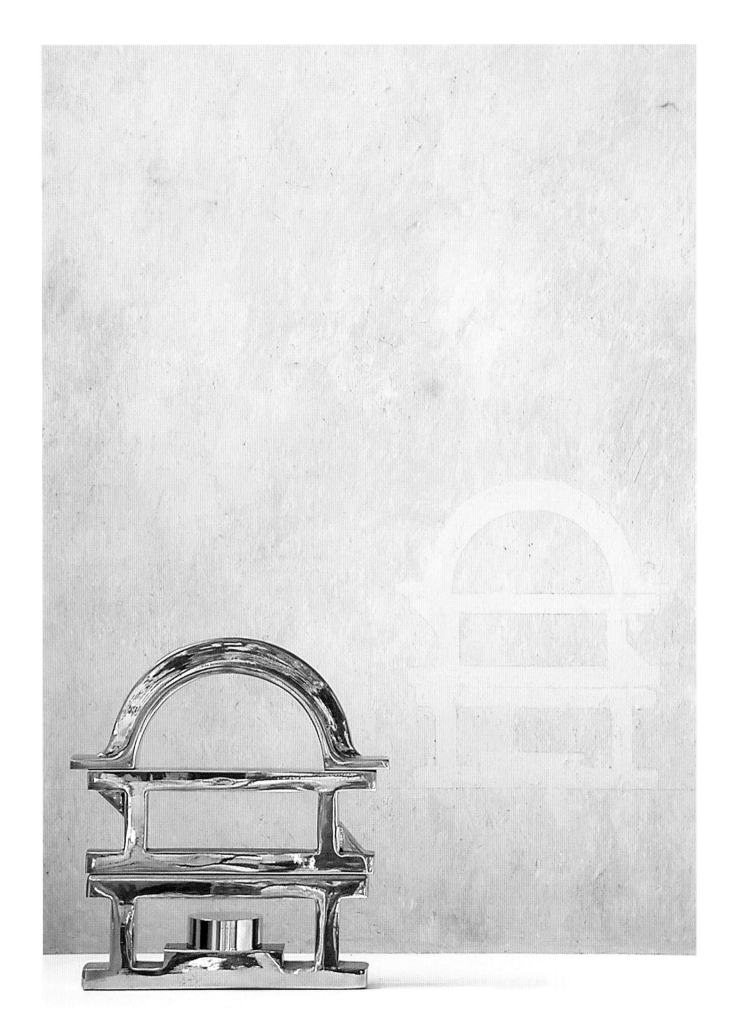

Patterns 2004 (Gates of Paradise. Collection Rossana Moielli, Rivoli, Italy)

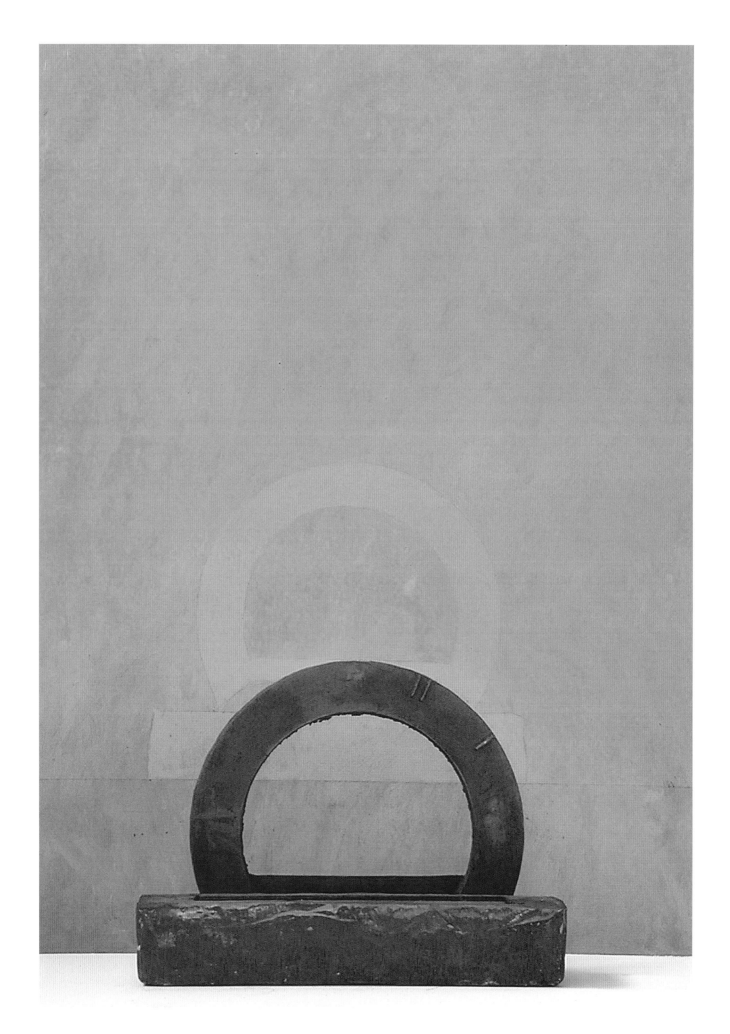

Water Clock 2004

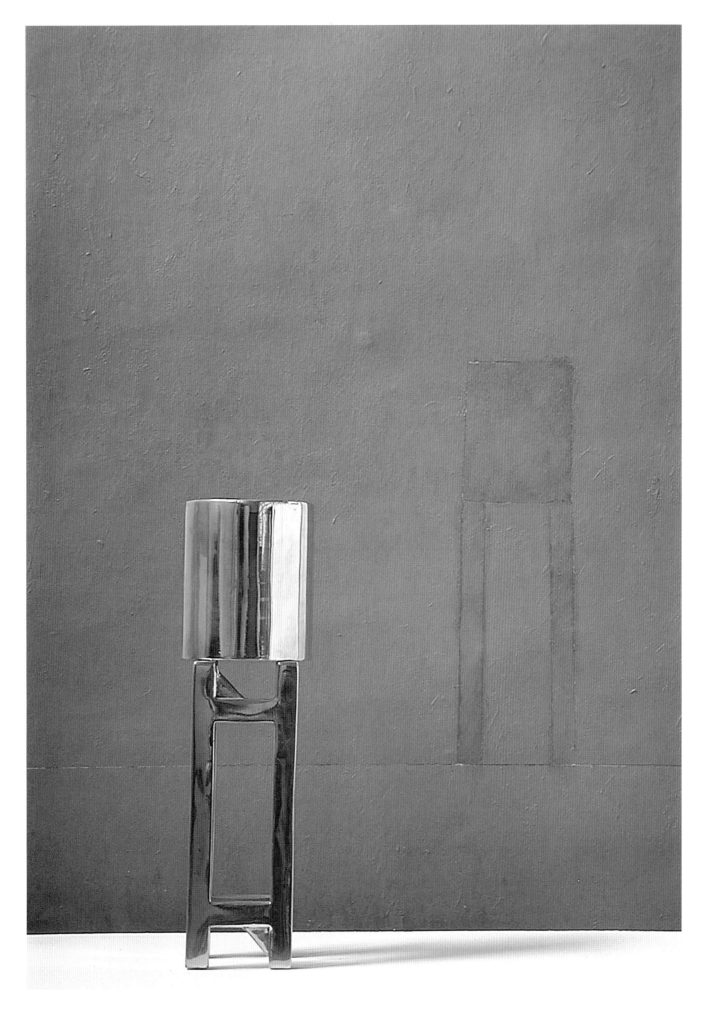

Water Tower Patterns 2004 Polished Bronze 47 x 11 x 12cm

Left page clockwise from top:

Untitled 1998 Pigment on KK Paper 124 x 90cm

Untitled 1998 Acrylic on KK Paper 124 x 90cm Collection Carol Barker Lister

Untitled 2002 Pigment on Ceramic Paper 124 x 90cm

Round The Yellows 2002 Acrylic On KK Paper 124 x 90cm

Right page:

Complex Natura Morte 2002 124 x 90cm

Left page clockwise from top:

3 Colour Split 2003 Acrylic on KK Paper 124 x 90cm

3 Colour Split 2003 Acrylic on KK Paper 124 x 90cm

3 Colour Split 2002 Pigment on KK Paper 124 x 90cm

3 Part Split 2003 Acrylic on KK Paper 124 x 90cm

Right page:

3 Colour Split 2003 Acrylic on KK Paper 124 x 90cm

3 Colour Split 2003 Acrylic on KK Paper 124 x 90cm

Brazil 2003 Pigment on KK Paper 124 x 90cm

Clockwise from top:
Different Places 2006 White Marble
Different Places 8, 2006 White Marble
Different Places 9, 2006 White Marble
Different Places 10 2006 White Marble

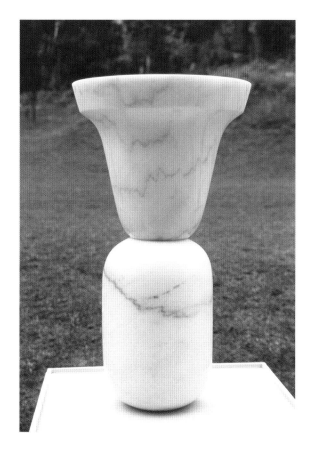

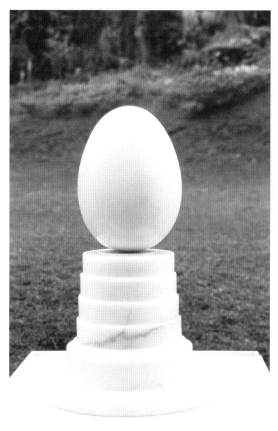

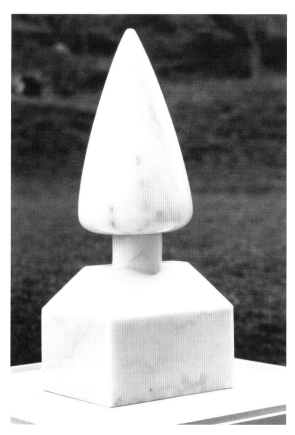

Clockwise from top:

Different Places 11 2006 White Marble

Different Places 12 2006 White Marble

Different Places 13 2006 White Marble

Different Places 14 2006 White Marble

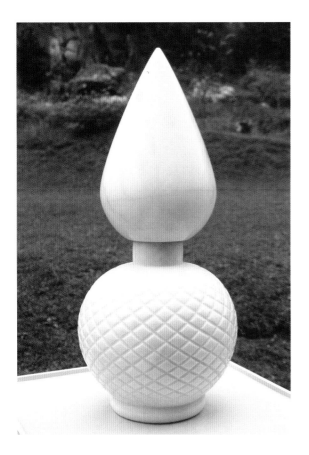

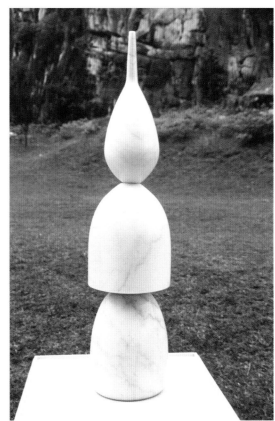

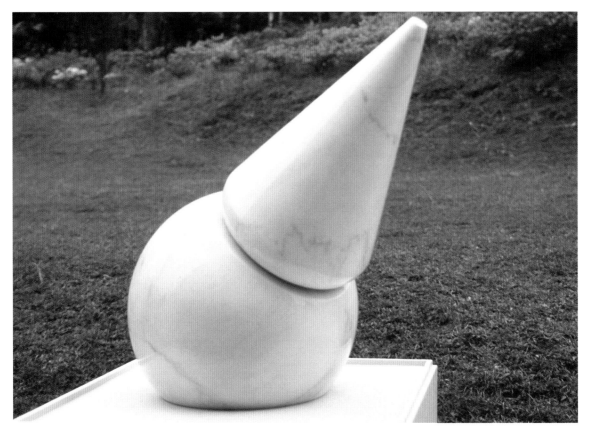

Clockwise from top:
Different Places 1. 2006 White Marble
Different Places 3. 2006 White Marble
Different Places 6. 2006 White Marble

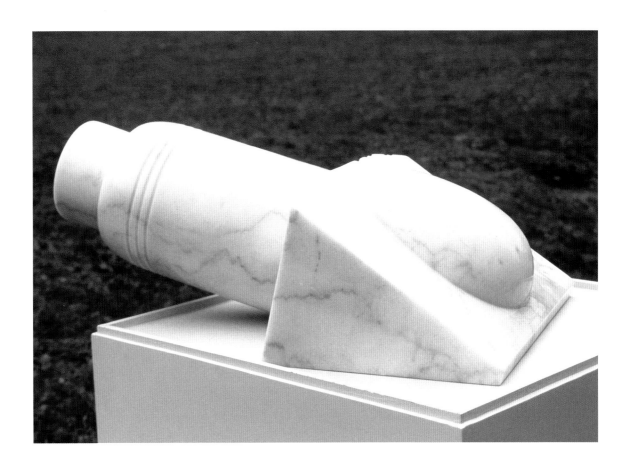

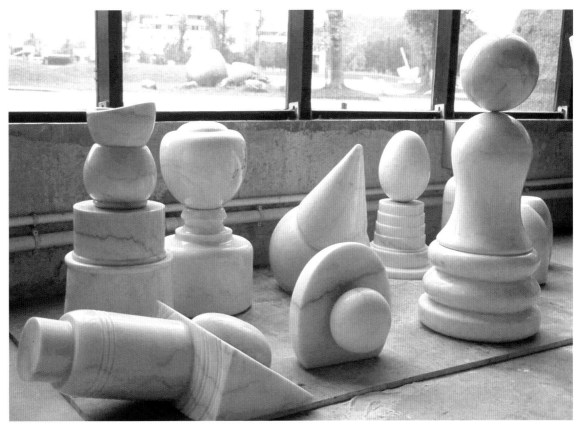

Clockwise from top:

Different Places 15 2006 White Marble

Stress 2006

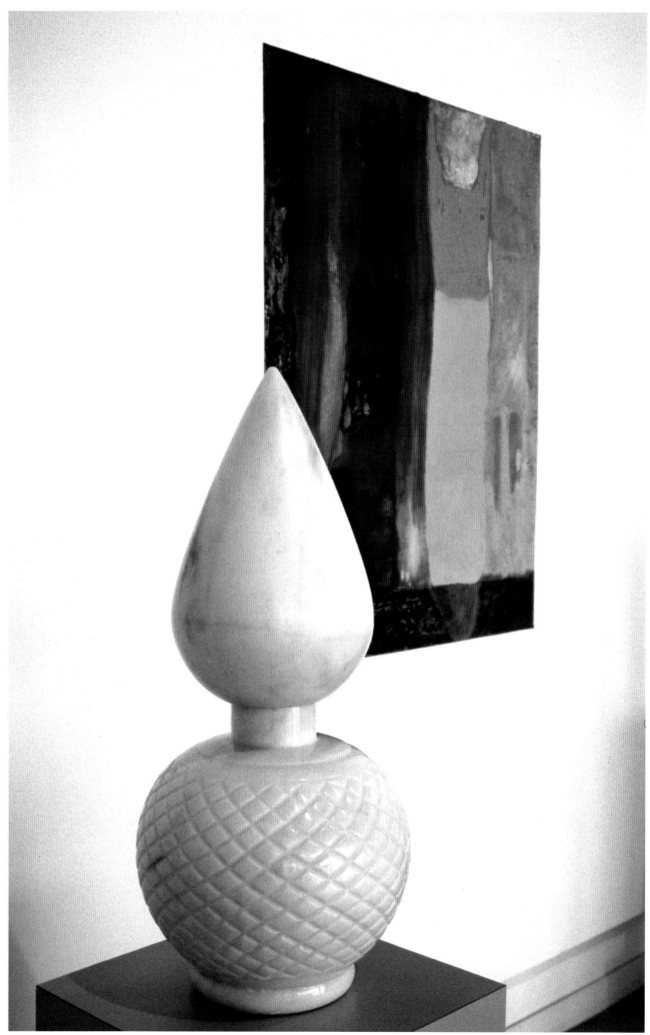

Left page clockwise from top:

Smotherfly 3. 2007 Pigment on KK Paper 49 x 35.3:4 inches

Smotherfly 4. 2007 Pigment on KK Paper 49 x 35.3:4 inches

Smotherfly. A River Runs Through 2007 Pigment on KK Paper 49 x 35.3:4 inches

Smotherfly. Windmill Lane 2007 Pigment on KK Paper 49 x 35.3:4 inches

Right page:

Diffrent Places Shanghai Sculpture Park 2007

Smotherfly 2. 2007 Pigment on KK Paper 90 x 76cm

Smotherfly, And The Birds Began To Sing 2007 Pigment on KK Paper 90 x 76cm

Left page clockwise from top:

Smotherfly 6. 2007 Pigment on KK Paper 90 x 76cm

Smotherfly 7. 2007 Pigment on KK Paper 90 x 76cm

Smotherfly. Cuckoo 2007 Pigment on KK Paper 90 x 76cm

Smotherfly. Cat and Dog Pond 2007 Pigment on KK Paper 90 x 76cm

Right page:

Smotherfly 8. 2007 Pigment on KK Paper 90 x 76cm

Smotherfly 9. 2007 Pigment on KK Paper 90 x 76cm

Smotherfly 10. 2007 Pigment on KK Paper 90 x 76cm

Smotherfly 12. 2007 Pigment on KK Paper 90 x 76cm

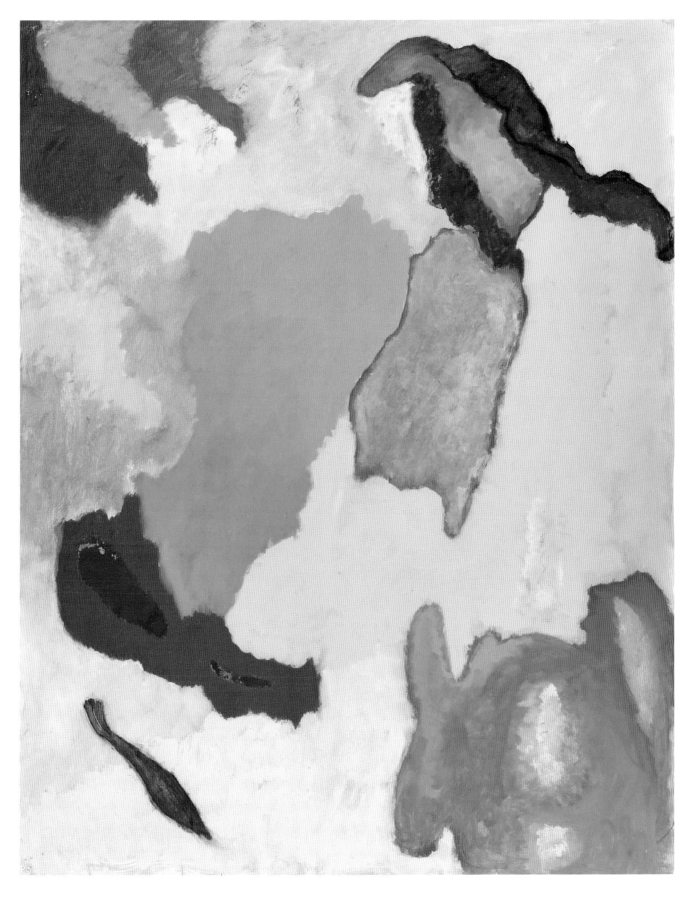

Smotherfly. 2007 Pigment on KK Paper 90 x 76cm

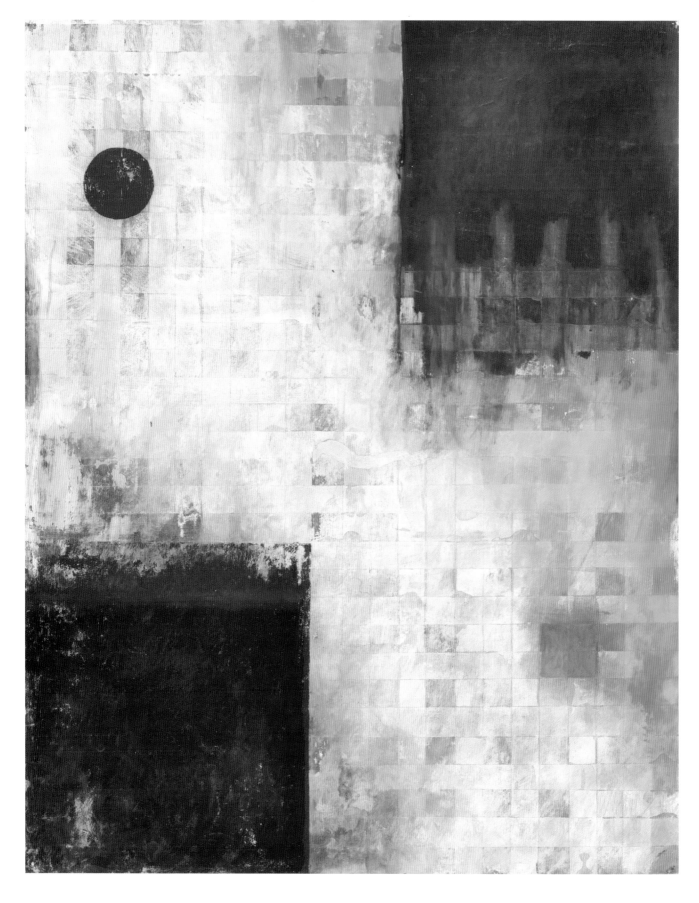

Smotherfly 1, 2007 Pigment on KK Paper 90 x 76cm

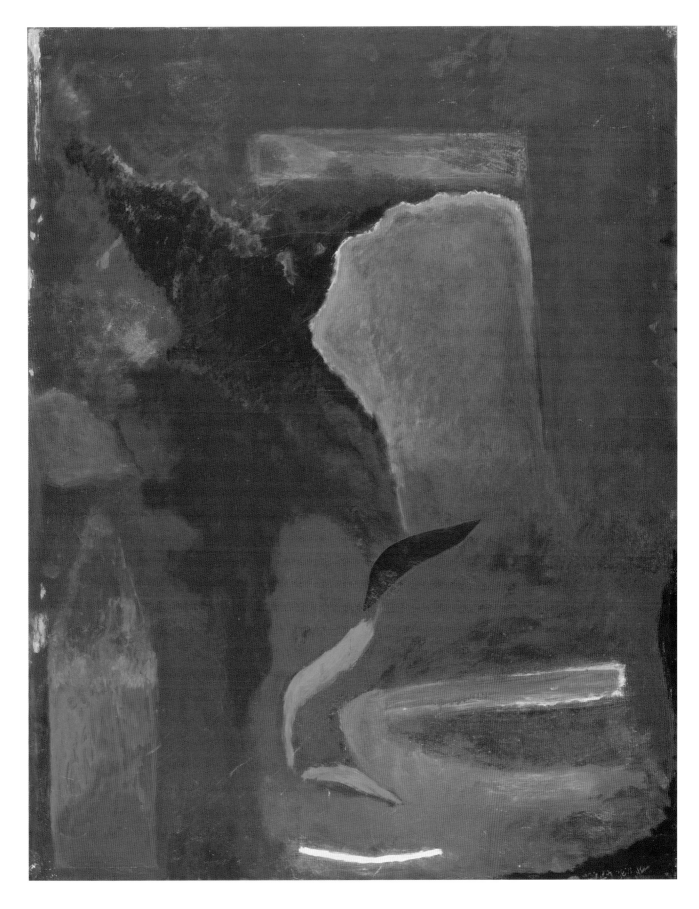

Smotherfly 14, 2007 Pigment on KK Paper 50 x 76cm

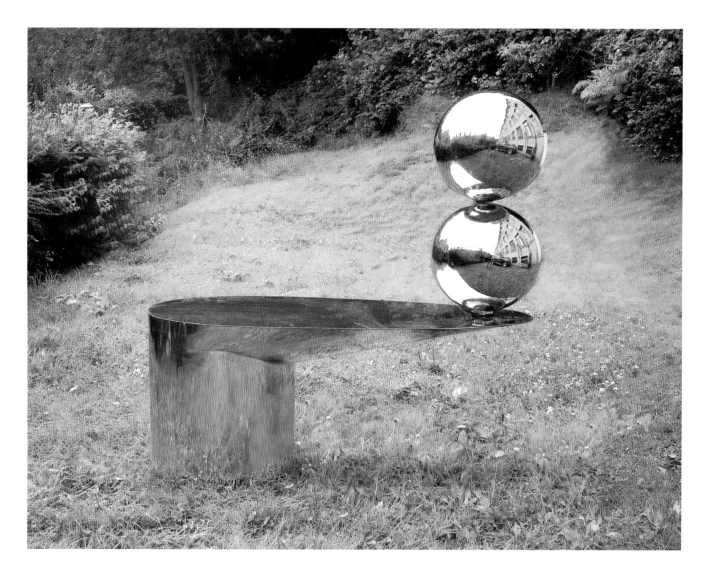

Left Page:
Shoe 2006 Stainless Steel 115 x 30 x 130 cm
Tiddle-I-Po 2005 Wood 65 x 280 x135cm

Right page:
Inversion 2004
Stainless Steel 180 x 80 x 10 cm

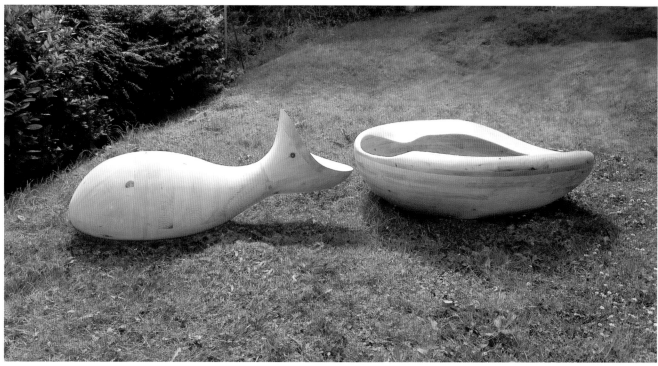

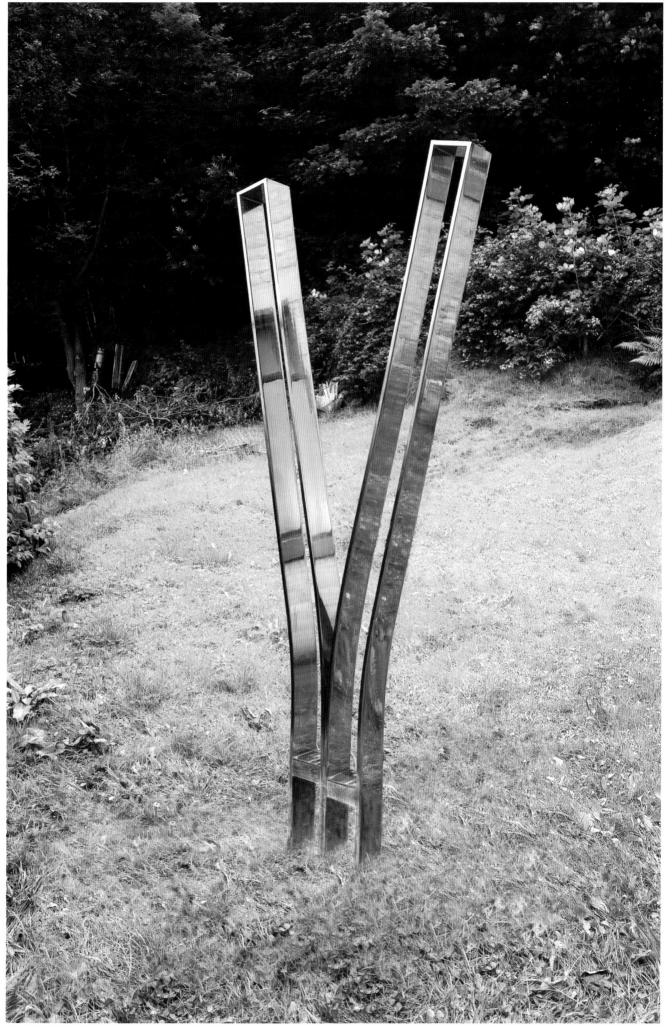

Left page clockwise from top:

Model For Different Places Sculpture

Model For Different Places Sculpture

Model For Different Places Sculpture

Right page:

Model For Different Places Sculpture

Left page clockwise from top:

Model For Different Places Sculpture

Model For Different Places Sculpture

Model For Different Places Sculpture

Model For Different Places Sculpture

Right page:

Model For Different Places Sculpture

Right page:

Model For Different Places Sculpture

Model For Different Places Sculpture

Model For Different Places Sculpture

Fantasy Tower 2003 Wood 135 x 110cm

Gates of Paradise 2006 Wood 190 x 175 x 75cm

Left page:

Spife 2004 Wood 160 x 30 x 17cm

Right page from top:

A Dozen Eggs 2007 Polished Bronze 12 x 26 x 20cm

Bath Time 2007 Cast Iron Found Object

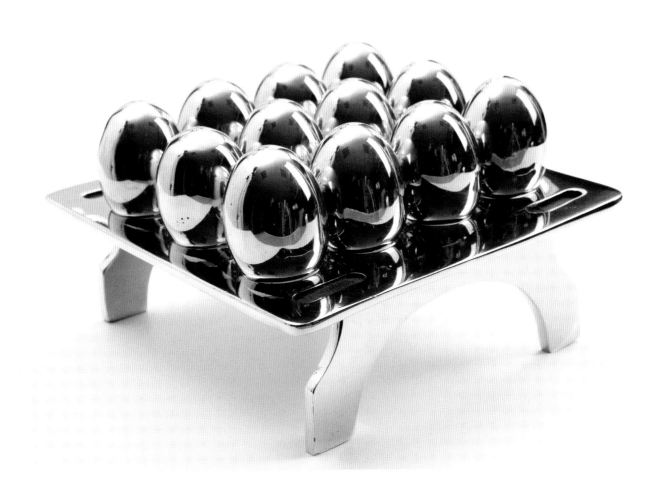

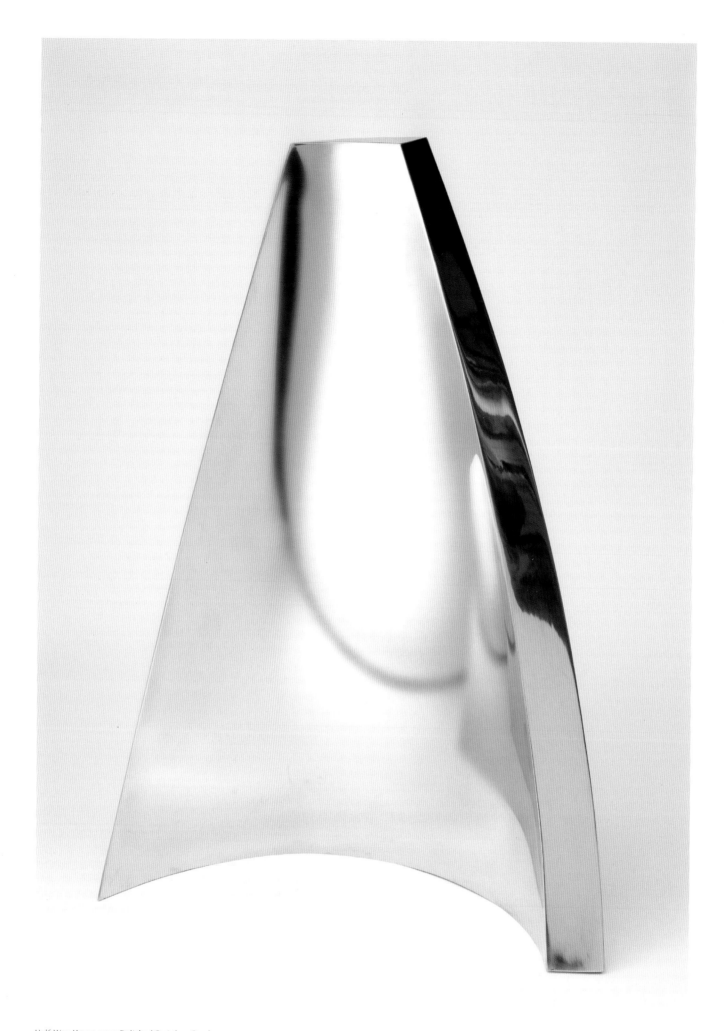

Half Way House 2005 Polished Stainless Steel 2m x 1.5m x 50cm
Collection Arcelor Mittal Luxembourg

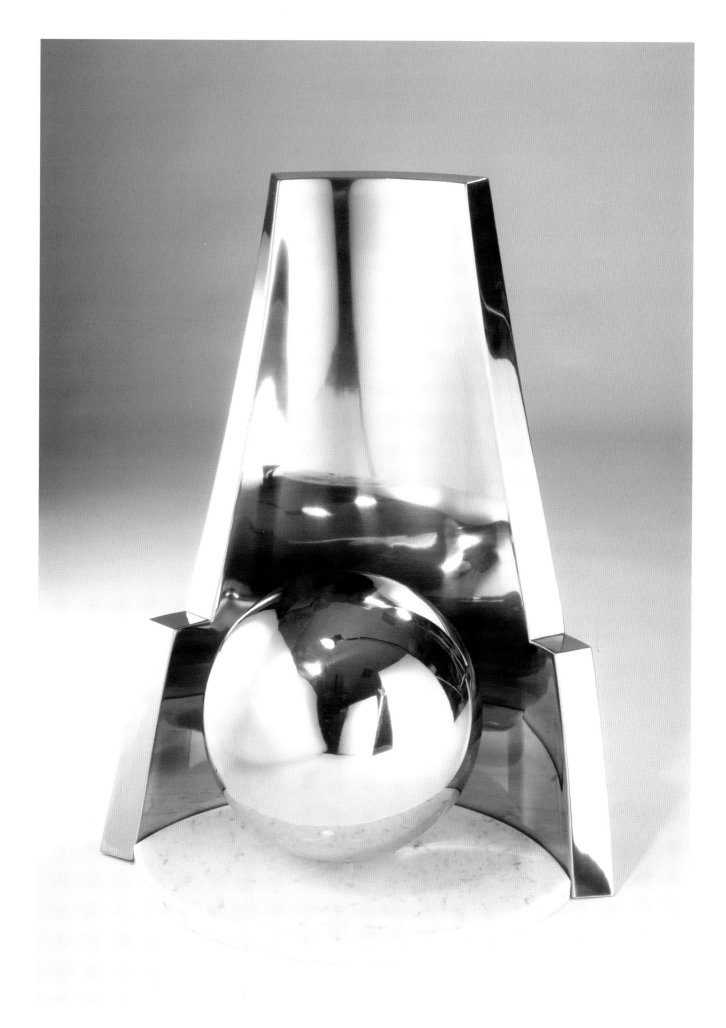

Gespipa 2004 Stainless Steel White Marble 50 x 25 x 20cm
Collection Gespipa GmbH Germany

Left page from top:

Wall2. 2006 White Marble

Screen 2007 Polished Stainless Steel 210 x 90 x 127cm

Right page:

Stressed A 2006 Mirror Polished Stainless Steel 250 x 90 x 25cm

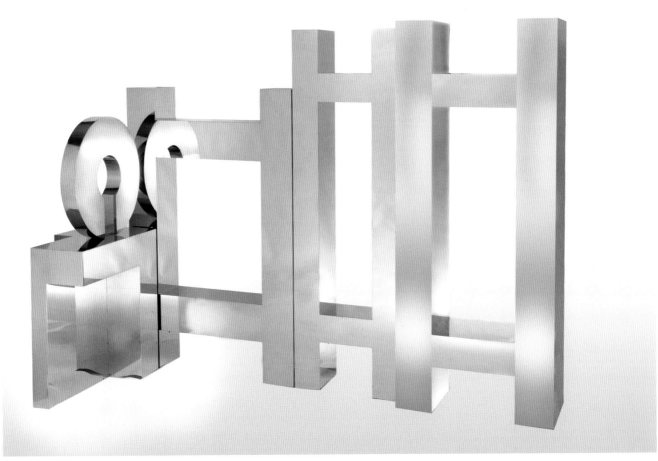

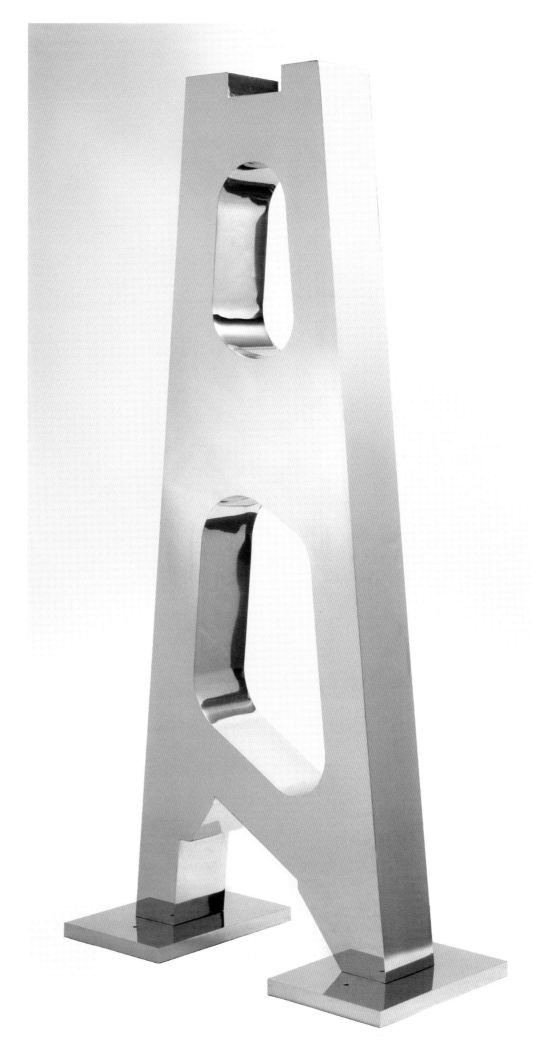

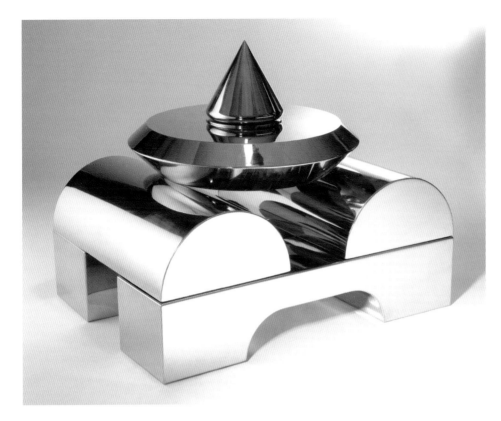

Left page from top:
Palace 2004
Polished Stainless Steel
50 x 40 x 30cm

Swing 2007
Bronze Polished Stainless Steel
185 x 80 x 80cm

Right page:
King Queen 2005/6
Black & White Marble

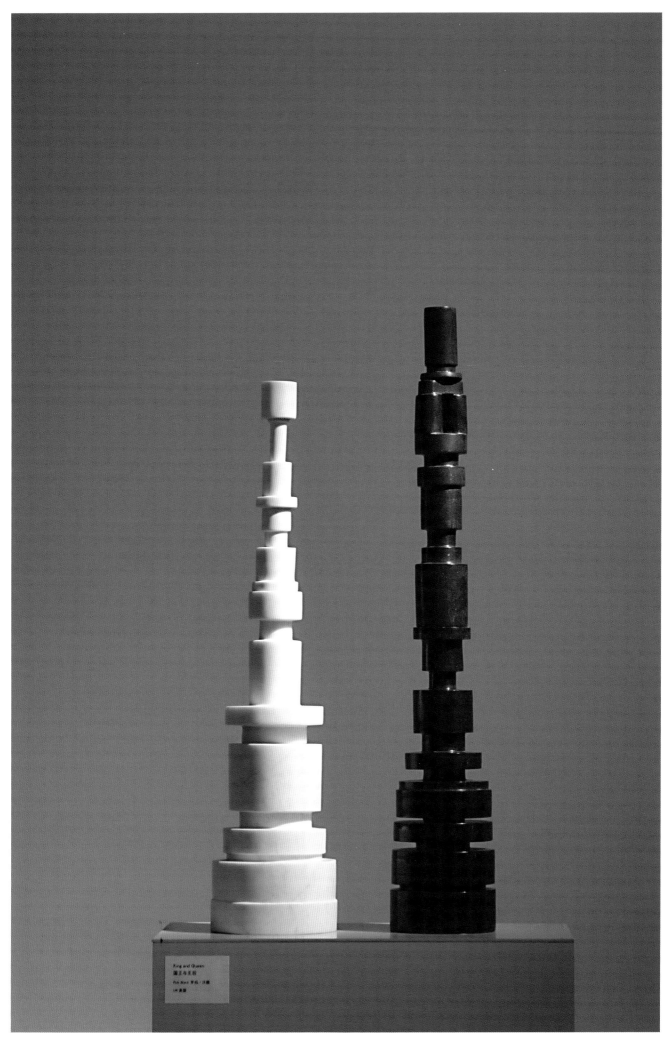

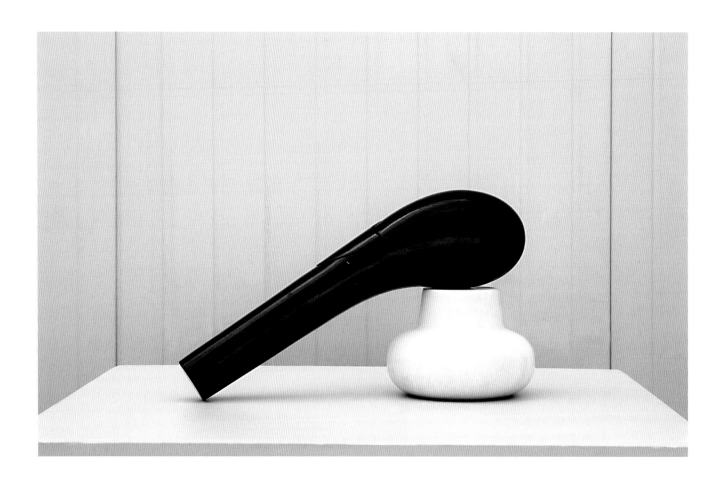

Left page from top:

Stick End 2007 Black Granite White Marble 40 x 60 x 20cm

Snwake 2007 White Marble Pink Granite 10 x 60 x 10cm

Right page:

Boat on Stand 2007 White Marble Black Granite 1m x 50 x 30cm

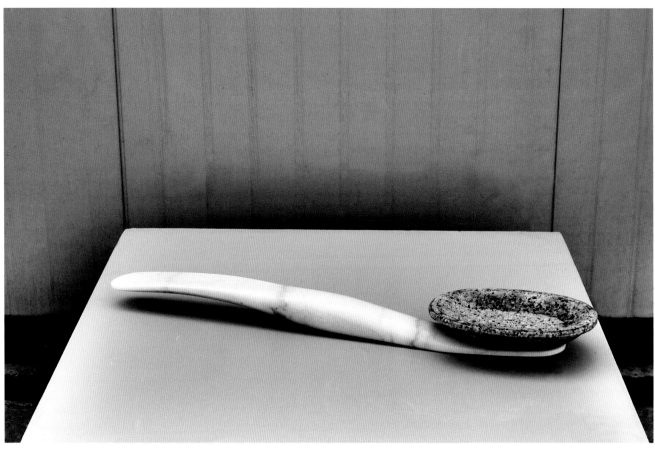

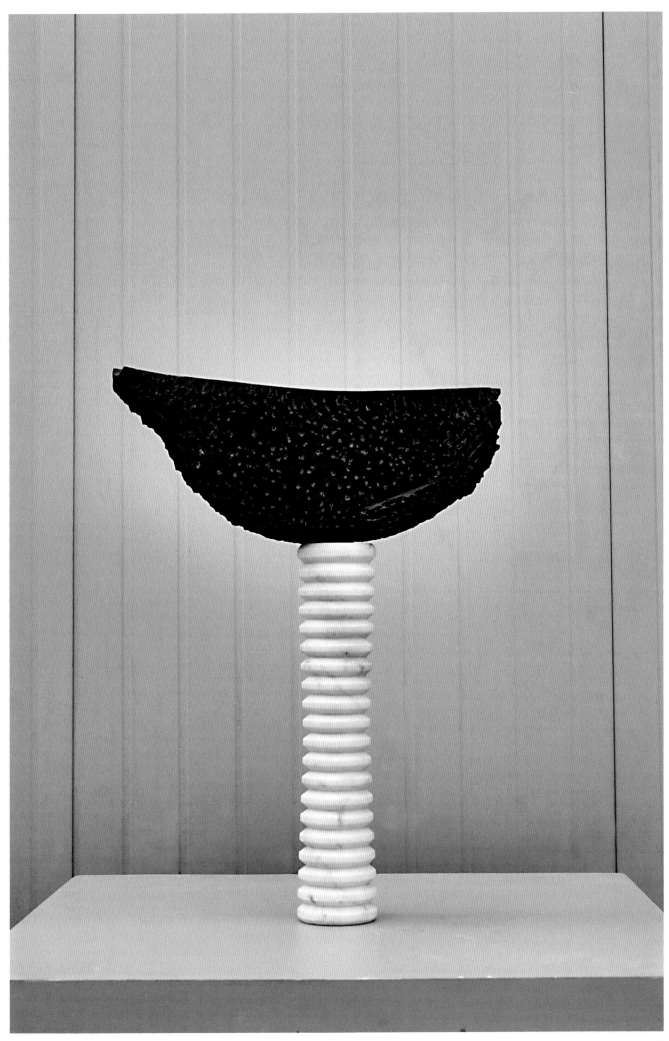

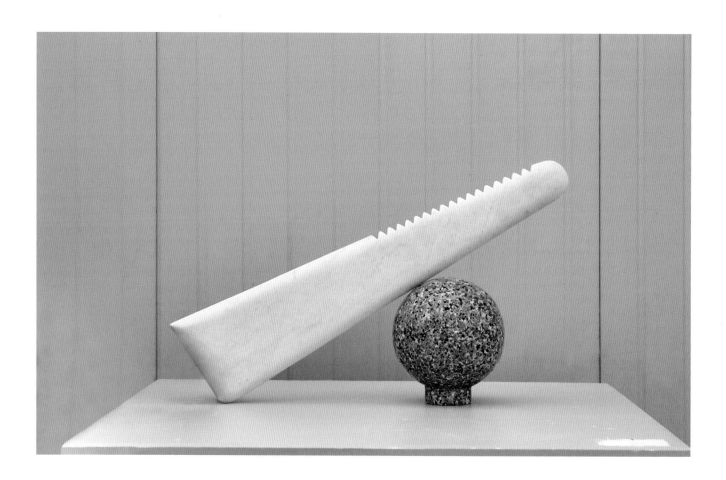

Left page from top:
Tool 2007 White Marble Pink Granite 50 x 1m x 30cm
Cone & Boat 2007 Pink Granite Black Marble 60 x 40 x 20cm

Right page:
Flask and Seed 2007 Pink Granite 1m x 20 x 20cm

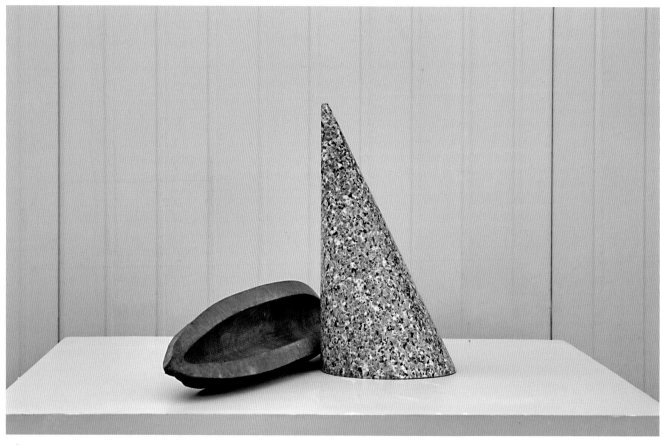

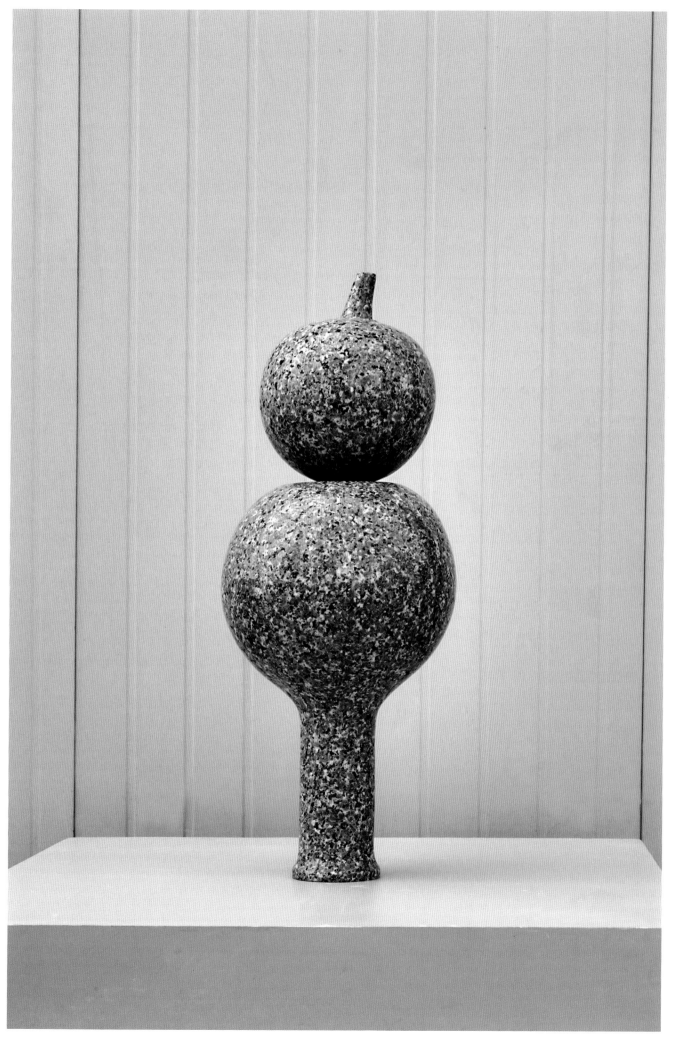

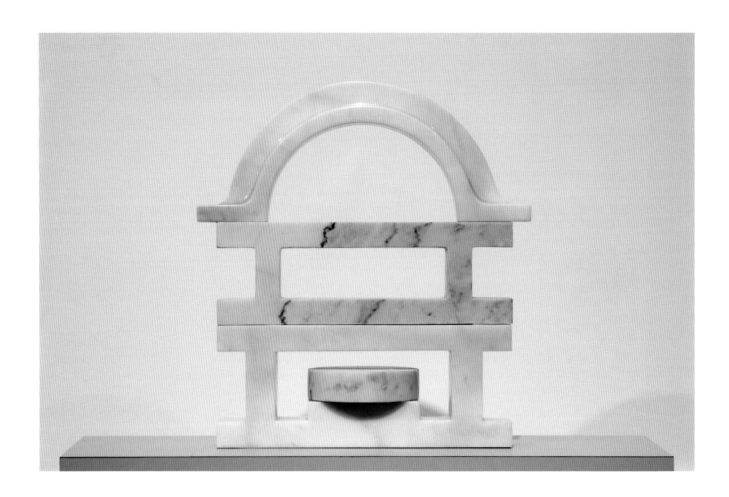

Left page from top:

Gates of Paradise 2 White Marble 36 x 4 x 30cm

Jordan 2007 Black Granite 40 x 60 x 30cm

Right page:

Fountain 2 2006 White Marble 52 x 26 x 26cm

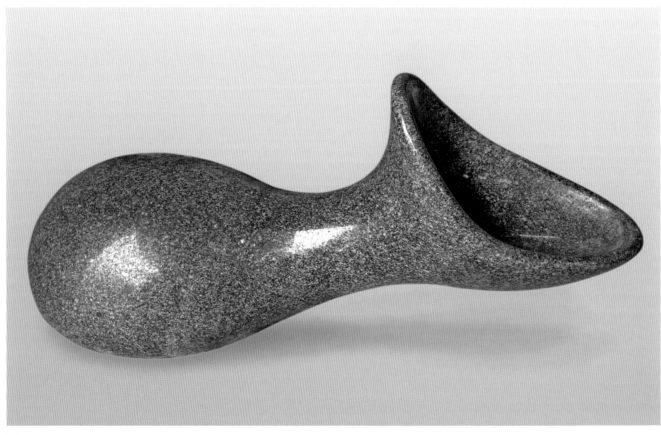

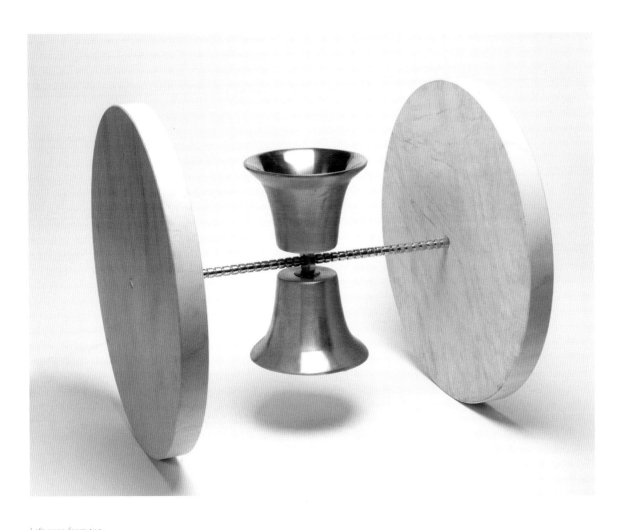

Left page from top:

Almost Equivalent Bells 2008 Portugese Limestone and Bronze 50 x 50 x 35cm

Real Gate 2008 Bronze 20 x 30 x 7cm

Right page:

Ding Dong 2008 Polished Bronze 76 x 35 x 35cm

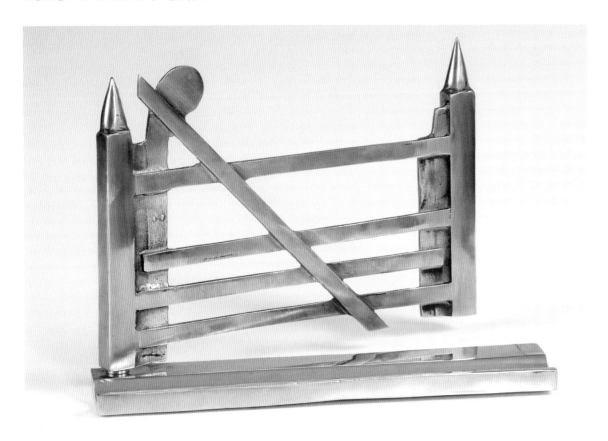

Left page:
Table 2008 Bronze 100 x 50 x 75cm

Right page:
Seat 2008 Bronze 150 x 40 x 40cm

Reflections

Marc Wellmann
(Translation Christopher Mühlenberg)

„What is real is not the external form, but the essence of things … it is impossible for anyone to express anything essentially real by imitating its exterior surface."
(Constantin Brancusi)

Highly polished reflective surfaces are the common attribute of the group of stainless steel sculptures that Rob Ward has extended continuously over the past seven years. This series represents the bulk of his current work. Three of his main works for public spaces are part of it: the nine meter tall Cathedral (2003) in Calder Park in Wakefield, the two-part House (2004) at the Chin Pao San cemetery in Taiwan as well as Gate (2007) at the CASS Sculpture Foundation, Goodwood. At first glance, the use of reflective surfaces may seem a decorative feature. But in Rob Ward's case, it is the conscious and consistent continuation of central topics in his work: The relationship between the sculpture and its surroundings, the use of color and pictorial elements in his objects and installations as well as the observer's participation in the work's genesis. The following reflections on reflective surfaces in sculpture are introduced coming from these specific problems dealing with their history, their art-theory roots and their nature.

A sign in space: Two sharp-cornered triangles directed upward, leaving a narrow gap between them, just wide enough for an adult to slip through. At each of both sides, an orthogonal triangle, smaller and wider than the central ones, the pointed corner again directed upward. These side triangles with their squat mass seem to stabilize and support the structure, but have no static function and are posited directly at the ends of the vertical central triangles, shooting into the sky like arrow points. The geometric object is six meters wide at its base and two meters deep, reaches nine meters into the sky overall and is made from polished stainless steel. All external surfaces are highly reflective. Even without knowing the title, Cathedral, metaphysical associations are triggered immediately. Obelisks, menhirs, church towers: in their upward gesture, they seem to be points of contact between the earthly and the divine, sender and receiver of transcendental messages. In Rob Ward's architectural sculpture, however, nothing is expressed about a ritual function or a religious persuasion. The observer is faced with a largely abstract object that merely contains the reduced indication of the nave and side aisles of a Christian sacral space. The main event in the visual and corporeal confrontation with the work is the representation of the entire surroundings on its surface. The grass, the trees, shrubs, the sky, clouds and the observers themselves are in the sculpture: A painting limited by the geometry of the form, as if it were cut into the space. The sculpture melds with its surroundings, which it flatly annexes and with which it forms an insoluble symbiosis.

Constantin Brancusi was the first to establish reflective sculptural surfaces in an art context. The novel use of polished bronze or brass in his work resulted from his endeavor to transform the weight and tactility of sculpting materials into an ultimately visual event that approaches the ideal or essence of a subject-matter without reproducing it. The notion of flight is a topic with which Brancusi dealt intensively. His famous work Bird in Space — the object of a historical 1928 lawsuit in the USA, hinging on the question of the classification of abstract sculpture as art — is not an animal sculpture in the traditional sense, instead concentrating on the verticality of a slim, elegantly curved form, whose sparkling, almost weightless appearance melds with the space around it. In this truly transitive moment, Bird in Space is indeed

Right page: Hymn 2008 Grugliasco Turin Italy Polished Stainless Steel 7.5 x 6 x 2m

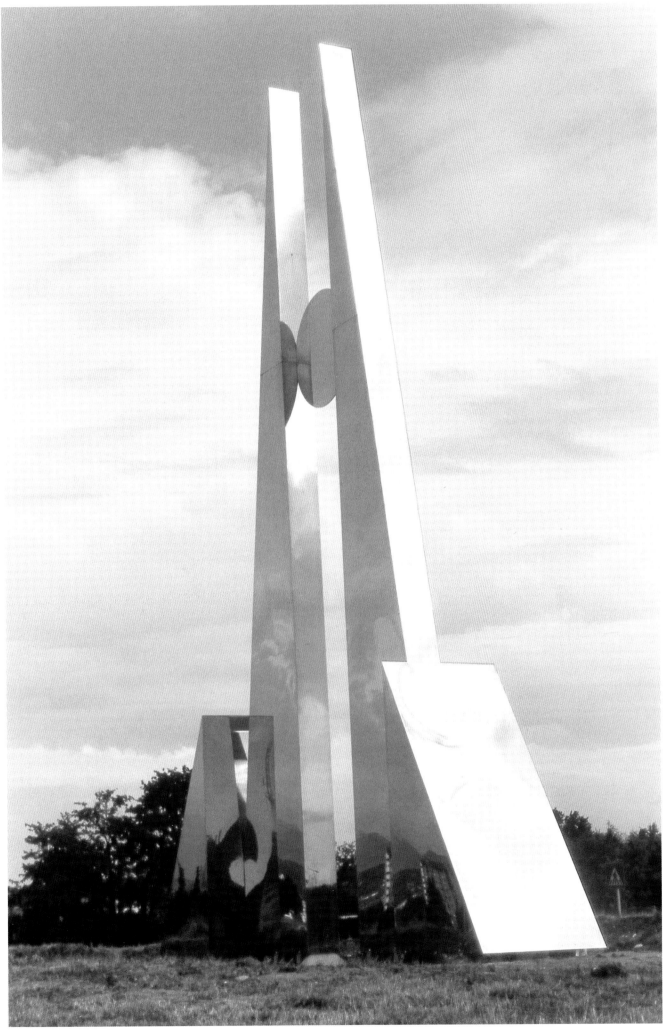

related to Umberto Boccioni's Unique Forms of Continuity in Space (1913), a futuristic sculpture that, in its best-known version, was cast in shiny polished bronze as well. The golden sheen of brass and bronze was also a material-iconographic reference to the precious metal in a sacral context, as with the gold base of Christian holy images or the gilded visage of Buddha statues. Brancusi studied far-eastern religion and philosophy extensively and strove for a separation of the ephemeral from the substantial both in his life and his art. From then on, reflective surfaces were used by various artists, as by Hans Arp, Barbara Hepworth, Arnaldo Pomodoro or, for some time now, by Jeff Koons in his „Balloon-Sculptures". Rob Ward repeatedly admitted to Brancusi as an important influence, but that alone is not an exhaustive explanation for his recent stainless steel sculptures.

Originally, Rob Ward was educated as a painter. His artistic roots are defined by Abstract Expressionism as well as Minimalism and the Color Field painters of the 1960s. He expresses the opposition therein with the conceptual pairings "subjective / material" as well as "objective / spiritual" and subscribes to both principles with varying emphases. The emotional aspect of color, as brought to Ward's attention by the works of Barnett Newman and Mark Rothko, defined his creative work as much as their materiality and the individual traces that the production process leaves on the canvas, aspects therefore that played a role as a psychological or lyrical abstraction with artists like Jackson Pollock or Willem de Kooning. Rob Ward's sculptural work cannot be understood without taking its origin in an initially painting-based line of thought into consideration. This not only characterizes his installation-work series, such as Conventions, Objects and Fields (1995) or Songs (1998), which have the dialogue between objects and fields of color as a declared subject. It also appears in Ward's repeatedly apparent preference for an intensely tinted, blotchy bronze patina that gives the sculptures a pictorial quality. His emancipation from the flatness of painting, his exit from the image into real space, could be traced almost literally in the exhibition Patterns (2003-04), in which sculpture models were placed in front of fields of color, into which their outlines were sketched akin to blueprints.

The topic of reflection can effectively be taken as a synthesis of Ward's explorations of the nature of painting and sculpture as genres, first exercised by the artist in Philosophical Sculpture (2000) at Guilin Yuzi Sculpture Park in China. In this case, a figure's pair of legs is balancing above a see-saw that is in horizontal equilibrium atop a pyramid. At its respective ends, a circle and an open cube are attached, referring to the Euclidean elements of geometry. But the crucial aspect in this context is the polished base made from black marble, in which the structure is reflected entirely. Visually, the sculpture therefore is present both in real form and (together with its surroundings) as an image, as an intangible representation. The implications of this arrangement, which Rob Ward developed into the polished stainless steel sculptures in the following years, can be appreciated more fully if one looks into the art-history dimension of the mirror image. For the Renaissance, the mirror (more precisely the flat mirror) was more than an instrument of feminine cosmetics. With the development of perspective depth and spatial illusion, the mirror image arrived at a previously unknown prominence at the center of the new image theory. In this vein, Alberti lauded Narcissus gazing into a mirror as the inventor of the painting in his treatise De pictura, and Leonardo da Vinci alluded to the mirror image repeatedly in his writings so as to express painting's new mimetic assertions, going as far as asserting, almost proto-Impressionistically, that the artist's spirit (ingegno) must resemble a mirror, so as to fill up with as many representations (similitudini) as there are objects in his sight. The period is virtually obsessed with the flat mirror as a topic of pictorial reality appropriation, but in this, an underlying problem of painting versus sculpture became increasingly apparent, which had played no role yet in the Middle Ages. Sculptures are real, they share the space with us, you can walk around them, and when you do, they present themselves in all directions. In a story about the Venetian painter Giorgione, originally told by Paolo Pino in his Dialogo di Pittura of 1548 and elaborated upon in Vasaris Vite in 1568, the mirror appears as a weapon in the so-called Paragone, the battle of the arts. Therefore, as a

Right page
Buttress 2005
Stainless Steel 250 x 130 x 30cm

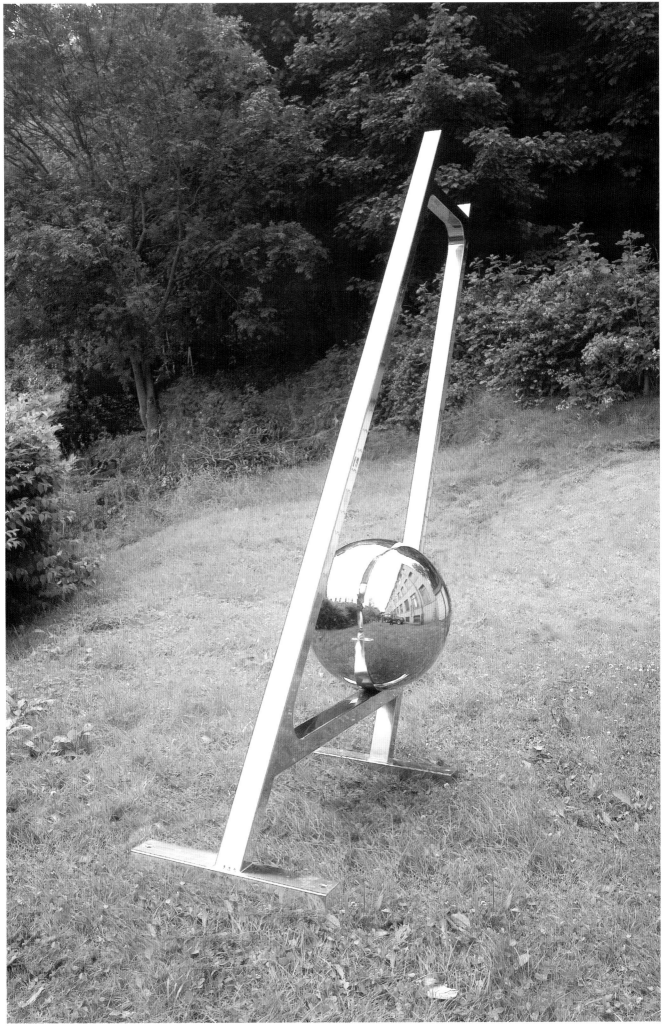

young man Giorgione had surprised the sculptors engaged in erecting Verrocchio's Colleoni monument with the declaration that painting could show front and back in just one representation. This had been completely beyond the sculptors' scope of imagination and Giorgione then created a painting (current whereabouts unknown), on which St. George is depicted in shining armor next to a wellspring, whose water surface reflects his image head to toe. In addition, two mirrors leaning against tree stumps showed different views of his figure. With the help of this catoptric arrangement, it was possible to create the simultaneous view of the whole body. But the illusionist perspective space in painting is subject to a fixed viewpoint and deceives the observer about the reality of the depicted. This is exactly what Narcissus was forced to acknowledge when he tried to touch his own reflection in the water of a spring, thus destroying the illusion.

Ultimately, the argument over the truthfulness of sculpture was able to build on Plato, who presented his fundamental critic of pictorial imitation in the tenth volume of Politeia based on the example of a mirror. According to Plato, a carpenter who makes a chair to predetermined specifications based on an idea already is an „imitator". Just as much, objects in nature were embodiments of an archetypal, invisible substance. The painter, or the mirror that Plato also includes in his critic, would therefore offer imitations of imitations, which would be defined by a dubious distance to actual reality. While a chair (or a mountain, a tree or even a sculpture) remains the same seen from the front as from the back, a mirror or a painter can only show its optical manifestation (phantasma). Pictorial and mirror images would therefore not only be further from the reality of the ideas than sculptures, but also fraught with the blemish of the ephemeral, intangible. Rob Ward's current work series combines Brancusi's methods of de-materialization of sculpture with a discourse on sculptural and pictorial presence in space. The tangible reality of the reflective objects, which are precisely crafted and draw their autonomy from the radical artificiality of their forms, competes with a veristic (sometimes distorted) mirror image of objects at their surface: A fully weightless appearance in the perfect smoothness and hardness of the sculpted material. Mirror images as optical phenomena have a fundamental ontological weakness. The mirror image has no individual existence as it has only the reflection to show for itself, on which it fully depends. It is canceled out when this disappears. With Ward's sculptures, this is part of the receptive process. The sculpture forms a visual unit with its surroundings: The world is both real and an illusion

— and this incidentally also concerns the sculptures directly, which often create reflections of themselves. But this situational constant has infinite facets and becomes a dynamic variant in the dialogue with the observer. In this respect, catalogue images of the works, drawn from the static medium photography, reach their limits, even if they can in fact document various atmospheric moments, by which the sculpture's appearance changes. The observer is the real focus. If the observer changes his vantage point, if he walks around the sculpture, the perspective structure of the reflection changes as well. Sooner or later, he will see himself in the sculpture's surface and see himself as the instigator of that interplay of colors and light at the sculptures' surface that transcends the lifelessness of the material. The sculptures mentioned earlier - Cathedral, House and Gate - embody this aspect in thoroughly different ways. Cathedral rests frontally vis-à-vis the observer. In the middle, a passage beckons that marks the central overlap of the force lines that the work creates. House consists of two curved concave elements that enclose an open space into which the observer can enter, where he then sees two opposing distorted reflections of himself. Gate is the most complex structure. Two gates stand at a right angle. The two entries are closed, save for a slit, by corner forms facing outward. Altogether, this provokes an association of crystal or star shapes. The surroundings are reflected from various different views, so that the observer sometimes sees two reflections of himself, or even several when inside the sculpture. Passage through the mysterious gates remains impossible. The things in front and behind the gates are present only visually. „The intention," Ward says about his use of the highly reflective surface of polished stainless steel, „is to return you to yourself through the space, place and time of the sculpture."

Right page

Gate 2007

Stainless Steel 3 x 3 x 3m

Collection David & Hannelee Tilles

London

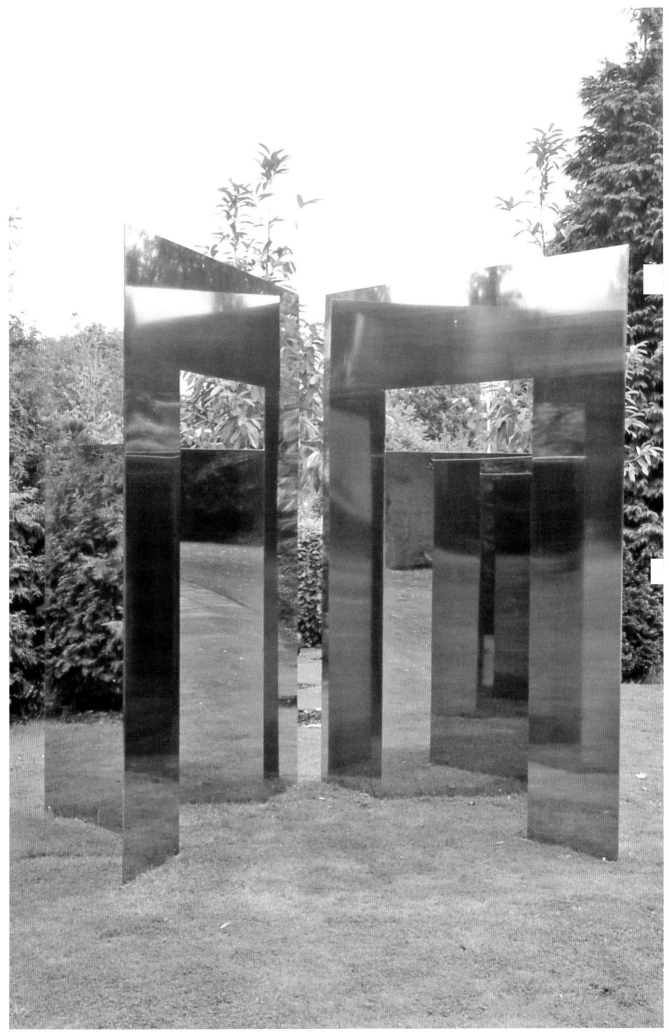

Capturing the moment

conversations between
sculpture and drawing
in Rob Ward's work

Sebastiano Barassi

Throughout his career Rob Ward has combined different media in his work to generate unexpected physical and psychological spaces. One of his main preoccupations over the years has been the exploration of the dialogues and tensions between the two- and the three-dimensional, the flat and the solid, the material and the spiritual, the inside and the outside and, most importantly, between sculpture and drawing. A study of his art, then, demands above all an investigation into the very nature of these tensions and dialogues.

In the last few decades artists and critics have recurrently explored the many possible conversations that can occur between sculpture and drawing. As art historical exercises, these enquiries can offer fascinating insights into the mental processes and working methods of sculptors. However, the majority of them seem to stop at superficial issues, such as the supposed economy of line of sculptors' drawings or the difference between a sculptor's and a painter's approach. Similarly, most analyses of the use of drawing in preparation for sculpture are confined to the identification of formal affinities and differences between the image on paper and the finished three-dimensional object. Ward's art asks viewers to go deeper than that. By juxtaposing sculptural and pictorial forms and by combining or inverting techniques and visual effects between the two, it challenges common ideas about each medium.

Ward's work frequently invites a reading of drawing as a physical object and not as an illusionistic space, and of sculptural forms as pictorial images. In 1989 he explained that in his view sculpture and drawing "rather than mutually exclusive, are inextricably linked ... the drawings are often about intimate, personal, new answers in my life and frequently have a spontaneity which is absent in the sculptures. The drawings are intuitive, inhabiting a world

more to do with becoming. The sculptures, which take longer to fabricate and often don't have that emotional intimacy, are very much about being ... For me drawings are poems; the sculpture is novelistic." Elsewhere he has pointed out that the experience of the viewer changes significantly with each medium, suggesting that drawing (and painting) require prolonged concentration, because of what he sees as their meditative quality, while sculpture invites a more direct, physical experience.

When he started the Fine Art course at the University of Newcastle-upon-Tyne in 1969, Ward wanted to be a painter. The teaching was designed to offer training in a wide range of techniques and to provide students with the opportunity to explore the latest visual trends. Ward soon developed an interest in recent American art, in particular Abstract Expressionism and Minimalism. An important influence at this time was the work of Jackson Pollock. As a young student, Ward enjoyed the freedom of expression and intense subjectivity of the American's painting. He has described his own early sculptural work - based on free, gestural marks on beds of clay, with forms emerging progressively - as "almost three-dimensional

Pollocks". More broadly, Ward was attracted to artists who challenged the traditional separation of media and explored new pictorial and sculptural spaces. He liked, for example, Barnett Newman's attempts to break down the barriers between painting and sculpture, through the exploration of the physicality and texture of paint. Equally interesting to Ward were the philosophical and spiritual aspects of Newman's work, in particular the idea of emptiness translating into subtle spatial modulation. As for sculpture, at this time Ward especially enjoyed the painterly qualities and the tension between volume and flatness of the work of Anthony Caro and David Smith. Already at this early stage, clearly, the combination of different techniques and visual effects had become one of his main preoccupations.

Around 1973-4 Ward realised that he found the exclusive focus on the self and the subjective of artists like Pollock too restrictive. This, coupled with his indifference to the study of issues such as light sources and colour theory, led him to seek more grounded and enduring subjects and techniques. It was at this point that his main focus shifted from painting to sculpture. And though he did not stop making two-dimensional work, he started to concentrate on its more physical and objectual possibilities.

It is perhaps unsurprising that even at this time the artists Ward was looking at were mostly painters. He cites, for example, the importance of the still-lifes of Giorgio Morandi and Georges Braque to help him focus on the exploration of objects in space. This interest suggests that the investigation of the tensions between represented and real space was becoming central in his research. While he may not have been the first artist to do this, the way in which, throughout his career, he has explored this idea by physically juxtaposing two- and three-dimensional forms remains, arguably, his most original contribution.

Over the years Ward has repeatedly worked in series, starting a new group of work with either drawings or sculpture, and generally treating the two as complementary. Rather than a linear development, there seems to be a natural circular rhythm to his practice. Once a prevalently sculptural series is completed he usually finds himself thinking about drawing, and vice versa. "I have one idea at the core of what I do, that manifests itself in different ways. The circularity of it is important to me. That is why I like the image of the wheel and the circle, which recurs in my work. Its impetus is what has allowed me to carry on working until now. From the beginning I knew I wanted this to be not only a journey, but for it to

be able to renew itself. There isn't a plan, I move from one thing to the next." This circularity is also evident in Ward's habit of reworking pieces many years after their creation, for example Self-portrait of 1986, or the Different Places drawings of 2007.

Ward's art, then, can truly be understood only if drawing and sculpture are considered together, as parts of a whole and of a single, circular practice. This essay attempts to do so primarily from the perspective of the two-dimensional work. This is almost invariably on paper and Ward generally refers to it as 'drawing', even though technically it could be classified as painting - an insistence loaded with meaning, also in light of his self-definition as a sculptor. There are two distinct strands to Ward's two-dimensional output: standalone drawings, which are often animated by the same concerns as the three-dimensional work; and drawings created in conjunction with, and to be displayed alongside, sculpture. Standalone drawings recur throughout Ward's career. In the early years, they were quite varied stylistically, ranging from organic figuration to almost geometric, rather minimal abstraction. Their palette is generally austere and the forms often free-flowing and with a marked gestural quality. Most importantly, the early drawings seem all animated by a strong sense of presence in space, both in the representation of the subject and as physical objects. This is especially evident in the works made using manhole covers for frottage (for example Well & Floor of 1974) or drawing around real objects (Tapestry, 1976). Here Ward exploited the reflective properties of densely applied graphite in contrast with the matt areas of the empty sheet, or used collage-like compositions, to play out the tensions between image and material, between the presented and the represented.

Despite an overall tendency towards formal simplification, the subjects of these drawings remain generally easily

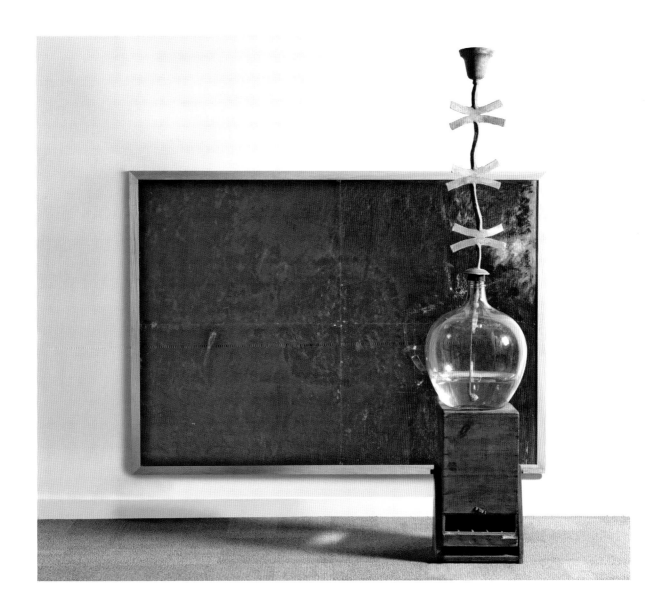

Left page:
Palm Beach Painting 2005 Watercolour on KK Paper 30 x 21cm

Right page:
Flowers in the Studio Dahha 2008 Wood Glass Water Bronze Pigment on Paper

identifiable. Ward is a keen collector of all kinds of objects, and for many years now he has been using them as the starting point for new work. A recurrent subject throughout the 1970s was the bucket, which appeared in both the three-dimensional work (mainly assemblages of everyday and other objects) and the drawings. Its presence gave openly sexual nuances to the work, as did the frequent appearance of fans and masks. Another favourite subject in those years was landscape. Through it Ward devised psychological and mnemonic maps that were intended to provide him, and the viewer, with a means to appropriate the many different places between which he was moving at the time (namely Greece, Australia and Yorkshire).

While living in Australia, in 1978-9 Ward began to use a support, Kromecoat paper, that was to have a major impact on his practice. Designed for industrial printing, it has a smooth ceramic coating providing a highly flexible and treatable surface. Since then he has invariably used this paper (which comes in two standard formats: 46 x 36 and 30 x 40 inches), either singly or in multiple sheets. The reflectivity of its surface, which makes the image "shine from the back", with an effect that reminds Ward of stained glass, is of particular importance. It offers a sense of depth and layering that, combined with strongly physical mark-making and application of paint (always as pure, unmixed pigments and in very tangible "slabs of material"), allows Ward to emphasise the three-dimensional, sculptural nature of his drawings. As he put it, "this was a wonderful discovery: I could draw, paint and 'sculpt' at the same time." More recently (most notably in the 2003-4 Patterns drawings) Ward has introduced a further way of layering the image, by using varnish over paint and etching marks into different layers of either.

Crucially, it was the relief-like potential of the drawings made on Kromecoat paper that first suggested to Ward the possibility of combining them with actual three-dimensional work, which, as we shall see, he began to do in 1980. However, he never abandoned the idea of standalone drawings. In the late 1970s and throughout the 1980s, for example, he created series of works characterised by the presence of floating symbols (such as crosses) and loose markings. Many of these drawings exploit the partitioning imposed by the standard size of the sheet, either as a narrative device (for example in The Map of Love of 1980), or to vary scale, or to introduce unexpected compositional solutions (as in Dancers of 1979).

More recent examples of standalone drawings are the series Tracings of 1997 and Crimsworth of 1998, both with

a strong textural and low-relief character. The Crimsworth series is of particular interest for its focus on rhythm and discipline. Ward set out to record his emotional responses to the walks he took with his dog in the Crimsworth valley in Yorkshire. The series was based on the principle of producing one drawing per week, with Zen-like discipline, to be accepted regardless of its quality. He deemed the group complete when he was satisfied with the result. The Tracings drawings were made thirteen years after Ward had left Australia. The title alludes not only to the tracing of steps back, but also to the traced feel of the drawings, which were made with very light touch, "like wind on a surface" - an approach intended to make them into real landscapes, not mere representations of places. Both series highlight the explicitly meditative nature of Ward's practice, which often derives inspiration, for example, from Buddhist thought.

Ward's interest in the juxtaposition of drawings and sculpture derives above all from his desire to introduce the viewer into new visual and mnemonic spaces, and to challenge our expectations about each medium. This places his work in a tradition that has its roots in early Modernism (in particular in the use of collages, reliefs and assemblages as means to challenge pictorial and sculptural conventions) and that later evolved into installation, environmental and time-based art forms.

Ward began to display drawings and sculpture together in 1980, in the exhibition Places, Paths and Mountains. Placing works around the room, he "manipulated the space almost like a Japanese garden ... The Place was the gallery, the Path was the sculpture and the Mountains were the drawings." Compared with later examples, the visual relationships were here relatively straightforward, with the paintings providing either an almost theatrical background to the sculptures or a direct visual counterpoint, a sort of

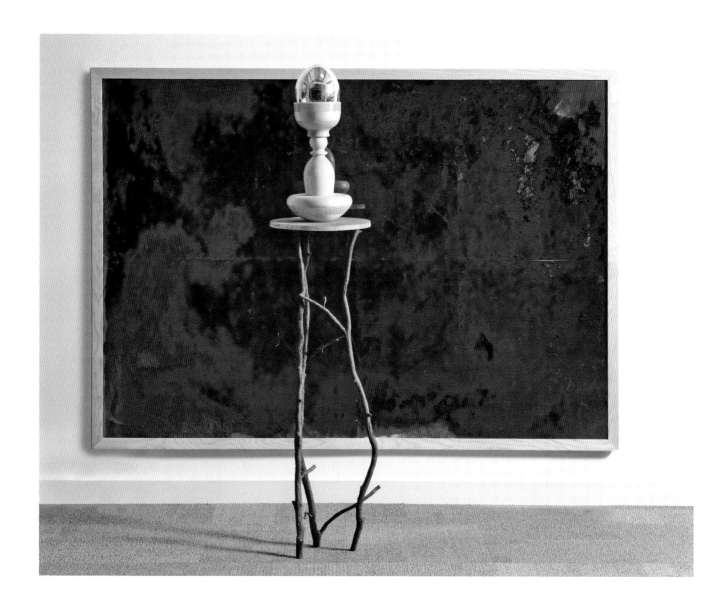

Left page:

Palm Beach Painting 2005 Watercolour on KK Paper 30 x 21cm

Right page:

Flowers in the Studio Cornflower 2008 Stainless Steel Wood Glass Glass Pigment on Paper

two-dimensional translation of the sculptural forms. This exhibition also saw the introduction, for the first time, of reflections: some of the sculptural pieces included metal buckets and trays filled with water, whose presence was echoed in the drawings. The repetition of images in different media and their recurrence through reflections was designed to invite the viewer to pause and think, and to encourage quiet contemplation.

The exhibition Epiphany (1989) provided a further development in this direction, but with a radical conceptual change. Constructed around the notion of tight pairings of drawing and sculpture, like the 1980 exhibition it explored the idea of space in relation to place. The title of the drawings (Mirfield) refers to the area where Ward and his wife, Cathy, spent their first years together. The drawings are made from four joined sheets of Kromecoat paper, with a substantial shift in scale from the earlier single-sheet works. As Ward pointed out "their new bigness made them more tangible as places: they were not illustrative of a place but became the place itself" – a comment reminiscent of the ideas behind the Tracings series. The imagery is here inspired by the humanised, semi-industrial landscape around the village. Stiles, in particular, provide a direct reference to the many walks that Rob and Cathy took in nearby fields. As a device that opens up new spaces, the stile offers a fitting metaphor for the linking of the drawings with the sculptures, which were effectively small landscapes in front of the drawings. This is an idea that has since returned frequently in Ward's work, through themes like gates, doorways and bridges. The placing of sculptures and drawings in relation to each other was conceived to provide spaces to accommodate the viewer between them. Again, the drawings became part of the sculptures through the reflections in the water-filled metal trays. The sculptural forms cast in bronze were also reflected in the water, thus multiplying and mixing up two- and three-dimensional images.

Ward's recurrent interest in reflections derives from his desire to "make nature become the artwork." The reflected surroundings not only create new flat images on the sculpture but also alter the three-dimensional forms, by both flattening and accentuating depth. Ward sees this as an additional kind of drawing, that is embedded directly into the sculpture. This use of reflections and highly polished surfaces is reminiscent of the work of Constantin Brancusi, whose influence is also openly acknowledged by Ward through the choice of titles such as Bird in Space or Brancusi's Joy. Ward has also commented on his fascination with the meditative quality and calmness of

Brancusi's work, and with the idea of carefully arranging sculptures, bases and other objects in relation to each other and to the surrounding space.

The 1994 installation Crimsworth presented a more radical integration of two- and three-dimensional spaces, combining drawings, sound and water (which covered most of the floor) to create a sculptural environment. This remains Ward's most explicit statement of his interest in exploring the space in which we, the viewers, live and experience art. The multisensorial environment (tactile, acoustic and visual) was designed to offer different types of perception through different media, which, as we have seen, is a central concern of his art. Again reflection (both visual and aural) played an important role here, this time informing our awareness of not just a sculptural work and its relationship with its immediate surroundings, but of an entire room.

The following year, the exhibition Conventions, Objects and Fields returned to the direct and tight pairing of sculpture and drawing. Each of the twenty-nine red drawings dealt with a different pictorial convention, mainly in compositional terms. And each was paired with an (according to Ward) incongruously chosen object, placed on a glass shelf to the left of the drawing, exactly halfway up its height. The lighting was carefully designed to make the objects project shadows onto the wall behind, next to the drawing. The aim of these juxtapositions was the exploration, suggested by the title, of the 'fields' that open up in the space between the drawing and the sculptural object, which is the space inhabited by the viewer. Interestingly, from the juxtaposition arose tension but also conversations, which are somewhat emphasised by the vibrant rhythm of the pairs' sequence.

For Ward inspiration may come from the encounter with

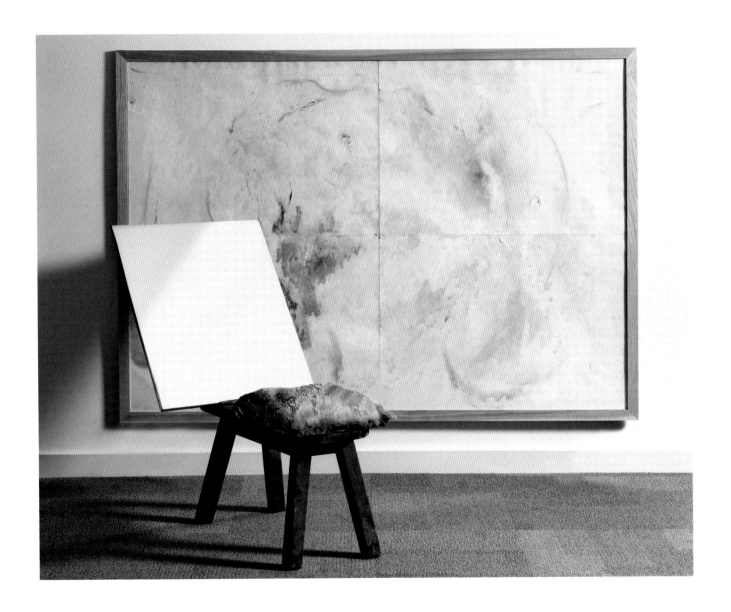

Left page:
Palm Beach Painting 2005 Watercolour on KK Paper 30 x 21cm

Right page:
Flowers in the Studio Carnation 2008 Wood Bronze Pigment on Paper

a new place, from his relationship with familiar places or from other sources, quite frequently literary. He refers, for example, to his interest in poetry as arising from the search for calmness and spirituality that informs his practice. Sometimes a single word, or a short poem, will generate an idea for a drawing or a sculpture. This is never planned, and has led to drawings conceived as illustrations from haiku. Other times, as for example with the 1998 exhibition Songs, the inspiration came from a specific text, Walt Whitman's collection of poems Leaves of Grass and Songs to Myself.

Although evolving from the same ideas at the foundation of Conventions, Objects and Fields, Songs saw several formal and semantic shifts. While in the earlier exhibition there was a strong emphasis on rhythm and repetition, here Ward individualised the pairs to a much greater degree, by modulating more the relationship between two- and three-dimensional and by exploring more widely the possible conversations between the two. One other noticeable difference was in the substantially larger scale of the works, while the interest in the use of lighting to cast shadows remained central.

The next major project was inspired by Italo Calvino's Six Memos for the Next Millennium, the book which Ward has described as an "incredible encounter." 6 Memos (2000) evolved the exploration of drawing by bringing the flat image (this time on canvas) into space, thus opening up a whole new set of issues. Using Calvino's values (lightness, quickness, exactitude, visibility, multiplicity and consistency) as a framework to order his own ideas, the five installations offered a reasoned summary of Ward's research to date. The dialogue between drawing and sculpture again featured prominently, as did the use of shadows and transparency.

With Patterns (2003-4) Ward returned to a tighter pairing method. The title refers to both his work rhythms and to the fact that the sculptures were made using redundant patterns recovered from an old engineering factory. Ward placed a small sculpture in front of a drawing that includes an outline made from the sculpture itself – thus retaining its almost exact size. At this time he was especially interested in exploring the implications of shifts in size and scale, and in particular the relationship between maquette and final work (the maquette being a small-sized 'pattern' for the final work). The juxtaposition of drawing and sculpture was designed to invite the viewer to relate to the same forms in the same size but in different physical (and mental) materialisations. The alternation of works

with reflecting and dense surfaces further accentuated the sense of journey through different spaces and places. As Cathy Ward pointed out in the exhibition catalogue, through the interplay of the object and its drawn image "the eye is pulled into an infinite loop of correspondence between the two and three dimensional form, which operates as the visual equivalent of a meditation chant."

The interest in pairing sculpture and flat images remains at the core of Ward's most recent work, Different Places (2007), in which white marble sculptures are juxtaposed to a group of drawings entitled Smotherfly (the area of Derbyshire in which Ward grew up). These were originally made in the late 1980s and have been reworked for this exhibition. In addition to the physical layers of paint and varnish, Ward uses here chronological layering. The marble sculptures are very dense and were carved from models made out of assembled and modified small objects and tools. They stand with all their weight next to the drawings, which are more ethereal, suggesting presences next to memories. Unlike previous exhibitions, the pairing is not tightly pre-determined but subject to casual associations, as if following a loose train of thoughts. The new interest in carving is at least in part the result of Ward's interest in the patterns of the marble's veins, a kind of in-built drawing that achieves similar effects to the reflections on the polished bronzes.

Early in his career Ward elaborated an idea of art which "has something to do with beauty, stillness, balance, reflection", which has remained at the core of his work to this day. As he remarked, he wants his art "to appeal directly through its space to the mind, through its luminous qualities formed according to my imaginary world. My drawings are profiles of space where time is allowed to occur. My sculptures are places where the object interacts with drawing, the landscape, and people."

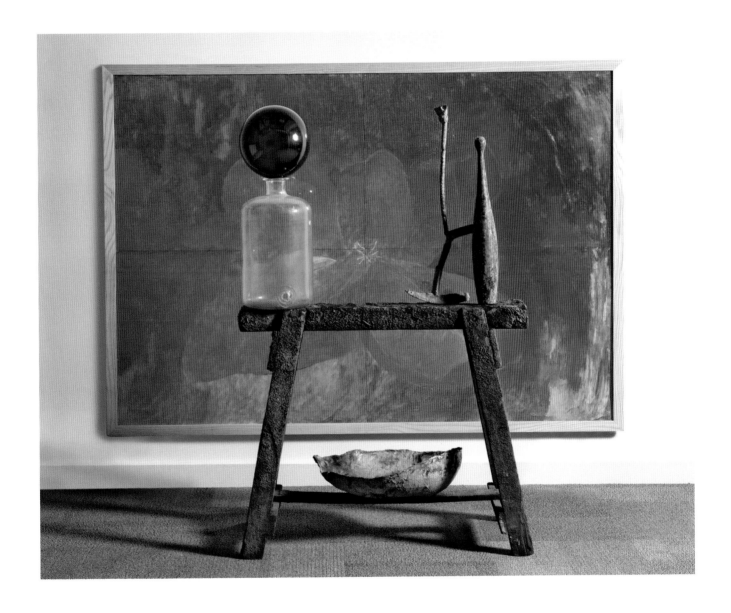

Left page:

Palm Beach Painting 2005 Watercolour on KK Paper 30 x 21cm

Right page:

Flowers in the Studio Camelia 2008 Wood Bronze Glass Pigment on Paper

On drawing

Rob Ward

Left Page from top:

34 Grate1974GraphiteOnPaper66x48cm

34b LightBucket1974GraphiteOnPaper66x48cm

Right Page from top:

42 ThroughTheWindow1974GraphiteOnPaper66x48cm

As with most young people drawing was my first introduction into the world of making art, quickly followed by painting.It wasn't until I went to Newcastle that I made my first sculpture, Shoe, the result of a project set by Ian Stephenson on distortion.In 2004 I completed the pair in stainless steel.

I had always intended to be a painter, and still do, and have consistently been guilty of unsculptural behaviour. My early drawings were a search for subject matter. War and disease occupied me, particularly the Vietnam War, until I realized that absorption in this was not good for me, and not compatible with who I am. I changed tack and worked under the spell of Pollock , Newman , David Smith and two fellow students Keir Smith and Brian Thompson, making the sculptures Brown Rhythmn, Watersplash and Landscape, all of which emanated from a flat casting process, akin to drawing, in fact drawing on clay, cast in rubber and made positive in GRP.When pieced together they became 3 dimensional. At the same time I made some architectural work with geometry at its core.

This flicking between the fluid and geometric has stayed with me, as have the working patterns I established of moving between 2 and 3 dimensions. The idea of casting in its many forms , the notion of lifting a surface became important.After 5 years working with the subjective or subconscious action, I felt the need to reengage with reality, and made a series of drawings which worked with the presence and absence of things , often the tools I used as a sculptor. Drawings such as Grate, Light Bucket, Bucket and Goggles, represented simple ideas about manipulating space and shifting the meaning and context of the object, followed by Through the Window and Tapestry, made in Athens, joining objects inside and outside into a single moment in time and space.A series of sculptor's still lives followed.Sculpture on a Table tried to dissolve or outline objects on a distorted table top.

My working premise became a concerted investigation into the relationship between 2 and 3 dimensions. This included a desire to paint , or use colour, and to look at the slices of space which make up a painting , a sculpture and the spaces in between.In an almost scientific way my major exhibitions have attempted to work in the now famous gap, not between art and life, but between dimensions, the flat and the round, the illusory and the real, the object and its shadow, time and memory .Subject matters change. Subjects can be situations , places , poetry , music or come from the collection and conjunction of things I own.They all become part of the uncovering of those intimate bits of space and time I try to reveal. Different means of expression have been necessary to deal with drawing which uses colour, or painting which is drawing. I use pure pigments , ceramic coated paper, sharp needles, sandpaper, and toilet rolls in an attempt to make line and colour work like an etching on glass, emanating light from behind the surface.

What I like about the process that absorbs me , this split personality, torn between the real and the imaginary, is the different time drawing and sculpture takes, and the different parts of the brain it occupies. I find sculpture more difficult and less enjoyable when making it, but more fulfilling when its complete.I call my coloured work drawings, because I never intended them to have the quality of finished paintings, though they are moving that way. I always wanted them to shine like the stained glass at Chartres.

As the ideas have developed working patterns have been established. When I have finished a series of minimal works I crave the active and organic. The circle of activity, seems to reinvent itself. New things are discovered , such as the recent work with bells, Ding Dong , and Almost Equivalent, and new materials , witness the stainless steel sculptures which allow drawing on the surface.. I was recently asked to design a manhole cover for a town in Italy. I wrote on it Here Time Turns Into Space. I remembered one of my early drawings was a rubbing of a manhole cover, titled Grate(1974). History repeating itself. Wheels coming full circle.

Left page from top:
Tracing 4. 1996 49 x 35 3:4 inches
Tracing 7. 1996 49 x 35 3:4 inches

Right page:
Tracing 2. 1997 49 x 35 3:4 inches

234

Left page clockwise from top:
Tracing 5. 1996 Acrylic on KK Paper 49 x 35.3:4 inches
Tracing 6. 1996 Acrylic on KK Paper 49 x 35.3:4 inches
Tracing 11. 1996 Acrylic on KK Paper 49 x 35.3:4 inches

Right page:
Tracing 9. 1996 Acrylic on KK Paper 49 x 35.3:4 inches

Tracing 10. 1996 Acrylic on KK Paper 49 x 35.3:4 inches

Tracing B. 1996 Acrylic on KK Paper 49 x 35 3:4 inches

Left page:
Green Shadow Carpet 150 x 152 cm
Left Page Bottom. Carpet 159 x 145 cm

Right page:
Secret Carpet 180 x 152 cm

Drawing for Sculpture
Drawing for Sculpture

Sculptures in a Landscape
Sculptures in a Landscape

Sculpture on a Stand

Still Life with Cast

Sculpture, Weather and Bridge
Sculptures on a Horse

Over the Bridge
Mountain Gate

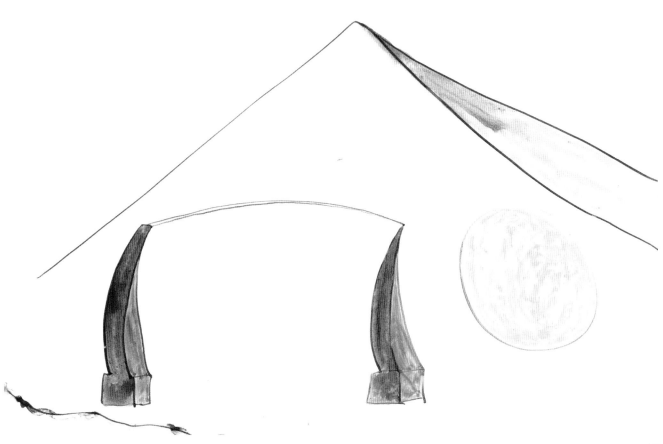

Left page clockwise from top:

Prelude - Carpet 2008 Acrylic on Photo Paper 125 x 107cm

Prelude - Absence 2008 Acrylic on Photo Paper 125 x 107cm

Right page:

Prelude - Yellow 2008 Acrylic on Photo Paper 125 x 107cm

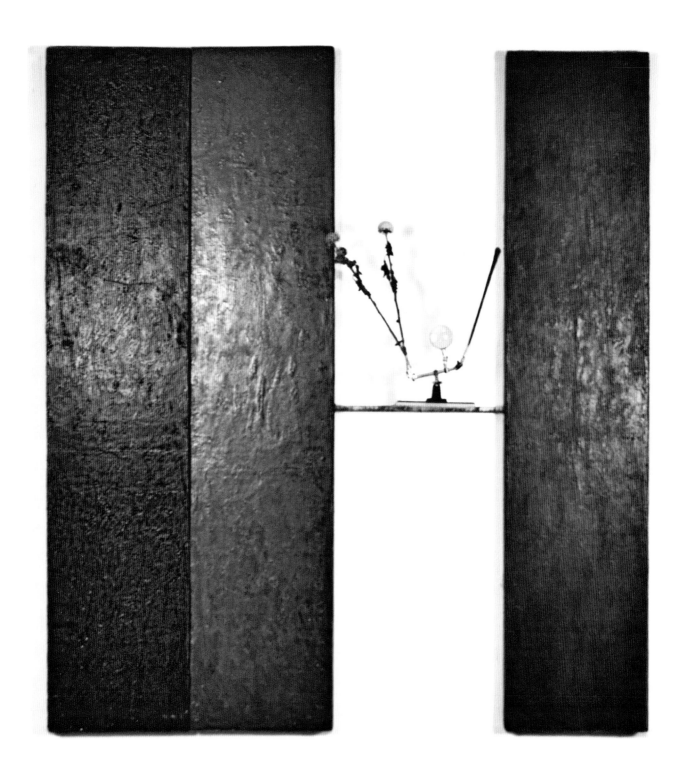

Natura Morte With a Helping Hand

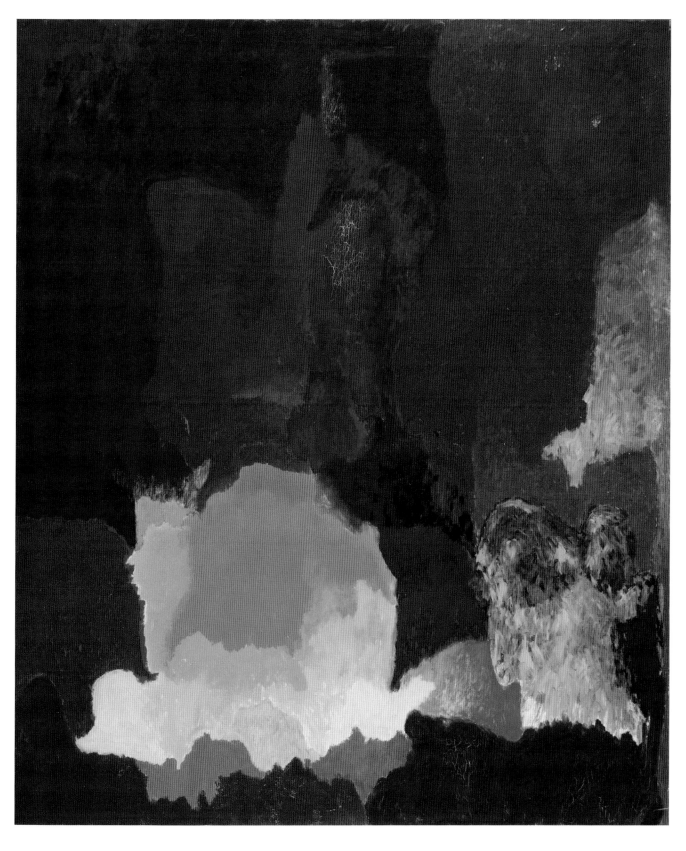

Sun Carpet 160 x 142 cm

Selected Texts
from previous catalogues

Conventions Objects & Fields

by Urszula Szulakowska

The first impression of these works is that Rob Ward is committed only to the bare elements which constitute a painting - field, surface, edge-, that is, to the minimalised object of American reductionism. Echoes are present of Rothko, Newman, the 'Field' painters, as well as of the ultra-minimalists with their barely-visible, scratched geometric grids. Ward's coloration recalls monochrome paintings of the sixties: the luscious seduction of pure paint, flooding the eye with singular, perfect luminosity.

This is a just impression to some extent. All contemporary abstract painters have to pass under the aegis of such modernist traditions, forced to acknowledge, test, verify, or negate, the conditions operating within the brief of absolute abstractionism.

However, Ward's work becomes problematic if seen only in such terms. For example, his use of colour is anti-modernist. For, the colour exists, not so much in itself, but as a consequence of two other factors which disintegrate entirely any modernist referants. First, his colours exist both to structure the painted surfaces and also as an 'illusionistic' device, due to illumination by flood-lights which alone reveal their full chromatic potential. Consequently, the drawings are less to be understood in terms of painting' and more in those of 'assemblage', that is, to be defined in terms of a sculptural context. Ward calls his works drawings', perhaps, partly for this reason. For, his mark-making does not refer only to the illusionism of the flat-support, but it also engages a three-dimensional space which exists simultaneously within the paper surface and as an actual material presence in reality'.

Ward's colour is neither pictorial, nor painterly, he builds-up a relief surface intended to activate three-dimensional space. He uses a ceramic-coated paper which resists the paint's sinkage. The surface traps light according to the direction in which the paint is laid by using cross-hatching, mopping the colour back and inter-layering with varnish. Out of one single red paint. Ward develops an orchestra of hues and tones which evolve into entirely different colours: from black, to purple, to orange-yellow, to gold. Into these he incises lines and, occasionally, geometric shapes. But, it is the final element of light, concentrated onto the surface, which is the „FIAT" of the work. Only then does the drawing come into existence. The light is an essential component of the structure of the work. In other words, the works imply a degree of theatrical temporality. They are not just objects on display'. The light is their skeletal basis and their mode of operation, as in the theatre-set. As paint and paper alone, the works have no existence.

Ward's intentions are similar to those of some kinetic sculptors who used light, such as Naum Gabo, and, especially, RJ.Soto who sought :

> 'to incorporate the process of transformation into the work itself. Thus, as you watch, the pure line is transformed, by optical illusion, into pure vibration,

the material into energy'.[1]

So, too, in Ward's installations, the staging requires the indispensable presence of the viewer, me second structural factor.

The aspect of the 'theatrical' in respect to 'fine art' constitutes a problem within me purist aesthetic of modernism. It is regarded as extraneous to the demands and essence of both 'the painterly' and 'the sculptural'. Perhaps, it is necessary to stop defining Ward's installations within such terms. Instead, one could place his extra-modernist references either within the arena of 'the post-modem', that which questions modernist purism, or, conversely, look at his art in terms of much older, pre-modemist traditions. In that the post-modem' involves a central focus on the narrative of popular culture and the production of a cultural critique, Ward's work is at the opposite pole. For, he avoids narrative and all commentary, meticulously removing his personal presence from the work.

One has to take into account at this point the shelved objects which accompany the twenty-eight drawings. They are a meditation on the history of drawing and on various compositional and conceptual problems which artists have to negotiate. The objects themselves are poetic in character and, occasionally, recall their cultural origins. But, this is not the reason for their selection by the artist. To assume an interpretation for them drawn from the use of 'objets trouves' by Dadaist, Surrealist and Pop artists over-simplifies their function in Ward's own installations.

In a sense, it does not matter what each object is specifically. In effect, in their form and meaning they are inter-changeable. Each one simply represents 0the object of observation' by 0the artist'. Thereby, Ward offers a resolution to the question of the relationship between an object and its representation in the art-work. He separates the surface of the drawing from the image on it. Then he telescopes together the image and the object by presenting the object as its own image, next to the field of representation.

There is another implication in such work which Soto described as the realisation of:

> 'an abstract world of pure relations, which has a different existence from the world of things......
> My aim is to free the material until it becomes as free as music... .not in the sense of melody, but in the sense of pure relations.'[2]

This well describes the poetic intentions of Ward's art which no longer concern the nature of the object itself, nor even the practice of art-making but, rather, the structure of relationships involved in viewing a work-of-art. This leads to a meditation in

which the viewer consciously considers proportion, space, siting and, gradually, as in classical art, the viewer becomes aware of time and space as pure forms in themselves. The objects in their size and placement, the quality of the light, the radiance of the colours, produces an intimate space which unites the viewer to the work.

> 'Separately, these things are nothing, but together
> something very strange happens.. -a whole world
> of new meaning and possibility is revealed by the
> combination of simple, neutral elements." (R.J.Soto) [3]

Ward likes to compare his installations to the Purist paintings of Morandi, as an actualisation of two-dimensional, still-life. The location of each object, its scale in relation to the others, develops into a series of harmonies and counter-balances, just as the form of Ward's objects echoes shapes in the surfaces of the drawings.

Placement, in fact, is the key to Ward's installations. Both the scale of the drawings and the height of the shelves are related to his own eye-level. The shelves are sited exactly half-way-up the side of each drawing and at a specific distance from the drawing. The shelves are made from transparent glass which allows the flood-lights to shine through onto the wall in order to create an independent shadow-installation/drawing: a work-within-the -work which only exists in time.

The spectator moves closer, cleaves the space between the light-source and the lit-objects and, finally, the work is complete. It is mobile, transient and, literally, transparent. Unlike traditional theatre, these installations are not a spectacle. There is no proscenium arch and they are not a picture, nor a 3D tableau.

These are works that have to be entered. The spectator, the human-figure, is the subject of the work. Within the space of light, viewpoints become inconstant, die painted surfaces enlarge and diminish, swim away as seas of colour, emerge as precise sets of marks. The objects on the shelving become monumental, their 'art-objet' preciousness disappears as the viewer negotiates the problem of seeing both the object and the field together. The space is restless. It allows no focal point of rest, demanding incessant measuring, moving backwards and forwards to view the whole. The presence of the viewer within the arc of light is challenging. The work is a puzzle, an active meditation.

This aspect of Ward's work: the installation / tableau involving multiple (or one single precise viewing-point on other occasions), plus the high energy of the drawing and the paint-work, goes beyond an English tradition of art-making. Often it is disturbing to English sensibilities which are used to works that neatly consummate their meaning in one, focused knot that 0pulls it all together'. Ward has been affected by his experience of non-English culture: first, the Mediterranean's heightened colourism and classicism. Second, he has engaged in the cultural dynamics of Australian art: in its use of complicated, mixed-media installation, its sprawling-scale, site-specific arenas: whole buildings dedicated to a single work centralised on a mobile viewer. Created environments which are closer to a tradition of physical theatre, than to the solid, isolated object of English modernism: a hall of mirrors springing and bouncing the viewer off the work, destabilising the focal-point. Australian eclecticism consists of promoting a theme only for as long as it is necessary to hold the viewer's attention, not exploring a single form for its own sake.

Yet, it cannot be denied that Ward's installations are effective in pictorial terms. Step back into the penumbra of the light and the installations become an exposition of visual beauty, a concern with a classical aesthetic of measure.

It is worth pausing to contemplate this aspect, involving the early Renaissance craft of glazing, trapping light between thin layers of colour. Also, consider Renaissance optical illusionism which often sought to place the viewer within the picture-space, as in Jan van Eyck's Arnolfini Wedding in which the artist's reflection in a mirror on the back-wall implies that he is actually standing behind the viewer.

In the same way, the installations made by Rob Ward demand an active consideration by the viewer of multiple-viewpoints within the work, measuring the parameters of one's own body against space and time.

[1] [2] [3] Signals, 1,10 Nov.-Dec, 1965, 13.

Crimsworth

by Urszula Szulakowska

Not for a moment
Must you think our voices die
Leaving no traces;
Truly more than what they are,
Words are equal to our hearts. [1]

(Ryokan)

In his current exhibition, Rob Ward is examining drawing on its own terms. He is producing objects which are concerned primarily with mark-making in a broad field of colour-tones. As such, the works assert their independence from academic art-theory. The drawings exhibit the material processes of art-making. These generate their own autonomous discourses. As such, they are completely open to the viewer who reads the surface unhampered by a subject-matter imposed by the artist. What results is a series of energized examples of purely visual thinking.

The drawings are the result of long years of study by Rob Ward in Europe and Australia. More immediately, they were produced on the basis of ideas and impressions from the artist's frequent walks with his dog in the valley of Crimsworth, near Hebden Bridge in Yorkshire during 1994 and 1995. The drawings represent a stream of consciousness, a series of exercises related indexically to the artist's sources of inspiration, rather than constituting a closed set of 'finished' iconic images. Not representational in any way, the drawings trace Ward's immediate responses to time and space. They are samples drawn from a field of purely visual resonance.

Although this was not a conscious influence, Ward's drawings could be compared to the Japanese poetry of Ryokan, Basho and Etsujin in their disciplined systems of construction. One glimpse of the initial image, but then rapidly unfolding a visual world concerned more with the structure of poetry itself and with memory in the aspect of 'art', rather than with Nature:

Bidding farewell,
Bidden good-bye,
I walked into
The autumn of Kiso [2]

(Basho)

Onto a bridge
Suspended over a precipice
Clings an ivy vine,
Body and soul together... [3]

(Etsujin)

Ward's drawings represent not the natural landscapes of Yorkshire but, as in Japanese poetry, they examine the landscapes of the mind. The images evolve through a dialogue independent of Nature between an artist and his materials.
Ward created his own system of working, akin in its austerity to the making of Haiku poetry. He determined to produce one drawing per week as a quick and accurate response to the idea generated in his mind during his walk in Crimsworth. Although the drawings vary in their complexity from minimalist single-colour statements, to architectonic works involving geometry and symbolism, each had to be completed within the given time span and accepted as a valid 'work' whether it was considered to be 'resolved' or not in formal terms.

This is an almost Zen-like discipline demanding a surrendered acceptance of outcome or non-outcome: one which consciously sacrifices the egoism of 'mastership', of personal control over product, of satisfied self-reflection. Rather, there is an attitude of humility before the Idea stimulated by the extraordinary particularity of Nature. Then, in the intimacy or the studio, another agreement is made with the autonomous process of art-making. Such an exercise demands considerable reserves of self-confidence and self-knowledge. It is the mark of an artist in his maturity.

The friction between the discipline of the rules and the unstructured impressions of the individual mind produce a work which, as in Japanese poetry, hovers between materiality and mind. The drawing, rather than representing Nature, is a continuation of Nature, carried into the human sphere of memory and being.

In many Eastern philosophies there is no dualistic opposition between Nature and mind such as that which plagues „Western concepts of existence. The intuition that Being is a continuum between matter and mind is the foundation of Japanese drawing and poetry. These creative forms cannot be classified according to the definitions of Western 'art' as forms which are created primarily by the intellect, but neither are they merely 'a picture' emanating from the influences of the natural world.

In a similar manner. Ward's drawings were created through his determination neither to manipulate his own memory, nor the process of 'making a drawing'. The resulting works are difficult to classify. Their connection with Crimsworth is real and continuous. The valley is not only a starting-point for the imagery, for the drawings have become an extension of Crimsworth. They are 'slices' from 'field' which is both visual and mental, natural and synthetic, impersonal and individual.

There is a passion in these works, paradoxically, as a result of maintaining the discipline of the rules of their making: a rapid and immediate response: 'getting it down. Yet, the rules mean that the works cannot be described as 'expressionistic'. They distance the artist from his wilful desire to express his own individual emotions. As in the discipline of poetry, the form of the work takes priority. A subtle distinction is made between pure memory and the flood of emotions which develop from that memory. The aim throughout Ward's art-practice is that of classical clarity.

Drawing for Rob Ward is a process of meditation and reflection, not of emotional response.

It is characteristic of Ward's drawings that his concern with the classical harmonics of balance and proportion modulates all his most intense ideas. He favours the distillation of essential ideas which communicate most immediately to the viewer. Hence, these are works which 'talk', which are accessible and permit entry by the viewer. The drawings are tangibly present to the audience as drawings, rather than as illusionistic windows onto a landscape. They are happening here and now due to their tactility and the broadness in handling the medium. The richness of subtle reference allows the viewer freedom to interpret the drawings in their own terms. They do not dominate through rhetoric. Rather, these are seductions by means of poetry and luminous surface. The drawings are as simple and immediate as the splash of a stone hitting the surface of water.

Above all, Ward's drawings delight in the haunting power of memory, in the mind's possibilities of both transcendence and imminence in relation to Nature.

The drawings vibrate with resonant colour, varying from the minimalism of a Chinese silk painting, to the colouristic text of the tradition of Rembrandt, the schematic colour contrast of Kandinsky, the geometric oranges and yellows of Mark Rothko, ending in a Baroque orgy of maroons and dark greens, burnished golds, ultramarines and coppers.

Rob Ward works on ceramic-coated paper, six foot by four, using two units per drawing. He draws with colour, scratching back to the ceramic surface, incising graphic lines and symbols, cross-hatching, with a variety of instruments: needles, spatulas, pincers, tweezers, spoons, compass-points and quills. Instruments recalling the contents of an eighteenth-century wunderkammer'. The 'surfaces are glazed, sometimes several limes, which occasionally results in crackling' which traps light like a dark reflecting jewel. Any 'mistakes' in technique are accepted and incorporated into the painting.

The colours are applied as pure pigment. Colours such as the range from yellow, through orange, into red and dark-maroon are produced from a single red paint. The palette emerges in the process of drawing as a result of the glazing technique. This technique is also used with the blue and green ranges. The use of varnishes causes new colours to appear magically only because of their surface placement. They have no absolute existence of their own.

Adding graphite Ward produces rough effects of gold within the maroons and purples. The colours are worked in simply with rough paper. Ward never uses brushes.

In his deep understanding of paint and glazing, Ward is one of the few contemporary painters who may have retrieved the famed 'alchemy' of Jan van Eyck's glazes. Colour contrasts can be minimal, subdued, butterfly-touches, or they can be jarring 'wake-up' contrasts. Gradually in the course of the production of the drawings a set of symbols evolves: at first, simple squiggles, punctuation marks, incised into the paint, glazed with dark reds. Then, more conscious forms develop: the shape of a metal triangle, or of a sculptors mould for casting. Many of these forms are drawn from Ward's own collection of marvels in his 'camera' of objet trouves. They have appeared throughout other works as

his own personal vocabulary.

Finally, straight lines and geometry emerge, dividing up the spaces, with indirect references to horizon and perspective lines. These introduce architectonic qualities into the drawings. The architecture of the working-surface is a major concern for the artist and justifies his definition of his drawing as being a form of 'sculpture', rather than a painting'. Ward compares his method of paint application to that of the process of constructing a three-dimensional work. For, the ceramic-coated paper resists the application of paint, pushing the surface incidents out into the viewer's space. The ceramic coating demands techniques taken from engraving in order to produce the graphics. Ward carves into the surfaces like a sculptor, rather than drifting his paints across two dimensions as in painting.

Furthermore, light is a structural component of the drawings, as it is in sculpture, since it is light and placement of the marks, rather than pigment by itself which creates the colours and the architecture of the works.

Later drawings in this series make delicate references to the outline of a female form, a lateral reference which cannot be defined. There are other images which flashed into the mind of the artist as he worked. These merely pass through the work like the undetermined persona of Calvino's novels, or like the 'non sequitur' fragments of Proust and Joyce: wanderings through the spaces of the mind: a pair of earrings, a hand, phallic shapes, ... the delicate eroticism of Milan Kundera's dreams... images which interrupt the ongoing dialogue of the artist with himself, but are only briefly acknowledged.

Ward defines his literary affiliations:
Proust dealt with the remembrance of the past and Joyce
dealt with living in the present moment.[4]
These delicate fragments reveal a sensuality in Ward's drawing. However, they do not detract from the almost impersonal measure of the creative process which the artist has set in motion. The innocence and freshness of the work rejects the heavy layers of the subconscious mind. As Ward has stated, for him the process of drawing is about 'returning yourself to yourself. It is not about self-analysis, nor is it a commitment to 'making a formal painting'. The drawing is a continuation of walking through Crimsworth valley, transient, changeful, without conscious purpose but in relation to a self-determined impersonal procedure.

The continuum of walking and drawing was for the artist Oan exercise in doubt'. He challenged his own drawing skills 'could you do this to your satisfaction in a week?'

There is a poetic wistfulness of mood in some of the works which conjures-up an image of a wanderer, willingly isolating himself within the landscapes of memory.

> High on a rocky hill...
> I hold my chin in my hands, and watch
> far clouds glide...[5]
>
> (Ryokan)

1 John Stevens trans, The Zen Poems of Ryokan, N.Y, 1977.
2 Nobuyuki Yuasa crans, The Narrow Road to the Deep North..., London,1966.
3 Ibid.
4 All quotes from Rob Ward, interview with U- Szulakowska, Bretton Hall, January, 1998.
5 John Stevens trans. The Zen Poems of Ryokan, N.Y, 1977.

Songs

by Urszula Szulakowska

The sole purpose of sculpture is neither description nor imitation but the creation of unknown beings from elements which are always present but not apparent.
(Duchamp - Villon)*

The three-dimensional artefact has its own curious logic which arises from the uncompromising density of sculptural materials, as well as from the sculpture's ability to warp and twist physical space by its very presence. Sculpture also disrupts the spectator's psychological space, raising difficult questions concerning its 'reality' and how the viewer should negotiate its singular demeanour.

However, the viewer has a significant degree of freedom in regard to the material art-object. A painting, or a film, for example, can subjugate their audience by illusionary tricks which cause viewers to lose their own sense of embodied self. But, in the case of a three-dimensional object, the significance of the work is generated by the audience, specifically by their physical presence and by their movements around the objects.

This is Rob Ward's working hypothesis in the present series of installations. He has addressed the nature of the sculptural artefact through a dialogue between two-dimensional drawing and the material object. Within these works, it is the viewer who creates the space and, thus, the meaning.

The drawings are simply structured, producing a vibrating space. Spare in colouration - red, blue, yellow, white - a few simple images relate to various bronzes placed at the side of the drawings. The installations are thematic, intentionally musical in inspiration and conceptual resonance. Each work is dedicated to a person, such as members of Ward's immediate family and close friends, but they are not works which address psychological issues. Instead, they range from phenomenological investigations concerning the viewing-point of the spectator, through to forms which bear resemblance to written script, or to organic nature. The original objects used for the bronze casts often discretely reflect Rob Ward's personal history.

In his experiments, it is the process of casting which acts as the conceptual bridge between the two-dimensional drawing and the sculptural object. This same process also determines the position and movements of the viewer in relation to the installations. The viewer is lured into close proximity to the works in order to examine the fine details of the bronze cast, such as the edges of a fraying rope, or the fragile delicacy of a cast raffia fan, as well as the luscious, green-blue patination of the surfaces. But, he then has to step back, restlessly, to catch the effect of the whole work.

There is no single viewing-point since Ward has introduced a strong contrast between the hermetic constituents of the bronzes and a broad spatial field of vision. In one work, for instance, three bronze tripods are perceived as stools, as a site for a 'conversation piece'. However, on retreating, the viewer perceives them as being a frontispiece to a stage set which incorporates the red painting behind them.

As Marcel Duchamp commented:
"It is the spectator who makes the pictures."

The installations produce a. sense of personal intimacy with the viewer. This aura of familiarity is itself a challenge to the history of rhetorical public sculpture. Ward has specifically chosen to use bronze, in a deliberated questioning of the monumental and architectural traditions of Western sculpture with their authoritarian resonances.

However, the form of his sculpture is also seemingly 'traditional' in that it is object-based. He even occasionally places it on a plinth, 'a sculpture's circle of solitude' (Rilke). At other times. Ward returns to Anthony Caro's motif of placing the work directly onto the floor. In some works, the bronze cast engages with the angle of the floor and the wall. Other objects are located on shelves, recalling the conceptualist works of the late 1960's.

In these references to such historical conventions of sculpture, Ward re-examines the nature of sculpture, bur he posits 'sculpture' as being a 'trope', a figure of signification which generates a series of contradictory historical discourses. 'Sculpture' is much more complex than the empirical history of iconic works as presented in the institutional art museums.

In the series of engagements with the aesthetic and institutional texts of history, the patination of the bronze in Ward's objects is extremely imporrant. The objects are loosely patinated in a painterly way. This type of finish is almost never seen in the gallery context. Usually, such extreme effects of patination occur only on architectural finishes, such as the casing of domes where they result from environmental stress. It is almost impossible to examine this kind of patinarion at dose view. In the gallery space, more often, the patinations are over-fastidious, finer in texture and mellow in tone, conforming to the 'objet d'art' tradition.

In Rob Ward's sculptures, the finish of the works serves as a type of painting. He describes it as a way in which he 'telescopes painting into sculpture' producing a 'tension' in the optic and haptic perceptions of the viewer. These surfaces are kin to expressionistic painting, yet they are also undeniably 'sculptural' since they are organically produced by the bronze itself.

In turn, the paintings are hung to the ground so that they act as backdrops to the bronzes. The paintings have become actual objects in the same space as the sculptures and their prime relation is with the space on the floor, not with any symbolic content on their surface. Again, the process of casting acts as a unifying conceptual trope between sculpture and the drawing. For, the paper of the drawings is cast-coated ceramic.

Consequently, Ward's drawing procedure is, in fact, close to etching, a procedure of inscribing marks in which the unyielding surface of the paper rejects the pigment, rather than absorbing it, contributing, thus, in an integral manner to the production of the specific colours of the paint-surface.

Similarly, his bronze sculptures are no longer locatedwithin the isolated glory of the academic tradition, but are placed in relation to the paintings. The bronzes are cast from utilitarian objects, such as a chemistry bench, or a pigsticker for a barbecue. Some sculptures, however, return to an investigation of'drawing in space'. One such work, dedicated to one of Rob Ward's daughters, is a three-dimensional graphic improvisation, cojoined with a blue painting. In its over-life size elongation, it is both totemic, implying a narrative content, as well as a form of musical notation, or a diacritical phrase of verse. Closer scrutiny reveals chat this 'phrase' is composed of the most surprising, loosely autobiographical, elements. It is cast from objects such as a bobbin, a water-sprinkler and a hammer.

A certain sexual element is overt in Rob Ward's current work, signified, for instance, by a water bowl with a bronze point dipping into it, or an incongruous found-object, consisting of a garish 'golden' vase with a shell-like form and vulvic mouth. In another work, severe coffin-like, but fetishistically female, triangular forms stand open against the wall in a double reflection of themselves. Finely balanced across the painting is a rod, suspended from the point of a triangle.

Although the present installations have not evolved from any singular historical influence, Brancusi is one of Ward's mentors and he is referenced in the stacked-up forms which recur in Ward's sculpture. Another reference to Brancusi is in his occasional use of glistening, burnished surfaces, as in one set of bronzes cast from the residues of another sculptures work, in an acknowledgement of their friendship. The use of light and shadow is also central to Ward's practice, reinforcing the viewer's after-image of the dense colouration of the paintings and sculptures. He often introduces water into his works, so that colours are picked up in their purity and reflected.

Yet, paradoxically. Ward also acknowledges the American abstract expressionists as another important factor in his artistic development and in his range of references. One clue which illuminates Ward's interconnection of these opposed aesthetic principles may be found in Harold Rosenberg's definition of abstract expressionism:

> The act-painting is of the same metaphysical substance as the artist's existence.
> (Art News, 1952)

This is essentially how Brancusi also viewed his sculpture, as an action beyond conscious enunciation which could unify diversified phenomena. He also sought some essential 'Isness' of unified Being which, for him, in contrast to the expressionists, was to be found within reductionist, minimalising processes aimed at revealing the essential qualities of matter in space.

In fact, within Rob Ward's installations, there is a determining overall order which, as in Brancusi's sculpture, tempers and refines the narrative motifs. Ultimately, although Ward questions the classical origins of the Western sculptural tradition, he himself belongs to that tradition. For, his experiments occur in relation to the classical determinants of balance and harmony, adjusted by right proportion between nature and sculpture.

This aspect of a natural, central discipline within Ward's improvisation is due to an aversion to excessive effect and to excessive personalisation. Rather, as in the classical tradition maintained and furthered by Brancusi, he seeks for those essential qualities which are timeless. Yet, as in Brancusi's work, these are humane qualities. It is often forgotten how warm, tactile and animated is classical Greek sculpture. It is sensual and begs to be touched. There is no bombastic rhetoric.

Nearly all of the ancient debates concerning the nature of art, those of Aristotle, Cicero and Seneca, were focused on the bronze sculpture of the Greek masters, such as Phidias. They argued over the exact relationship between the artist's imagination, organic nature and the raw artistic materials. In their discourse, they established that the sources of artistic inspiration were those same principles which underlay nature, namely, those which produced life-supporting order.

Perhaps, this is what Rob Ward means when he states that his overriding intention is 'to create a song', a form of expression which, although personalised, nonetheless, rises from a source deeper and more universal than ponderous psychology or dour theory. In this aspiration. Ward has a kinship with Brancusi, who urged his audience:

> Don't look for obscure formulas or mysteries.
> It is pure joy that I am giving to you.
> Look at my sculptures until you see them.*

Quotes taken from:
John Goldinp, Cubism, NY, 1955.
John Golding, Marcel Duchamp, London, 1973.
Sidney Geist, Brancusi, NY, 1975

6 Memos

by Rob Ward

Lightness

A sepal petal and a thorn
Upon a common summer morn —
A flask of dew — a bee or two
A breeze — a caper in the trees
And I'm a rose

(Emily Dickinson)

World view which values lightness against heaviness. Lightness representing the potential for flight to another space where solidity and knowledge are dissolved.

And then those bodies built of unions small
And nearest, as it were, into the powers
Of the primeval atoms, are stirred up
By impulse of those atoms unseen blows
And thereafter good the next in size
This motion ascends from the primeval oh
And stage by stage emerges to our sense
Until those objects also move which we
Can mark in sunbeams, though it not appears
what blows do urge them.

Lucretius - De Rerum Natura II 139-149

Lightness of thought/ lightening of language meaning conveyed through texture that seems weightless until meaning takes on the same consistency.

'As snow falls in the mountains without wind'

Dante- Inferno XIV 30

Melancholy is sadness that has taken on lightness, humour is comedy that has lost its bodily weight. Humour casts doubt on self and the network of relationships. Doubt is what we are left with.

But it is a melancholy of mine own compounded by many simples extracted from many objects, and indeed the sundry contemplation of my travels which by often rumination wraps me in a most humorous sadness.

Shakespeare - As You Like It

Already all the air darkens deepens to blue and shadows glide from roofs and hills at the whitening of the recent moon.

Leopardi - History of Astronomy

An existential function -
Astride our bucket we shall face the new millenium without hoping to find anything more in it than what we ourselves bring to it.

Kafka - The Knight of the Bucket

Quickness

Chang-Tzu was an expert draftsman — the king asked him to draw a crab, Chang-Tzu replied that he needed five years. Five years later the drawing was still not begun 'I need another five years' said Chang-Tzu. At the end of these ten years Chang-Tzu took up his brush, and in an instant, with a single stroke, he drew a crab, the most perfect crab ever seen.

Any object is magic. Each object is endowed with powers which determine relationships. There is always a drive of desire toward a thing that does not exist, towards the lack or absence, the empty circle, toward the rhythm - rather than the narrative. The secret lies in economy, events however long are connected by rectilinear segments in a zig zag pattern that suggests incessant motion.

Time can be delaying cyclic, still/ drawing is an operation carried out in a length of time, acts on the passing of time. Repetition is a way of dealing with time and its relativity. The function of art is to achieve communication between things which are different sharpening the difference. The triumph of media is flattening communication into a homogeneous surface. Mental speed can not be measured nor does it display its results historically, it is valuable for its own sake. Time is wealth.

'Words words that make me think. Because I am not devoted to aimless wondering. I'd rather say that I prefer to entrust myself to the straight line, in the hope that the line will continue into infinity, making me unreachable. I prefer to calculate at length the trajectory of my flight, expecting that I will be able to launch myself like an arrow and disappear over the horizon. Or else if too many obstacles bar my way to calculate the series of rectilinear segments that will lead me out of the labyrinth as quickly as possible'.

Calvino - Six Memos

An artist takes account of patience and intuition so instantaneous that it acquires the finality of something that would never have been otherwise. The rhythm of time that passes with no other aim than to let feelings and thoughts settle down, mature and shed all impatience of ephemeral contingency.

Visibility

Ineluctable modality of the visible: at least that if no more, thought through my eyes. Signatures of all things I am here to read, season and seawrack, the hearing tide, that rusty boot. Snot green, blue silver rust: coloured signs. Limits of the diaphane. But he adds: in bodies...shut your eyes and see.

(Ulysses – James Joyce)

To place visions directly in the mind without making them pass through the senses. Visual fantasy which precedes verbal imagination. I want my work to appeal directly through its space to the mind, through its luminous qualities formed according to my imaginary world.

A visual contemplation and composition of place, seeing from the imagination the physical place. Images rain down into fantasy and are differentiated through the unconscious. Time regained in feelings from time lost. Epiphanies concentrations of being in a single spot or point in time involving processes which go beyond our intentions and control acquiring a kind of transcendence. This process may change by working from a text where the image is determined creating an imaginative process in the spirit of the text.

Imagination is a repository for what is potential and does not exist. The artist's mind works according to a process of association of images that is the quickest way to choose between the possible and impossible. The imagination is a machine which takes account of all possible combinations appropriate to a purpose or are most interesting/ pleasing or amusing. Visibility of needs concerns itself with bringing forth forms and colours, and thinking in terms of images, fields of analogies, symmetries and confrontations. Form arises from fragments of the imagination coming together in unexpected ways.

Two paths seem to be open.

1. Recycle used images in a new context changing meaning, mass media, taste for the marvellous, accentuating alienation, post modernism.

2. Start again. Reducing visual elements to a minimum.

All realities and fantasies take on form only by means of doing in which outwardness and innerness are composed of the same artistic materials. The visions of the eyes are continued in colour, line, geometry, conventions, objects and fields of activity representing the world on a surface that is always the same and always different like dunes shifted by the wind.

Multiplicity

I reflected that everything to everyone happens precisely now, century after century and only in in the present do things happen. There are innumerable men in the air, on land and on sea, and everything that happens, happens to me.

(Borges – The Garden of Forking Paths)

There is a multiplicity of connections between events, people and things. The world is a system within a system. I deal with fragments and whatever the starting point the work spreads out to vaster horizons. Involvement with multiplicity demands knowledge of things of past and future, real and possible to locate everything in time and space.

To know is to insert something into what is real and hence to distort reality. Things, therefore, are distorted by representation. The tension between me and the things represented creates the work. Knowledge of multiplicity carries me from objectivity to subjectivity, from the rational to the distorted. It involves mental orderliness, exact process, poetry, science and philosophy. Knowledge is the awareness of the incompatibility of two opposites, exactitude and chaos.

Exactitude

For the ancient Egyptians, exactitude was symbolised by a feather that served as a weight on scales used for the weighing of human souls. This light feather was called Maat, goddess of the scales. The hieroglyph for Maat also stood for a unit of length — the 33 centimetres of the standard brick — and for the fundamental note of the flute.

Exactitude means:
1. A well defined plan
2. An evocation of clear inclusive memorable visual images
3. Language as precise as possible

The inability to look has created generic formulas, anonymous dilute meanings and blunt expressiveness, politics, ideology, bureaucracy, mass media contribute to the lack of exactness and form. Visual images are stripped of meaning and form and leave no trace in the memory.

The unknown is always more attractive than the known. Hope and imagination are the consolation for the disappointments of existence. Exactitude goes side by side with lack of definition.

'Why couldn't there be in some way a new science for every object. A mathesis singulars and no longer universalise'.
(Barthes - La Chambre Clair 1986)

Measure, limits, series, numerical proportion, abstract pattern, effort made to present things as precisely as possible. Mental space and space of objects. Language is defective saying less with respect to what can be experienced.

A naked silence and a most profound quiet will fill the immensity of space. So this marvellous and frightening mystery of universal existence before being declared or understood will fade away.
(Leopardi - Song of the Great Wild Rooster)

Detail the positive incision, the perfect line. I am drawn to the small set against the vast. The way the world is entropic. Irreversible within this process there are portions of order and form privileged points at which we discern a design or perspective.

There are two paths:

1. The last degree of abstraction and nothingness to be the ultimate substance.

2. The drawing seen as an amalgam of minutely complicated forms and things.
The horizon overscored with misty accents, marks, seems to be

printed in small letters of darker or lighter ink depending on the light. What lies closer gives me no more pleasure than a painting. What lies still closer no more then sculpture or architecture. As to the reality of things right up to my knees like food, a feeling of real indigestion. Until finally everything sinks into my body and flies out through my head, as though through a chimney open to the sky.
(Landscape Francis Ponge - The Voice of Things)

Each life is an encyclopaedia, a library, an inventory of objects, a series of styles and everything can be constantly shuffled and recorded in every way conceivable. Think what it would be like to have a work conceived from outside the self, a work that would let us escape the limited perspective of the individual ego not only to enter into selves like our own but to give speech to that which has no language, to the bird perching on the edge of the gutter, to the tree in spring and the tree in fall, to stone, to cement, to plastic ...
(Italo Calvino - Six Memos for the Next Millenium)

Rob Ward's Memo

by Elio Grazioli translated by Elena Cologni

Rob Ward's reference to literature is much more than a simple pretext, it constitutes a poetics in itself. This is made more explicit by his new body of work exhibited in Bergamo, which is inspired by Italo Calvino's Six Memos: American Lessons. These installations represent a kind of cross reference, in which the role that the literary has in Ward's work corresponds to the role that the visual always had in Calvino's texts. An issue, this one, that has regained importance after the climax of the so called 'conceptual' art (art "after philosophy", as Joseph Kosuth put it).

What is the right place for speech in a figurative artwork? Clearly Ward is not a 'conceptual' artist and there are no words in his work, which tends more evidently towards silence instead. Text is pre-text, word which comes first, as source and convergence point, but without imposing itself on the image, the matter and the composition. The most evident quotations, in Ward's new body of work, remind us of this very concept: on the one hand Barnett Newman in the vast mono-chromatic surfaces with 'zips', on the other Giorgio Morandi in the 'skittle' which reappears in different parts. Sublime, metaphysical and with a strong literal ascendance, Ward's work replaces words that have extinguished, that have already had a place and of which just the echo is perceived — according to Ward's metaphor.

Games of rebounds, reflections, variations in dimension and mutations which articulate the whole of Ward's work recreate with a visual language what echo recreates for speech. Sound Metaphor: the only written words in the exhibition are on the back of the vertical element of the convoked metronome. In Ward's Quickness this is a ready-made object that speaks of being called, convoked - at the appointment, as Duchamp said - rather than being taken, exhibited, pointed at. The words are: "moderato", "allegro", "molto allegro". They are ambiguously connected to music and sound, like the whole of Quickness, through measure and time — rhythm, with which Calvino defines Lightness in Cavalcanti — but also sentiment — just like with the verb 'to sense', etymological synonymous of 'aesthetics'.

Let us go back to Six Memos. What Calvino did, or what Ward believes he did, Ward does in his own memos: free, but respectful quotations are collected in the thread of a discourse open to deviations, returns, flashbacks, grouped around main themes. This is a discourse in which we can't get lost, based upon the belief that just through an indirect, mediate and wide open approach we can hope in a truth as the result of a strategy of rebounding.

It is a poetics that we would call 'of the reader' - as well as 'of the reader of images' (this is the metaphor that started Modernism, more precisely Cubism) - rather than 'of the author-writer'. Such poetics now belongs to those who are interested in other people's ideas and images and in the concepts of combining and repositioning, in the dynamics of attention and desire, of taking in and giving back (in Ward's work: mugs, cups, bowls... and again reflections, mirroring...)

A central figure in Six Memos is the ring - with all its variations - about which Calvino tells us a legend: Carlo Magno would fall in love with whoever wore it, even the lake in which it got thrown at the end, which he would never leave. This image is also often found in Ward's Memos. In Calvino's text the ring does not represent the usual perfect circle, but the 'magical' object, whose movements determine the relationship between the characters and the dynamics of the evolving story. This is an object that goes back to fetishism and perversion rather than narcissism, that is to say, in psychoanalytical terms, a kind of Lacanian object "petit-a" whose slippings and turnarounds mark the route of desire, the succession of meanings and the destiny of sense.

'Readers' see texts, images and ideas as something similar, build their own text and work through their reunion. What changes, what has changed already, is the relationship between word and image, as well as that between truth and fiction, between memory and proposals ("memos" in English and "proposals" in the Italian version). This is due to the impossibility of a pure representation of the real, and therefore these relationships require a non-direct, mediated and knotted strategy ("filleted", we would say referring to the various filleted objects in Ward's work exhibition). Still, the circle is not closed: in the end, the multiplicity of elements involved refers, in a kind of cross-mirrored image, to a single 'I': that of the author, but the one ending the journey, not that at its beginning, an 'I' that the author takes back.

This represents, after all, the originality of Ward's work, the uniqueness of his achievement. The artist shares a challenging interpretation of Six Memos: American Lessons, according to which they are not mere lessons or narrative drafts by a writer, but a complete, finished piece of literature. This is a possible interpretation which is left open because of the absence of the last 'lesson' he had conceived. The subject should have been Consistency: coherence, congruence, solidity connecting the parts of a whole. In Calvino's intention this should have been the sixth memo, to Rob Ward it represents the whole of the exhibition.

Patterns

by Cathy Ward

Patterns is a show of thirty new works by Rob Ward. The title refers to both material objects and to abstract rhythms of working and thinking that Ward has developed and refined during his career. A pattern is essentially a design or plan for something to be made but also the organization of forms (or perhaps ideas and processes) in a repeated sequence. Important to both senses of the word is the idea of relationship — the relationship of the plan to the realised form, or of one element in a sequence to another. Indeed Ward's new works are primarily about relationships of various kinds; in particular formal, spatial, emotional and imaginative.

All of the thirty pieces exhibited here consist of a cast or fabricated metal sculpture and a supporting plinth; twelve of them also have the additional and integral element of a wall-hung drawing. Incised into each drawing's surface is the precise outline of the corresponding object on its plinth; the plinth in turn is suggested by a horizontal base line towards the lower edge of the drawing. This repetition of formal elements in both two and three dimensions establishes one of Ward's primary concerns; the relationship between sculpture and drawing.

Many of the forms used to construct the sculptures are casts of redundant patterns salvaged during the closure of a Yorkshire-based engineering factory. By using these moulds to cast sculptural components, Ward has changed their function from mechanical to aesthetic. Within this new role the patterns reveal their exciting potential to articulate scale at a variety of levels. The actual size of many of the pieces makes it possible to pick them up or otherwise handle them. However, the implied or potential size additionally invites the experience of 'entering into' or being 'enclosed by' the interior space of the works.

This shifting character is further heightened through variations in surface as well as scale. A range of metals including bronze, aluminium and cast iron, gives each of the pieces a distinct quality. Works such as House, Cathedral, Twin Spires, Bird in Space and Water Towers 1 and 2 are highly reflective of their surroundings, whilst others like Fountain and Bath have a dark, dense, light-absorbing surface. One effect of reflection is to dematerialise form by producing the illusion of space beyond (or inside) the object's surface; in contrast, a non-reflective material tends to intensify qualities of weight and solidity. Another result of a shiny surface is to make the viewer conscious of the object's special status, which both arouses and inhibits the desire to touch.

Ward has often used cast objects as sculptural components but these have usually consisted of much lighter and more open forms. Water sprinklers and fans made a regular appearance in earlier work, evoking the heat of another country along with the memories of a warm suburban life. The patterns also belong to a world of heat but it is the violent heat of the furnace and crucible; a man-made heat created in the midst of a cold grey country,

evocative of toil instead of leisure.

Although the solidity and monumentality of the pieces exhibited here are in some ways a departure from Ward's previous work, they do continue several enduring themes. These include reflection, balance, relationships between two and three dimensional space and the investigation of formal, geometric elements within both drawing and sculpture. In this show Ward has gathered these themes into a series of meditations on size and scale in which he explores the potential of small sculptures to function as ideas for larger works, without confining their status to that of maquettes. As small-scale pieces within the gallery context, they give full expression to their sculptural and spatial intentions but also hint at the possibilities beyond their restricted size.

In many of the present works there is a vivid sense of architectural space, which is both a social space where human life unfolds and a private space of the mind. Because all architecture is related to the scale of the human body, the viewer's relationship to the work is constantly shifting between the scale of the hand and the scale of the body, alternately inspiring the desire to hold and the desire to enter. Some of the titles — House, Door, Gate, Cathedral — further encourage this subconscious conversion of scale in the viewer's mind, which works just as well in reality as in the imagination.

One successful conversion from small to large is evident in a nine-metre-high outdoor version of Cathedral, commissioned by Peel Holdings in 2003 for a prominent site on a Wakefield business park. At this size the reflective potential of polished stainless steel is fully and stunningly realised. The relatively flat, open aspect of the site is perfectly suited to the sharp, soaring verticality of the sculpture. The use of a high mirror finish introduces a dynamic element of movement into the work. Sun, clouds, grass, buildings and people dance across its surface, turning hard metal into a molten trap of light and space. As the viewer moves around Cathedral its appearance shifts from solid to liquid, like an ever changing silver portal to another world; a world perhaps of spiritual transcendence or just as likely, a formal, immanent world of objects and things.

Like Cathedral, House is also finished in a highly reflective material, this time the warm shiny brightness of polished bronze. Because the surface of the form is curved there is a higher degree of distortion in the reflections than in the flat planes of Cathedral. Its deceptive simplicity conceals a sophisticated shape and construction. Essentially House is formed from two halves of a tapered circle, the width changing gradually from thick to thin at its opposite edges. In the centre of each of these halves is a doorway inviting access to an interior space. This is an intimate space of enclosure but not of isolation; a form which suggests protection rather than confinement.

Unlike Cathedral or House, One is a self-contained contemplation of itself which does not invite the same kind of speculation regarding scale. In this show it stands perhaps as Ward's most thorough exploration of the relationship between sculpture and drawing.

One consists of a tall, painted aluminium rectangle, open at its centre, which sits vertically in the middle of a plain white plinth. Its simple shape alludes to the figure 1. On the wall behind the sculpture is an intense red drawing created from layers of pigment and varnish. Into this field of colour Ward has 'etched' the exact outline of the sculptural element and given the interior of this shape an extra layer of varnish. The effect is that of a strange blueprint, reflection or shadow. Hovering in a sea of colour, the shape seems to exist as both a plan and a trace; something which may have dictated the construction of the three dimensional object and yet could simply be an after-image floating on our retina, a result of having stared at the sculpture for a moment too long.

In this way One continues the theme of reflection on two main levels; that of casting an image of itself but also that of meditation. To reflect is a private consideration of actions, events or situations, a quiet moment of subjective evaluation. In One, this deeper, subjective level of reflection is actualised by the interplay of the object and its own image in the drawing. The eye is pulled into an infinite loop of correspondence between two and three dimensional form, which operates as the visual equivalent of a meditation chant.

In the context of the show as a whole, the drawings attract the eye with a sumptuous intensity of colour and texture, which contrasts with the solidity of the sculptural objects. All the drawings are made on identical sheets of ceramic coated paper, a favourite material that Ward has developed into a unique process of working over the years. The shiny resistant surface can be scratched and 'etched' or areas of it peeled off, to reveal a more absorbent under-layer. Pure pigment can then be floated and pushed around or wiped and rubbed back. The result is a luminous field of monochromatic colour into which Ward has placed the formal shapes of the corresponding objects at their exact dimensions. The drawings generate a sensuous coloured light which floods across the intervening space to drench the surface of the metal sculpture and spill over onto the whiteness of the plinth.

This show, like much of Ward's work, cannot easily be contextualised within any coherent art-historical category. Like many of his contemporaries, he uses whatever is available and best suited to his investigation of the formal relationships between sculpture and drawing. The resulting works often occupy the boundaries of sculpture, drawing and installation, underpinned by the Classical principles of balance, measure and proportion. Ward received his art education at a point in time when the objective quality of Minimalism had recently countered the deeply subjective nature of Abstract Expressionism. Without following the tenets of either movement in any strict sense, Ward's means of expression are embedded in some of their principles. For example, the drawings exhibited here - although more reductive than earlier works - still present a richly textured surface, which hides none of its reliance on process. In contrast, the use of industrial forms and practices organised along geometric principles, returns a strong element of objectivity to the work.

Finally, what is it that transforms this rather sober sounding assemblage of industrial moulds and fabricated metal into the delightful reality of this current exhibition? Perhaps it is the playfulness and momentary disregard for gravity that makes the viewer smile at an amusing or unlikely conjunction of shapes. Or maybe it is the ambiguity of scale which invites us to play out our physical participations in space. But most importantly the transformative element is provided by the very human themes and democratic accessibility of the pieces. They 'reflect' (literally and metaphorically) our shared understanding of scale and space, our delight in the sensuality of colour and surface, and the enduring dilemma of balancing our subjective existence against our worldly experience.

Right page from top:

Wall 1

Wall 2.

Wall 3

Wall 4.

Wall 5.

265

Robert Ward

Date of birth 13 September 1949 – Nottingham, UK

Naturalised Australian 1980

1969-73	University of Newcastle-upon-Tyne
	BA(Hons) Fine Art
1973-75	University of Reading
	Master of Fine Art
1975-76	Athens Ecole des Kalon Technon (Greek Govt Scholarship)
	Academia di Belle Arti, Roma (Italian Gov. Scholarship)

Awards

1976	Northern Arts Awards
1982	Northern Arts Awards
1983	Artist in Residence, Grizedale Forest
1985	Lincolnshire and Humberside Arts Award
1989	Artist in Residence, Leeds City Arts Gallery
1990	British Council Grant
1991	Artist in Residence, Grizedale Forest
1994	Yorkshire and Humberside Arts Award
1995	Artist in Residence - Schmidt Centre for Art, Florida Atlantic University
1995	British Council Travel Grant
1999	Centre for Canadian Studies, University of Leeds Travel Grant

Teaching

1973-74	Tutor, University of Reading
1974-77	Chelsea School of Art
	University of Newcastle-upon-Tyne
1977-82	University of Newcastle, NSW,Australia
	Programme Co-ordinator, Sculpture
1982-87	Senior Lecturer in Sculpture
	Humberside Polytechnic
1987-89	Senior Lecturer in Art and Design
	West Glamorgan Institute of Higher Education
1989-94	Senior Lecturer, Head of Sculpture
	Bretton Hall University of Leeds
1994-2001	Principal Lecturer
	Head of Centre of Sculpture
	Bretton Hall University of Leeds
2001-	Head of Centre for Sculpture, University of Leeds.
1977-2002	Visiting Lecturer

University of Tuubingen , Germany
Norwich School of Art
Liverpool Polytechnic
Newcastle Polytechnic
Brighton Polytechnic
Massachusetts Institute of Technology
Falmouth School of Art
Sydney College of Arts, University of New South Wales
Royal College of Art
Visiting Professor
University of Newcastle N.S.W. Australia
Florida Atlantic University

One Man Exhibitions

1969	Hatton Gallery — University of Newcastle-upon-Tyne
1975	British Council Gallery — Athens
1976	Hatton Gallery — University of Newcastle-upon-Tyne
1977	Coventry Gallery — Sydney
1978	These Foolish Things
	Newcastle Regional Gallery, NSW, Australia
1978	The Sculpture Centre — Sydney
1980	Places, Paths and Mountains
	Coventry Gallery, Sydney
1983	Northern Centre for Contemporary Art
	Ceolfrith Gallery, Sunderland, County Durham
1985	Gone Fishin'
	Posterngate Gallery, Kingston-upon-Hull and Polytechnic Gallery, Newcastle-upon-Tyne
1989	Drawings 1977-1987 and Epiphany Drawings and Sculpture
	1988 —89 The Henry Moore Centre for the study of Sculpture, Leeds
	(first retrospective)
	Publication
1990	Kimberlin Gallery, Leicester.UK
1990	Le Cadre Gallery, Hong Kong
1991	Le Cadre Gallery, Hong Kong
1991	Ldee Gallery, Tokyo
1992	Le Cadre Gallery, Hong Kong
1994	'Crimsworth' Installation
	Angel Row Gallery, Nottingham
	Leeds Metropolitan University Gallery
	Music by Bill Nelson
	Publication
1995	Schmidt Centre Gallery
	Florida Atlantic University, U.S.A.
1995	'Tracing'
	Mark Widdup Fine Art,
	Newcastle, NSW Australia

1997	'Crimsworth' Drawings
	Galleri Il Salto del Salmone
	Turin, Italy
	Publication
1998	'Songs' — 14 bronze sculptures
	Usdan Gallery, Bennington, Vermont, USA
	Publication
2000	'Six Memos for the next millennium'
	Chiesa di St Agostino
	Bergamo,Italy,
	Publication
2004	'Patterns'
	Villa Grugliasco
	Parco Culturale Le Serre
	Grugliasco, Torino, Italy
2007	Stadt Museums Werwaltung
	Waiblingen
	Germany
	Publication
2008	Different Places.
	Shanghai Sculpture Park. Shanghai. China.
	Publication
2009	Zeestone Gallery Hong Kong

Group Exhibitions

1973	Young Contemporaries – London, Camden Arts Centre
1974	Reading Museum and Art Gallery
1975	Cleveland International Drawing Biennale – Middlesborough
	Publication
1977	Sydney Biennale
	Publication
1978	Australian Sculpture Triennial, Mildura
	Publication
1979	8 x 2 x 3 Sculpture Drawings
	Ivan Doherty Gallery, Sydney
1981	Australian Sculpture Triennial, Melbourne
1983	Northern Open-Laing Art Gallery, Newcastle-upon-Tyne
	Publication
1983	Drawing in Air: An Exhibition of Sculptor's Drawings
	1882-1982
	Ceofrith Gallery and the Henry Moore Centre for the Study of Sculpture, Leeds
	Publication
1984	Hull Artist's Association, Kingston-upon-Hull
1986	Hull Sculpture
	Fernes Arts Gallery, Kingston-upon-Hull
1986	Athena Art Awards, Barbican Art Gallery, London
	Publication
1991	Redfern Gallery
	Summer Show, London
2000	De Saumerez Manor – Jersey
	Summer Exhibition
2001	Concepts for New Sculpture, Sculpture at Goodwood
	Publication

2002	Whitney Baldwin Gallery. West Palm Beach, Florida. U.S.A
2002	Blue – Place Art Contemporanea, Turin, Italy Publication
2002	21st Century British Sculpture, Guggenheim Museum, Venice, Italy, Publication
2002	British Geological Survey, Keyworth, Notts. Exhibition of Competition Entries
2002	'Solid State' Contemporary British Stone Carving, Burghley Sculpture Garden, Stamford, Lincs Publication
2003	BLOK, Canterbury Festival of Sculpture.
2003	Form and Content in British Sculpture, Villa Gruliasco, Parco Culturale La Serre, Gruliasco, Turin
2004	Scultura International Exhibition, Castello di Aglie, Italy
2006	Line and Colour in British Art. Chalet Allemand. Grugliasco, Italy
2006	18@ 108. Bronze . Royal British Society of Sculptors. London
2007	Toyamura Sculpture Biennale. Toyamura. Japan . Publication
2007	Art is Steel . Arcelor Mittal. Reims France Concours Europeen de sculptures monumentales Publication
2008	Neue Kunst in Alten Garten . Gehrden – Lenthe . Hanover . Germany

Commissions

1991	Ironbridge Open Air Museum of Steel Sculpture Permanent sitting of 'Epiphany'
1991	Grizedale Forest, Cumbria Residency and Installation of - Tall Poppies
1992	ICI Huddersfield, UK, Installation of 'Building Bridges'
1994	Tall Poppies, Installation and siting, Yorkshire Sculpture Park
2000	Guilin, China, Installation of 'Philosophical Sculpture'
2000	Installation of 'Centurion', Newcastle Railway Station
2001	Manor Heath, Halifax, Installation of 'Poppy'
2001	Arriva, Wakefield, West Yorkshire, Installation of 'Oil Catcher'
2003	Commission to produce 'Cathedral "', Calder Park, Wakefield. Peel Holdings PLC
2004	Commission to produce sculpture for Another Paradise Taiwan",Theatre" and "House"installed 2005
2004	Commission to produce sculpture for Gesipa. Germany
2005	Commission to produce" Palace" and" Zig". Menin Developments , Florida U.S.A
2006	Commission to produce " Ships of Fools" and " Flower"for Shanghai Sculpture Park. China
2006	Commission to produce " 1634 ". Stadt Museum Waiblingen , Germany.
2006	Commission to produce Ducks , Leather and Bells . Waiblingen Germany
2007	Commission to produce. Gate. Cass Sculpture Foundation. Goodwood . U.K
2008	Commission to produce Monument. City of Grugliasco. Turin .Italy
2008	Commission to produce Arcelor Mittal Awards

Collections

Newcastle Regional Gallery
NSW, Australia

Ferens Art Gallery
Kingston-upon-Hull

Henry Moore Centre for Study of Sculpture
Leeds City Art Gallery

Northern Arts
Ironbridge Museum of Steel Sculpture

Grizedale Forest

Bretton Hall, UK

Arriva – UK

Guilin Yuzi Paradise – China

Gesipa, Germany

Peel Holdings PLC . UK

Stadt Museum , Waiblingen , Germany

Menin Developments , Florida . U.S.A

Shanghai Sculpture Park. China

Chin Pao San Group . Taiwan

Arcelor Mittal . London . UK

Private collections.
U.S.A, Italy, U.K , China, Australia,
Germany and Austria

Articles and Publications

Rob Ward Dr David Bromfield
 1980, Coventry Gallery

Rob Ward Bill Varley
 Re: Guardian 1983

Drawing in Air Drawing in Air. Sculptors Drawings 1882-1982. Ceolfrith Gallery. Sunderland.
 Glynn Vivien Art Gallery Swansea. Henry Moore Study Centre. Leeds.
 Text by Paul Overy, William Packer . Dr Terry Friedman 1983

Rob Ward Urszula Szulakowska
 Artefactum November 1991

Visual Poetry Drawings 1977-1987.Epiphany Drawings and Sculpture 1988-1989.
 The Henry Moore Centre for the Study of Sculpture. Text by Nigel Walsh. 1989

Crimsworth John Penny 1994
 Catalogue Notes Exhibition
 Angel Row Gallery, Nottingham
 Leeds Metropolitan University

Conventions, Urszula Szulakowska Exhibitions Catalogue
Objects, Fields 1995 Schmidt Centre Gallery, Florida Atlantic University,
 USA. Published by Stichting Het Grafisch Centrum

Crimswoth 1998 Urszula Szulakowska, Catalogue II Salto del Salmone
 Published by Making Space

Songs 1998 Urszula Szulakowska,
 Catalogue Published by Making Space

2000 Guilin Yuzi Paradise International Sculpture Symposium. Text by Nina Jung

Six Memos for the Catalogue text by Elio Grazioli
Next Millenium 2001 Published by Making Space

Thinking Big, Guggenheim Museum Venice
21st Century British Sculpture. Articles by Tim Marlow and Rob Mengham

Contemporary Burghley House . Lincs
British Stone Carving Text by Martin Barrat

Sculpture Message	John Spurling, The Spectator
Form and Content in British Sculpture 2003	Catalogue text by Patricia Botallo
Scultura Internationale 2004	Scultura Internationale Castello Aglie . Turin Italy. Text by Luciano Caramel
Patterns 2005	Catalogue text by Cathy Ward
Toyamura International Sculpture Biennale. 2007	Toyamura Japan.
2007, Art is Steel	Arcelor Mittal Concours Europeen de sculptures monumentales. Reims France
2008	Neue Kunst in Alten Garten. Hanover . Germany. Text by Thea Herold
2008	Shanghai Sculpture Park. Publication .
Rob Ward 2009 Reflections	Monograph. Published by MakingSpace Publishers Text by Clare Lilley. Sebastiano Barassi . Marc Wellman. Introduction by Jon Wood

Membership of Professional Organisations

1977	Member Higher Education Board of New South Wales
1983-85	CNAA Panel Member
1987-89	Welsh Advisory Board on Foundation Studies
1993-94	External Assessor University of Derby
1997	Arts Council Assessor Combined Arts Unit
1998	External Assessor University of Sunderland
2000	Fellow Royal Society of British Sculpture
2000	Elected Fellow Royal Society of Arts
2000	Elected Trustee, Royal Society of British Sculptors
2000	External Examiner, Kent Institute of Art & Design U. K Coordinator. European Sculpture Network
2007	Board member European Sculpture Network
2000	International Sculpture Conference – Chicago
2000	Six Memos for the Next Millennium. Bergamo, Italy
2001	Institute of Contemporary Arts, London. 'Remix' featuring Six Memos for the Next Millennium
2006	International Sculpture Symposium, Guilin, China
2006	European Sculpture Network, Graz , Austria Keynote Lecture . Sculpture in Pubic Places
	Royal British Society of Sculptors. Lecture . Attitudes on Bronze

Left page:
BeBop Runner
178 x 107 cm